Dorothy

With deep appreciation for
the vigor, vitality and creation
you have brought to, and
reawakened in, Cedar Crest College
in all her facets —

Ry
9/90

# SITINGS

Hugh M. Davies      Ronald J. Onorato

# SIT

## Alice Aycock / Richard

*Edited by Sally Yard*

# INGS

## Fleischner/Mary Miss/George Trakas

La Jolla Museum of Contemporary Art

La Jolla Museum of Contemporary Art
La Jolla, California
April 5–May 25, 1986

Dallas Museum of Art
Dallas, Texas
June 8–August 10, 1986

High Museum of Art
Atlanta, Georgia
September 16–November 16, 1986

This exhibition and catalogue have been made possible through the generous support of Mr. and Mrs. Rea Axline, Mr. and Mrs. James S. DeSilva, Dr. and Mrs. Jack M. Farris, and the National Endowment for the Arts, a Federal Agency, Washington, D.C.

Library of Congress Catalogue Card Number 86-80303. ISBN 0-934418-25-X

Previously published essays by the authors have been incorporated into several chapters of this catalogue and are included in the bibliographies.

In captions throughout the catalogue, media and dimensions are given for movable works. Height precedes width precedes depth.

COVER: George Trakas, *Pacific Union*, 1986, La Jolla Museum of Contemporary Art, permanent installation under construction. Funded in part by the Art in Public Places Program, National Endowment for the Arts, a Federal Agency, Washington, D.C.

# Contents

# Preface
## Acknowledgments

Auspiciously linked early on, Alice Aycock, Richard Fleischner, Mary Miss, and George Trakas have been in the forefront of the thrust toward site-specific sculpture for more than a decade and a half. During the past ten years, major works by the four have appeared virtually side-by-side in landscapes and exhibition spaces in America and Europe. A subterranean network of passages constructed by Aycock, a "sod drawing" inscribed across a field by Fleischner, and paired pathways, built by Trakas, which led to a clearing in the woods were momentously included in the *Projects in Nature* exhibition in Far Hills, New Jersey in 1975. The following year the three again appeared together in *Sculpture Sited* at the Nassau County Museum of Fine Arts, where two years later Miss built *Perimeters/Pavilions/Decoys*, its towers, embankments, and underground structure composed across several acres of land. All four constructed pieces at Artpark in 1976–77, and Aycock, Fleischner, and Trakas worked on adjacent sites at the 1977 *Documenta 6* in Kassel, Germany.

Most of the early works, built on location for temporary exhibitions, are gone. While a number of museums have been vigorously supportive, dedicating substantial portions of their exhibition space and budgets to sited works, by nature the art of Aycock, Fleischner, Miss, and Trakas has been unwieldy and, until recently, by circumstance, transitory. Museums like the Dallas Museum of Art, with a courtyard designed by Fleischner, and the La Jolla Museum of Contemporary Art, with a permanent Trakas work in the garden, have been the exception.

Hearteningly, the four have, as they approach mid-career, constructed permanent works under the auspices not only of museums, but also of the National Endowment for the Arts and the General Services Administration; of cities and towns from New York to Dayton, Ohio and Thiers, France; and of universities and private patrons. Universities—with their park-like, public open spaces—have been an important source of support and cauldron for creativity. Permanent pieces by one or more of the four have been commissioned by Emory University in Atlanta, Governors State University, Massachusetts Institute of Technology, Oberlin College, Salisbury State College, San Diego State University, the University of Massachusetts, Amherst, and the University of California, San Diego. With its focus on site-specific sculpture, UCSD's Stuart Collection is rapidly becoming a West Coast public analogue of the collections of interior environmental works commissioned in Varese, Italy by Dr. Giuseppe Panza di Biumo, and of permanent outdoor installations, including ones by Trakas and Aycock, commissioned by Giuliano Gori in 1982 at the Fattoria di Celli in Pistoia, Italy. It seems appropriate that this exhibition should originate just down the road from the Stuart Collection.

We are delighted that the exhibition will be seen in cities that are home to permanent public works by some of these artists. It has been a pleasure to work with Sue Graze, Harry S. Parker III, and Anna McFarland of the Dallas Museum of Art, and with Peter Morrin and Gudmund Vigtel of the High Museum of Art, Atlanta.

The realization of this exhibition and catalogue has been made possible through the generosity of Mr. and Mrs. Rea Axline, Mr. and Mrs. James S. DeSilva, and Dr. and Mrs. Jack M. Farris. We are indebted to Mr. and Mrs. Charles S. Arledge and Mr. and Mrs. Frank Kockritz for their support and vision. The National Endowment for the Arts has provided funding not only for this project, but also for the work of Aycock, Fleischner, Miss, and Trakas over the years. NEA's Art in Public Places program has contributed matching funds for the commissioning of *Pacific Union*, the permanent environmental work by Trakas in the La Jolla Museum of Contemporary Art's garden. We are grateful for the energy and enthusiasm of the Museum's Board of Trustees, and in particular to Christopher Calkins and Edgar Marston.

We deeply appreciate the willingness of collectors and museums to part with their works for the duration of the exhibition. Among these are Lauren Ewing, Michael Krichman and Leslie Simon, Henry S. McNeil, Jr., Derrel Marsella and Donald Marsella, Mrs. Sue Rowan Pittman, Gilbert and Lila Silverman, John Weber, Emory University Museum of Art and Archaeology, National Gallery of Canada, Ottawa, and the University Gallery, University of Massachusetts, Amherst.

We are grateful to Drew Cottril and Rush Press for the fine printing of the stunning catalogue, which has been designed with imagination and subtlety by Lilli Cristin. RS Typographics has been meticulous in the setting of type, and Juliana Terada and Alex Mariano of Swain's Graphics were gracious and patient in preparing the numerous stats. The catalogue as a whole has been edited with sensitivity and creativity by Sally Yard. She and editor Julie Dunn have together guided the manuscript into print with diligence and tact.

Many on the Museum's staff have been essential. Michael Arthur has painstakingly done much of the photography for the catalogue; Lynda Forsha and Candace Bott have attended to myriad details; Bolton Colburn has arranged loans, shipping and framing, while Tom Flowers, with Kevin Stephens, has installed the exhibition. Tauno Hannula has worked with George Trakas on *Pacific Union*. Marilyn Mannisto and intern Lee David Ahlborn have helped to track down important information, while Catherine Hogan and Tammy Papp typed the catalogue text. Davilynn Furlow has been of invaluable help in reviewing the galleys and, with the assistance of Michelle Caldwell, has organized public information and outreach programs surrounding the exhibition. Janet Ciaffone, Connie Wood, and Dawn Dickstein have also helped to bring the project to fruition.

A number of individuals have been especially helpful, among them Michael Levin of the Tel Aviv Museum; Clark Poling and Mary Woodward of the Emory University Museum of Art and Archaeology; Jessica Bradley and Joseph Martin of the National Gallery of Canada, Ottawa; Betsy Siersma, Helaine Posner, Craig Allaben, Fred Moore, and Fred Tillis of the University of Massachusetts, Amherst. Jane Carey, Teresa Bullock, Ardy Young, Mary Panton, Giuliano Gori, Lane Myer, Merry Short, Joan Simon, and Jean Paul Judon have all played important roles. Leo Castelli Gallery, Paula Cooper Gallery, Xavier Fourcade Gallery, and John Weber Gallery have helped locate photographs for the catalogue. We are delighted that Mary Beebe of the Stuart Collection, Jeff Kelley, and Sally Yard have joined us in a symposium with the artists.

Sabbaticals granted to Hugh Davies by the University of Massachusetts, Amherst in 1981–82, and to Ronald Onorato by the University of Rhode Island in 1985 allowed time for our consideration of sited art. A Museum Professional Fellowship Grant from the National Endowment for the Arts in 1981–82 was vital for Hugh Davies's research. Having for more than a decade shared an admiration for the work of Aycock, Fleischner, Miss and Trakas, we are delighted to have collaborated on this project. The exhibition and catalogue are the culmination of more than five years of dialogue between us. The process of planning the show has been a thoroughly enjoyable one, made all the more so by the participation of the four artists, whose input has been as sensitive as their art is bold.

*Hugh M. Davies, Director*
*Ronald J. Onorato, Senior Curator*
*La Jolla Museum of Contemporary Art*

■

# Introduction

*Sitings*, an exhibition of the work of Alice Aycock, Richard Fleischner, Mary Miss and George Trakas, originated from a critical need within the art world of the past two decades. While much has been written about the plurality of styles, scales, and scenarios of art since 1960, little critical attention has been brought to bear on artists, like these four, whose work, generally of architectural scale, is often related to their sites and reflects public and environmental concerns as well as their own personal aesthetic agendas. Each member of this quartet is representative of options that emerged with the generation of artists who matured after Minimalism and before the current debate over issues of site specificity and public art became widespread. While the group is by no means gathered to represent an institutionalized or stylistic "school," we feel confident that there is a coherency here of background, age, and attitudes that affirms such a selection.

The realization of this exhibition, however, marks more than just a representative sampling of four major site artists at work today. It attempts to initiate a direct and emphatic response to the limitations of support shown for this kind of non-commodity work by museums of art. Over a decade ago, William Rubin of the Museum of Modern Art anticipated that museums might not be able to expand their institutional format widely enough to show and support all forms of contemporary art:

> Perhaps...it will appear that this modernist tradition really did come to an end within the last few years, as some critics suggest. If so, historians a century from now—whatever name they will give the period we now call modern—will see it beginning shortly after the middle of the 19th century and ending in the 1960s. I'm not ruling this out; it may be the case, though I don't think so. Perhaps the dividing line will be seen as between those works which essentially continue an easel painting concept that grew up associated with bourgeois, democratic life and was involved with the development of private collections as well as the museum concept—between this and, let us say, Earthworks, Conceptual works and related endeavors, which want another environment (or should want it) and, perhaps, another public.[1]

Touching on the difficulty for most museums of coming to terms with art that does not fit into the conventional format of exhibiting, collecting, and packaging—related as these elements are to institutional support—Rubin continued:

> I think there is an inevitable distance between much post-Minimal art, Earthworks, Conceptual art, and *all* museums....I would say that some Minimal art is less than comfortable in museums, though other pieces look very good. However, its implications and its nature—insofar as Minimal art makes the context, the very structure of the space, part of the work, as Bob Morris points out—seem to point in another direction. Most Earthworks are obviously beyond museums....[2]

If we accept this concept, exhibiting artists who work outside a museum context might seem a futile attempt that undermines the aesthetic intent of the work itself. But given the power of museums as the central agency in our culture through which works of art can be disseminated, discussed and discovered, the inclusion of the work of these artists within the museum realm is imperative for both the validity of the art and vitality of the institution. As Douglas Crimp has remarked, "It is only the exhibition institutions that can, at this historical juncture, fully legitimate any practice as art."[3]

With a few exceptions, hindered by the difficulty of illuminating the richness of such extra-mural work using slide documentation, voice-over narrations, texts and photographs, no major museum effort has been made to redress this serious shortcoming. It may ultimately not be possible to embrace art whose ambitions and goals are indeed antithetical to the givens of a museum context, but *Sitings* attempts to begin such a revisionist process. The show and accompanying analytical text offer first and foremost a balanced look at a small group of artists—selected because of their aesthetic, personal, and geographic proximity. While a background context of the myriad influences against which their art should be seen is discussed in the chapters entitled "Post-Studio Sculpture" and "Real Time–Actual Space," the core monographic essays explore the artists' constructed work in depth, acknowledging parallels and divergences among them. "A Dictionary of Assumptions" focuses, as does the show itself, on drawings by the four, bringing real art works into the context of an aesthetic investigation. Resolved entities in themselves, the drawings reveal much about the creative process that leads to the environments built by these artists. Eschewing the familiar and often misread documentation of photography,

*Sitings* uses these graphic works as primary documents suggesting attitudes and priorities rather than attempting to replicate the finished works.

At each of the participating museums, one of the artists will construct a work on site. With this bi-part exhibition we hope each museum thus becomes both a traditional expository institution and a supportive mechanism for living artists who are creating work heretofore largely outside, and despite, the museum context. Rather than usurping or co-opting this art, *Sitings* signals a new attempt at programmatic expansion through which museums and public alike might come to terms with artists whose primary concerns engage the real world as often as they do the one of their own making.

*Hugh M. Davies and Ronald J. Onorato*

■

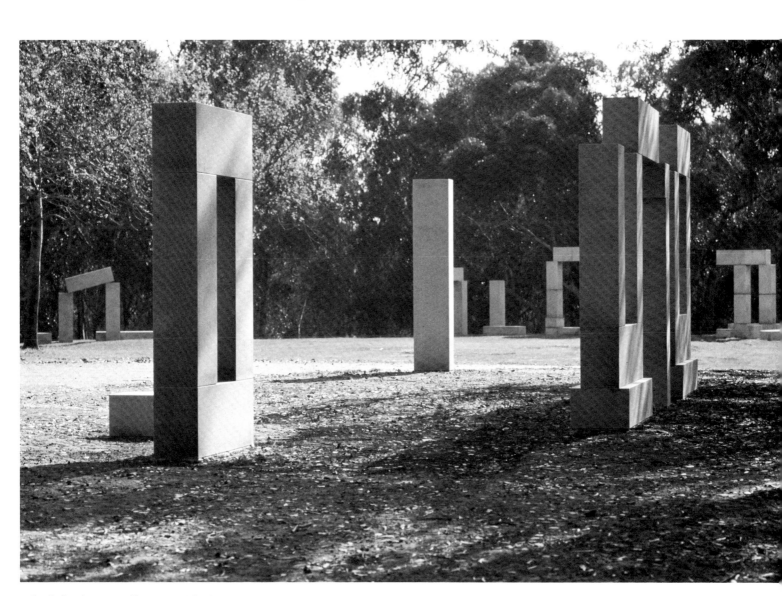

Richard Fleischner, *La Jolla Project*, 1982–84, Stuart Collection, University of California, San Diego, permanent installation.

Carl Andre, *Lever*, 1966, firebrick, 4½ inches x 8⅛
inches x 34½ feet, Collection National Gallery of
Canada, Ottawa.

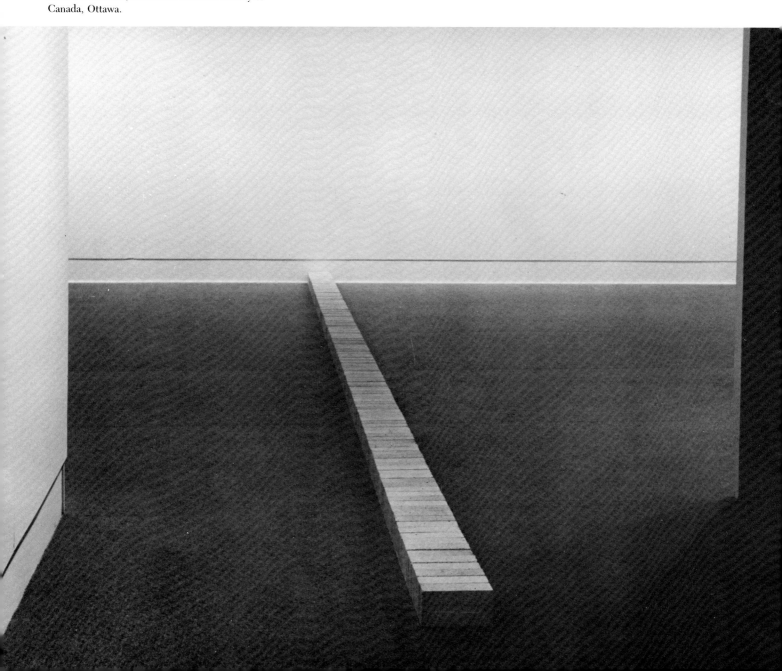

# Post-Studio Sculpture

Carl Andre's haiku-like summation of sculptural development is as spare, rational, and aesthetically efficient as his own sculpture. The statement was made in the fall of 1966 following Andre's participation in the exhibition *Primary Structures* in the spring at the Jewish Museum. This timely exhibition organized by Kynaston McShine essentially defined Minimalism as a movement by assembling for the first time a large number of works by artists who shared a common predilection for geometrically based, reductive, impersonal forms or, as the title stated, primary structures.

The three stages of Andre's scheme define sculpture's past, present, and future. Sculpture as form referring to traditional studio object sculpture prior to Minimalism. Sculpture as structure alluding to the work of the day included in the exhibition *Primary Structures*. And finally, sculpture as place defining his own sculptural concerns at the time and accurately forecasting the direction to be pursued by sculptors over the next decades. The progression from form, to structure, to place conveys an increasing engagement of space that parallels twentieth-century sculpture's development from the discrete object removed on its pedestal, to the Minimal structure which shares or crowds our space, to environmental or site sculpture which is integrated with the space and transforms it in a way that creates a new place for the viewer.

*The course of development*
*Sculpture as form*
*Sculpture as structure*
*Sculpture as place.*
—Carl Andre, 1966[1]

Andre's submission to *Primary Structures* may be viewed as the work which as much as any other heralds the change in sensibility from space-displacing objects or structures to place-defining or site-specific sculptures. Although in most ways a Minimalist modular structure—a straight line of 137 unattached firebricks—*Lever*'s significance derives from the fact that it was specifically made with the floor in mind as support. *Lever* was designed to have one end abut a particular point on the gallery wall, and from there to extend 34½ feet across the floor and on center with a doorway in the facing wall. As described by David Bourdon:

> The piece was designed for a specific space, so that viewers in two neighboring galleries would have distinctly different views of it. From one adjoining gallery, viewers . . . saw a segment of the work in elevation, extending horizontally like a horizon line. From the second entrance way, viewers met the piece head-on, seeing it in receding perspective.[2]

Although *Lever* is described as having been designed for the space, its proportions were not determined by the proportions of the room. The firebricks are common materials of standard dimensions, and the piece's length was the result of Andre's selection of the prime number 137 rather than his precise tailoring of the number of units to the width of the floor.[3]

*Lever*'s claim to site specificity is further compromised by the fact that it was not a unique, temporary installation which ceased to exist once the exhibition closed and the piece was dismantled. *Lever* was subsequently acquired by the National Gallery of Canada, Ottawa and during Andre's retrospective which opened in 1978 it was installed successively in nine different museum spaces over a two-year period. Hence, since its initial installation at the Jewish Museum *Lever* has functioned as a traditional object sculpture in the sense that it has remained unchanged in its configuration and has been exhibited in many different spaces. However, what both distinguishes this work from traditional object sculpture and provides the important connection with subsequent site sculpture is its complete dependence upon and integration with each architectural context. In every installation one end of *Lever* abuts a wall at a right angle, and the line of 137 bricks extends across the floor into the gallery space. The piece draws its energy as sculpture from this specific placement joining wall and floor. As the title implies, *Lever* functions as a spatial fulcrum; by precise positioning and resultant architectural integration it "lifts" or energizes the entire surrounding architectural space. The object itself, the line of mundane bricks, is de-emphasized, truly minimized, as *Lever* serves as a tool to achieve the end of activating a space much larger than the zone surrounding any traditional piece of sculpture.

*Lever*'s importance above all derives from its genesis. Invited to participate in *Primary Structures*, Andre proposed to create a work for a specific space in the museum rather than to exhibit an extant piece. With this decision to respond to a particular situation Andre made the leap into "post-studio sculpture" by shifting the emphasis from the object to the way the object is placed in and interacts with its environment.

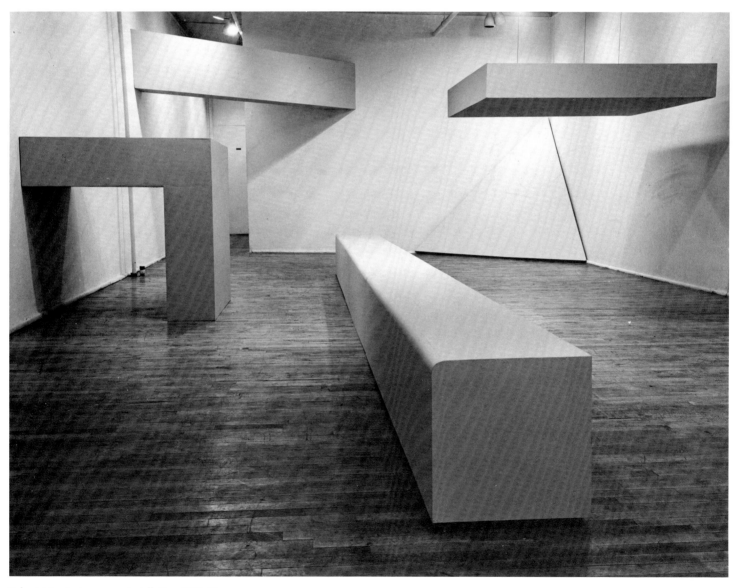

Robert Morris, temporary installation, 1964, Green
Gallery, New York.

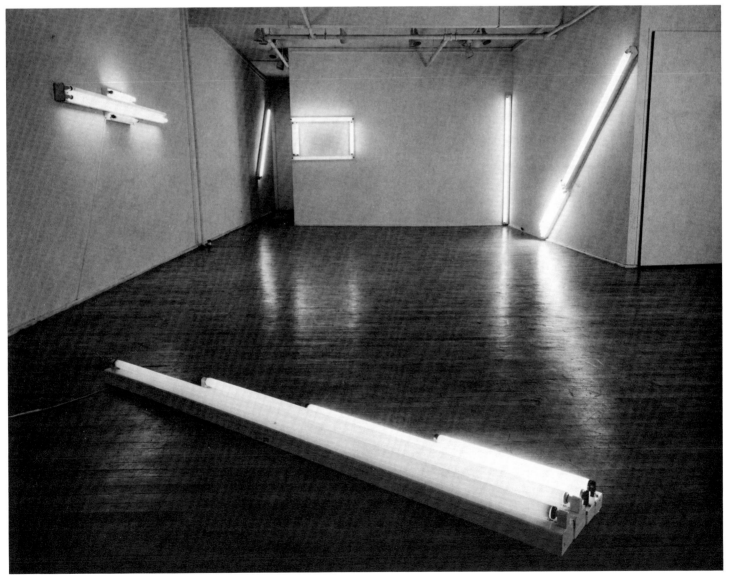

Dan Flavin, temporary installation, 1964, Green
Gallery, New York.

While Andre was probably the first declared "post-studio" sculptor, other Minimalists had for several years been creating works which reflected a consciousness of, and even a dependence on their architectural settings. Both Robert Morris and Dan Flavin, like Andre, made pieces specifically for the *Primary Structures* exhibition and had acknowledged the architectural context in one-person exhibitions at the Green Gallery in 1964. Morris's Untitled rectilinear structures first installed at the Green Gallery included a rectangular plane suspended from the ceiling at eye level, a long beam extending across the floor, and an upside down L-shaped form braced between wall and floor. These generalized forms could be exhibited in any interior space but they are more than Minimal objects to be placed in a room. Both conceptually and physically they depend on the architecture. As simple rectilinear shapes they replicate architectural forms, their disposition paralleling the basic horizontal and vertical planes of floor, wall, and ceiling. And most importantly, by resting, leaning and hanging on the room, they enlist the architecture as active support rather than as passive foil or container.

Dan Flavin's exhibition in the same gallery that year depended not just on the generalized architectural container but on the particular configuration of this specific space. Fluorescent light fixtures were the ostensible objects, but the medium was the light they produced. The resulting works of sculpture were to a large extent determined by how the light was reflected and contained by the supporting and surrounding surfaces of walls, floor, and ceiling. The ambient envelopes of light were shaped by the architectural setting while at the same time, in Flavin's words, "the actual space of a room could be broken down and played with by planting illusions of real light (electric light) at crucial junctures in the room's composition."[4] These early works of Flavin are truly environmental; while Morris developed a symbiosis of setting and sculpture, Flavin achieved a synthesis controlled by the artist.

These artists who actively cultivated a dialogue between sculpture and setting are an exception. For the most part as Minimal sculptors made larger and larger structures they were forced to customize them to accommodate the architectural container. As the structures displaced increasingly more space the viewer's focus remained on the object rather than on the surrounding space. *Scale as Content: Ronald Bladen, Barnett Newman, Tony Smith*, a stunning exhibition of 1967 organized by the Corcoran Gallery in Washington, D.C., well illustrates this tendency. Bladen and Smith, two prime movers of Minimalism, both made gigantic geometric structures of black painted plywood which completely dominated and filled the two-story-high ground floor galleries. Both pieces were temporary mock-ups intended to be fabricated as permanent steel pieces at a later date for other sites. Bladen's enormous *The X* extended toward the surrounding architecture like an anthropomorphic Samson but only touched the floor. Smith's *Smoke*, a modular open lattice, expanded to occupy the space as its title implies, but the size of the module was independent of the architecture, and the piece merely stood in the space.

Minimal structures like these which exemplified "scale as content" could operate just as effectively, if not more so, outdoors, but it was a function of patronage that urban museums sponsored them in the space available. A group of younger artists in part reacting to this spatial dilemma and at the same time rejecting the commodity aspect of the transferable object, the industrial materials and assembly line look of Minimalism, and the exclusively urban context of "fine art" moved sculpture out of the gallery into the land.

## Physicality of Time, Space, and Motion

The *Earth Art* exhibition sponsored by Cornell University in Ithaca, New York during the winter of 1969 historically served a function similar to that of the *Primary Structures* exhibition of 1966 in that it clarified a new sculptural tendency. *Earth Art* brought together several artists from both Europe and the United States (Jan Dibbets, Hans Haacke, Neil Jenney, Richard Long, David Medalla, Robert Morris, Dennis Oppenheim, Robert Smithson, and Gunther Hecker) whose sculptural concerns went beyond Minimalism and beyond the traditional object. These artists shared an interest in process and working with nonprecious materials; their works were anti-formal and more involved with conceptual than visual concerns. The title *Earth Art* both implied the rejection of the precious object or art commodity and suggested moving beyond the confines of studio and gallery. The conceptual approach to art shared by the participants was a more important unifying aspect of the *Earth Art* exhibition than the superficial fact that they all had used earth as a material in their previous work.

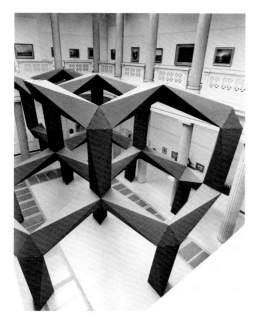

Tony Smith, *Smoke*, 1967, Corcoran Gallery of Art, Washington, D.C., temporary installation for the exhibition *Scale as Content: Ronald Bladen, Barnett Newman, Tony Smith*.

Michael Heizer was not included in the Cornell show but was the first artist to realize a series of large outdoor earthworks. During the summer of 1968 he and Robert Smithson travelled together to remote desert sites in Nevada and California. While Smithson gathered materials for his Site/Nonsite pieces—rocks to be placed in the Minimalist steel containers that served as "three-dimensional maps"—Heizer was moving tons of earth and sculpting his *Nine Nevada Depressions*. *Dissipate*, 1968, No. 8 of *Nine Nevada Depressions*, now deteriorated, consisted of five wedge-shaped, wood-lined depressions carved into the floor of the Black Rock Desert. While the action of carving is traditional and the negative forms are clearly "Minimal," the vast, neutral location on the remote desert and gesture of sculpting voids by removing mass below the ground plane place this work well beyond conventional museum sculpture.

The following season Heizer built—or carved—*Double Negative*, 1969–70, by displacing 240,000 tons of earth to form two wedge-shaped depressions facing each other across the scalloped edge of the Virgin River Mesa in Nevada. The form and gesture are similar to *Dissipate* but the size (each negative being 50 feet deep and 30 feet wide and the total length 1,500 feet) is vastly increased. The cuts are aligned parallel to the Virgin River below the mesa, as if the artist's rapid displacement echoed the river's aged and ongoing erosion. For all its tremendous scale, *Double Negative*, which is below eye level as one approaches, is ironically almost inconspicuously integrated into its site.[6] Heizer dismisses any suggestion that the work is "site-specific" and discusses *Double Negative* only in strictly formal terms: "What can be said about a work of art that can't even be seen? The north and south cuts function simply to imply or persuade a volume in between. Whatever sculptural qualities these setups might or might not have are coincidental."[7] Despite these protestations the implied volume can only be felt as the viewer walks the piece from one end to the other, descending into the two cuts and approaching the nonexistent center. The influence this work has exerted on subsequent artists has been primarily through photographs, but it is the physicality and awesome scale rather than the conceptual premises that account for its impact. The sheer ambition of a work of art that by its size demanded physical interaction on the part of the viewer/ participant and is so much a "part of where it is" had great import for sculpture in the seventies.

While Robert Smithson had been the leading spokesman for earth art and through his writings and physically modest Site/Nonsites had promulgated the move into landscape, it was not until the spring of 1970 that he realized his first major earthwork, the *Spiral Jetty* in the Great Salt Lake of Utah. Composing the *Jetty* as a 15-foot-wide path spiraling counterclockwise for 1,500 feet out into the dead lake, Smithson utilized his familiar entropic emblem, the spiral, as physically and conceptually appropriate to the site. In a conversation with Bruce Kurtz in 1972 Smithson stated: "I find a lot of artists completely confused, especially people working with sites. They don't really know what they're doing there. They're imposing an abstraction rather than drawing out an aspect, or cultivating something in terms of the ecological situation."[8]

In an unanticipated ecological twist the waters of the Great Salt Lake rose and swallowed (covered) the *Spiral Jetty* in 1972 and have yet to recede. Hence the work, for the time being at least, can only be evaluated through photographs and films which, given its remote site, is how the vast majority of us would have known it anyway. Like *Double Negative*, the *Spiral Jetty*'s influence on artists is largely a result of its romantically remote site and its ambitious scale. That it would take time and physical effort to walk the *Spiral Jetty* is conveyed in a film made by Smithson, but is somewhat obscured in the ubiquitous aerial photographs in which we see the piece as a geometric abstraction imposed on the landscape. To Heizer's credit, he has attempted to prevent publication of aerial reproductions of *Double Negative* in order to eliminate such a bird's-eye, all-encompassing view which subverts the physically interactive experience which he intended in the work.

Smithson in his influential article "Towards the Development of an Air Terminal Site" of 1967 concluded that "'Site Selection Study' in terms of art is just beginning. The investigation of a specific site is a matter of extracting concepts out of existing sense-data through direct perceptions. Perception is prior to conception, when it comes to site selection or definition. One does not *impose*, but rather *exposes* the site...."[9] The collapsing spiral form seems an apt symbol for a dying lake as salt crystals are its microcosmic equivalent. Perceptually the desolate landscape setting of *Spiral Jetty* suggested to the artist "an immobile cyclone."[10] In this way Smithson may be said to have been "extracting concepts" from the site. However,

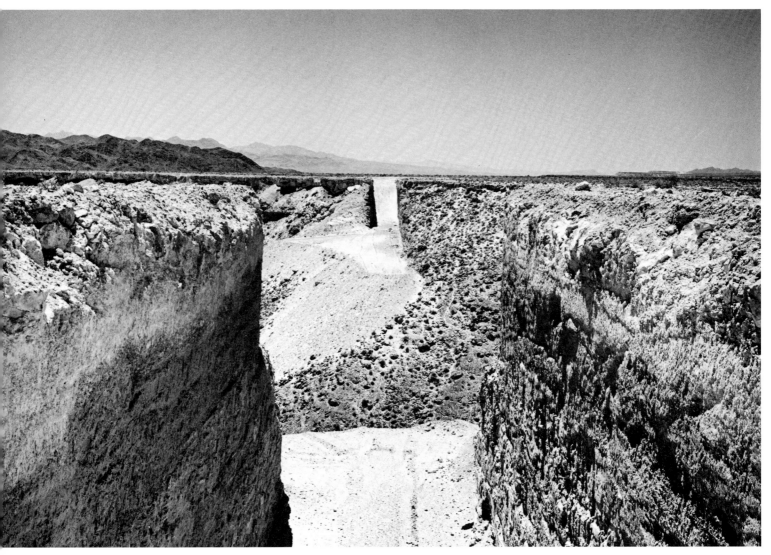

Michael Heizer, *Double Negative*, 1969–70, Virgin
River Mesa, Nevada, permanent installation,
Collection Museum of Contemporary Art, Los
Angeles, Gift of Virginia Dwan.

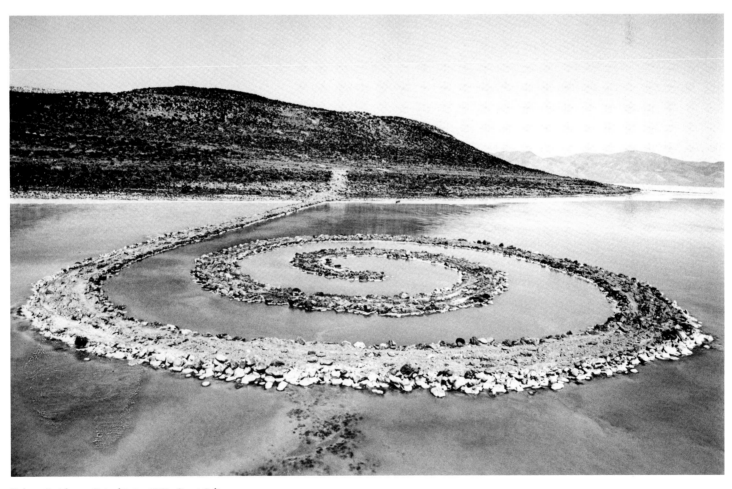

Robert Smithson, *Spiral Jetty*, 1970, Great Salt
Lake, Utah, permanent installation (currently
under water).

as the spiral is such a prevalent form in his work and the notion of entropy so central to his philosophy, it is hard to resist the conclusion that he selected a place for which the piece was appropriate.

An important distinction between Smithson and subsequent site sculptors resides in the nature of their respective sites. Smithson sought vast, Western settings, largely neutral in terms of topographic incident or vegetation, and exposed their character by imposing a single, bold geometric form. Artists of the next generation were drawn by choice or opportunity to work with more active Eastern landscape sites rich in topographic incident and often populated by mature trees. A central concern of theirs has been the integration of sculpture and site, in works that accommodate the inherited vagaries of terrain and elucidate the character and history of the place. Unlike Smithson, who was attracted to spoiled sites ("My own experience is that the best sites for 'earth art' are sites that have been disrupted by industry, reckless urbanization, or nature's own devastation.")[11] and Heizer, who was drawn by the vast, neutral space provided by the desert ("The museums and collections are stuffed, the floors are sagging, but the real space still exists."),[12] the site sculptors who emerged in the seventies have utilized all manner of sites from the spoils pile at Artpark, to city parks, urban plazas, and interior galleries. Indoors and out, the prime consideration has been to go beyond the self-contained, studio object to create structures which transform the character of the space and almost invariably take as the starting point the physical givens of the specific site.

Richard Serra, a leading Minimalist sculptor of the sixties, was profoundly affected by his firsthand encounter with Heizer's *Double Negative*, by the experience of helping Smithson stake out the *Spiral Jetty*, and by a visit to Zen gardens in Japan in 1970.[13] Over the next two years he built two outdoor pieces, *Pulitzer Piece: Stepped Elevation*, 1971, and *Shift*, 1970–1972, which may be regarded as the first fully site-specific sculptures in that their forms were determined by the particular topography of the landscape. In describing the *Pulitzer Piece* Serra wrote: "The land defined the work, the elements pointing into the landscape as it undulates in various directions. The dialectic of walking and looking into the landscape establishes the sculptural experience."[14] The experience of building the work encouraged Serra to tackle the more ambitiously scaled *Shift* in King City, Canada.

*Shift* consists of six cement walls in groups of three spanning a shallow valley between two hills; its overall length is 1,500 feet. (Coincidentally both the *Double Negative* and *Spiral Jetty* are also 1,500 feet long.) The placement of each element was determined by the contour of the land, specifically the shortest contour interval or steepest slope in 5-foot increments. Hence each element emerges from the hill, its top edge establishing a true horizontal and running the shortest possible distance until the height to the base reaches 5 feet. The resulting work establishes a volumetric cross-section of the valley and a true three-dimensional map of the site. The landscape has determined the configuration of the sculpture and in walking the piece the viewer/participant becomes keenly aware of previously unpunctuated topography. The work refers to the land rather than to itself unlike Heizer's *Double Negative* which, as Heizer has indicated, might have been positioned on any number of possible mesas. *Shift*'s complete physical reliance on the site distinguishes it from the *Spiral Jetty* which, while alluding to historic, ecological and spiritual aspects of the Great Salt Lake, is finally an imposed geometric abstraction.

Serra's stated intention was "a dialectic between one's perception of the place in totality and one's relation to the field as walked. The result is a way of measuring oneself against the indeterminacy of the land. . . . The intent of the work is an awareness of physicality in time, space and motion."[15] The example of Serra's landscape works and perhaps more importantly the credo of generating sculpture from clues provided by the setting and the intention of directing the viewer's physical awareness of self and site had more impact on the next generation than the earthworks of Heizer and Smithson.

A strong case can be made that Robert Morris is the most important artist of his generation; he has unquestionably been the greatest single influence for Aycock, Fleischner, Miss, Trakas, and other site sculptors. Since his performance works and Minimal sculpture of the early sixties Morris has been at the forefront of each successive sculptural innovation of the past two decades. A listing of his works, the exhibitions in which he has participated, and the articles and books that refer to his contributions could serve as a profile of sculptural evolution of this period. While only Aycock studied formally with Morris at Hunter College, early works of the other three artists clearly reveal his influence, and he is acknowledged by all four as a role model and mentor.

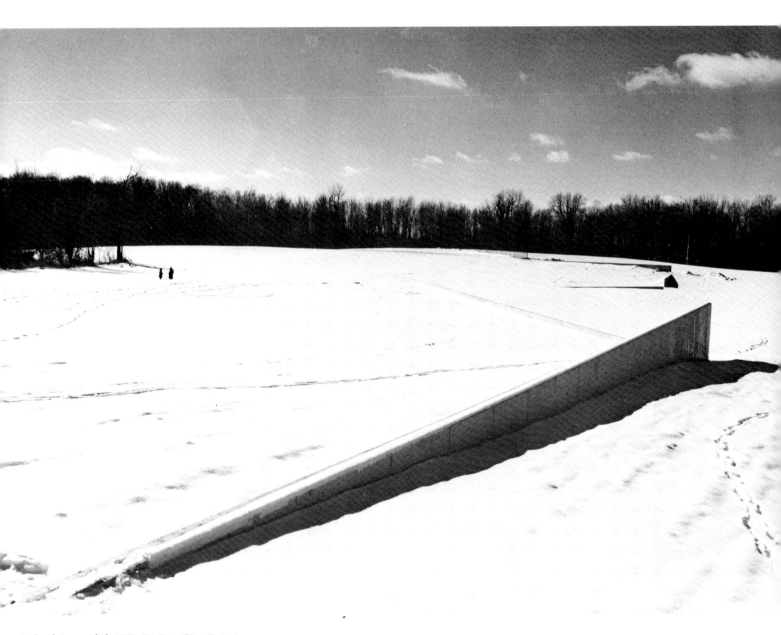

Richard Serra, *Shift*, 1970–72, King City, Ontario,
Canada, permanent installation, Collection
Roger Davidson, Toronto.

Robert Morris, *Observatory*, 1971, reconstructed
1977, Oostelijk Flevoland, The Netherlands,
Collection Rijksdienst for Ijsselmeerpolders,
Lelystad.

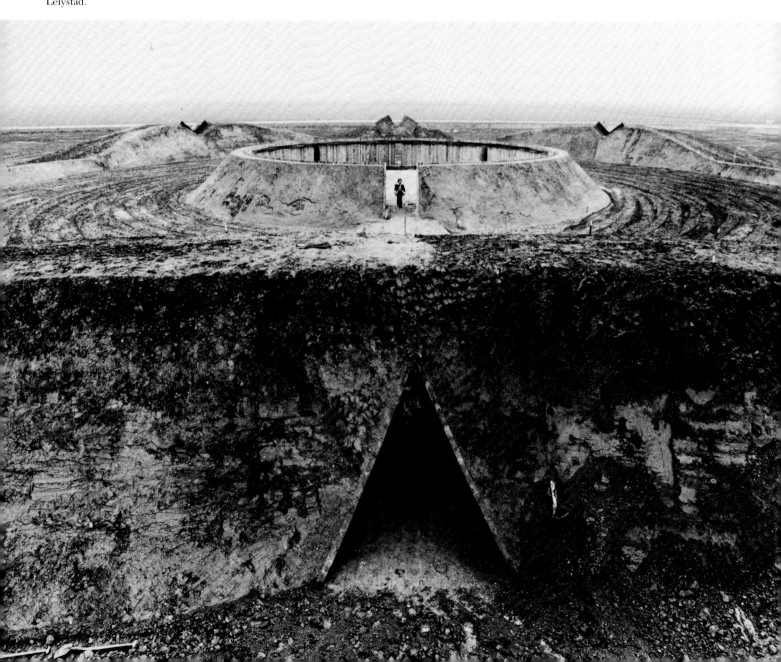

Like Donald Judd and Smithson, Robert Morris is an articulate spokesman and intelligent writer about both his own work and art in general. Since the mid-sixties his articles in leading art journals have served to define and clarify new directions in art and art criticism, though he has often been too modest to cite his own works as primary pieces in this evolution. His declaration in a 1971 *Artforum* article, in retrospect, marks the general acceptance of post-object sculpture: "It seems a truism at this point that the static, portable indoor art object can do no more than carry a decorative load that becomes increasingly uninteresting."[16]

Morris's contribution is embodied in the cumulative import of his work rather than in any single "masterpiece" such as *Lever*, *Double Negative*, *Spiral Jetty*, or *Shift*. Hence the sequence of prime works outlined in this essay needs to be broken to acknowledge his pivotal place in the emergence of site work. His earliest Minimal pieces, dating from the time of his Green Gallery exhibition in 1964, acknowledged the contextual role of the surrounding architectural space. *Location* of 1963 is a two-foot-square painting-like construction to be hung on a wall. An arrow points toward each of the four sides of *Location*. The four directional indicators are accompanied by the words "floor," "wall," "ceiling" and "wall," and are paired with adjustable counters set to record the number of feet to the designated architectural surface. As the title implies, the entire logic and purpose of the two-dimensional piece is to locate the surrounding, three-dimensional spatial context. The following year with *North-South Track* Morris extended the notion of location beyond the immediate architecture. A compass set in a horizontal wooden form permitted the work to be self-siting on the north-south axis in whatever space it was installed.[17]

*North-South Track* (like a related outdoor proposal, *Track*) was a conceptual harbinger of Morris's first realized, large-scale outdoor work, *Observatory*, built first in Santpoort-Velsen in the Netherlands for the 1971 *Sonsbeek* exhibition and in 1977 reconstructed as a permanent work in Oostelijk Flevoland. *Observatory* is essentially a large compass built into the land and also marks time by means of sight lines constructed to align with the solstitial and equinoctial sunrises. The piece is not site-specific since the design of the work preceded a site visit, and as attested by the fact that *Observatory* was reconstructed at a second location. However it marks the emergence of work that bridges art and architecture in the composition of "enclosures, courts, ramps, sight lines, varying grades, etc. [which] assert that the work provides a physical experience for the mobile human body."[18]

Like earthworks, the piece required the viewer's physical interaction over time, defying comprehension through the more passive, visual confrontation permitted by object sculpture. Interviewed in the Netherlands the year of *Observatory*'s permanent re-installation, Morris explained that he objected to the physically remote sites of most earthworks, resented the pilgrimage required to experience them, and preferred the quiet location but easy access of this work. Further distinguishing *Observatory* from earthworks, he reflected:

> I think it is different in the sense that it focuses on space, shaped space, rather than a figure-ground situation, objects on the ground, or lines on the ground, or cuts in the ground, which seem to me much like a figure-ground situation, that I was not at all concerned with. I am concerned with spaces that one enters, passes through, literal spaces, not just a line in the distance, but a kind of space the body can occupy and move through.[19]

Morris has since defined site work as sculpture "structured by thematic responses to its context of site."[20] While *Observatory* is not by this definition a site work, its innovative articulation of space and demand for physical interaction separate it from earth art and from other contemporary sculpture still tied primarily to formal concerns associated with the object. However Morris's subsequent works, for example, the *Grand Rapids Project* of 1974 and particularly *View Point in Seattle* of 1979, clearly respond to the thematic context of their respective sites. Transforming a gravel pit into a community park, the Seattle project consists of a bowl-like series of concave, grassed terraces tracing the process by which the gravel was extracted and creating a small amphitheater. A row of tree trunks, brutally chopped off at waist level, are a reminder of the devastation that Morris's art has been commissioned to redress. As always, he is aware of the economic and social implications of art and with characteristic prescience concluded his address at a Seattle symposium on "Earthworks" warily:

> It would seem that artists participating in art as land reclamation will be forced to make moral as well as aesthetic choices. . . . But it would perhaps

be a misguided assumption to suppose that artists hired to work in industrially blasted landscapes would necessarily and invariably choose to convert such sites into idyllic and reassuring places, thereby socially redeeming those who wasted the landscape in the first place.[21]

Sculptors of the earth art generation moved outdoors and particularly to the great arid landscape of the West to find the "real space," but the shift also reflected a decision to escape the constrictions of museums and cities and to bypass the commodity orientation of the art world. At the time institutional support did not exist for these ambitious projects, and only the enlightened patronage of individuals like Virginia Dwan made them possible. The next generation of site sculptors benefited tremendously from temporary outdoor exhibition opportunities presented by *Monumenta* in Newport, Rhode Island in 1974, *Projects in Nature* in Far Hills, New Jersey in 1975, and the ongoing summer projects at Artpark in Lewiston, New York and at the Nassau County Museum on Long Island. In the mid-seventies the Art in Public Places Program of the National Endowment for the Arts shifted its emphasis to encourage environmental work as well as large-scale object sculpture. Subsequently the General Services Administration legislated that a percent of construction costs be set aside for art works in federal building projects, and many states and cities have followed this successful federal lead in establishing a supportive environment for public art in non-museum settings.

Unlike the earth artists who for the most part worked in splendid isolation, this generation of site sculptors emerged together, frequently building pieces on adjacent sites, with the same deadlines, audiences, and budget limitations. The museum context was the exception rather than the rule, urban sites were welcomed as a new challenge, and financial support was forthcoming from a variety of sources as a result of the recent acceptance and enthusiastic civic sponsorship of public art.

It is appropriate that Carl Andre, whose *Lever* marked the thrust toward site-specific sculpture, was a participant in the *Projects in Nature* exhibition which marked the joint debut of three of the four artists discussed in this book. Moreover Andre's experience in building his first outdoor permanent work, the *Stone Field Sculpture* of 1977 in Hartford, Connecticut, underlines the complexities involved with working in the public domain. Apart from the necessary vagaries of zoning permits, engineering studies, funding packages, and political base touching is the problem of public response. The gauntlet of public opinion, voiced most vociferously by the man in the street, isolated from the world of contemporary art, is part and parcel of the opportunity afforded in working in the public domain. It is a world far from the rarefied atmosphere of the museum or desert.

*Stone Field Sculpture* is a brilliant resolution to an awkward urban site and unquestionably one of the most significant and successful public art works of the past decade. Taking his lead from the adjacent colonial cemetery, Andre placed thirty-six indigenous glacial boulders in eight rows across the site.[22] The stones vary in size, color and texture, with the largest boulder singly marking the downhill corner of the sloping triangular site. Moving up the hill, in each successive row an additional stone is added, the size of the stones reduced, and the open space between stones and rows increased. This dynamic configuration activates the site, compressing space and perspective from the top of the hill while visually extending the space from the bottom of the hill. With this deceptively facile disposition of commonplace elements Andre transforms an unremarkable, leftover urban space into his dictum of "sculpture as place."

Upon completion *Stone Field Sculpture* was greeted with nearly universal scorn by all but the art community. The residents of Hartford couldn't see the *Stone Field* for the rocks and vilified this unconscionable waste of money. Some nine years later the fuss has died down, and it is rewarding to see people eating lunch on the boulders, lounging on the grass between rows, and otherwise availing themselves of this public aesthetic amenity created by an artist. The time lag between creation and public acceptance of works of art is a well-known phenomenon. A great irony of art created specifically for public spaces is that the immediate confrontation with the people for whom it has been made is frequently hostile. In extending the vocabulary of sculpture beyond the museum-bound object and in rebuffing the detachment of isolated sites literally miles from anyone, the four artists who are the subject of this exhibition and book share the benefits and shoulder the burdens of working directly in the public domain. This more than any other factor sets them apart from artists of the preceding generation.

*Hugh M. Davies*

■

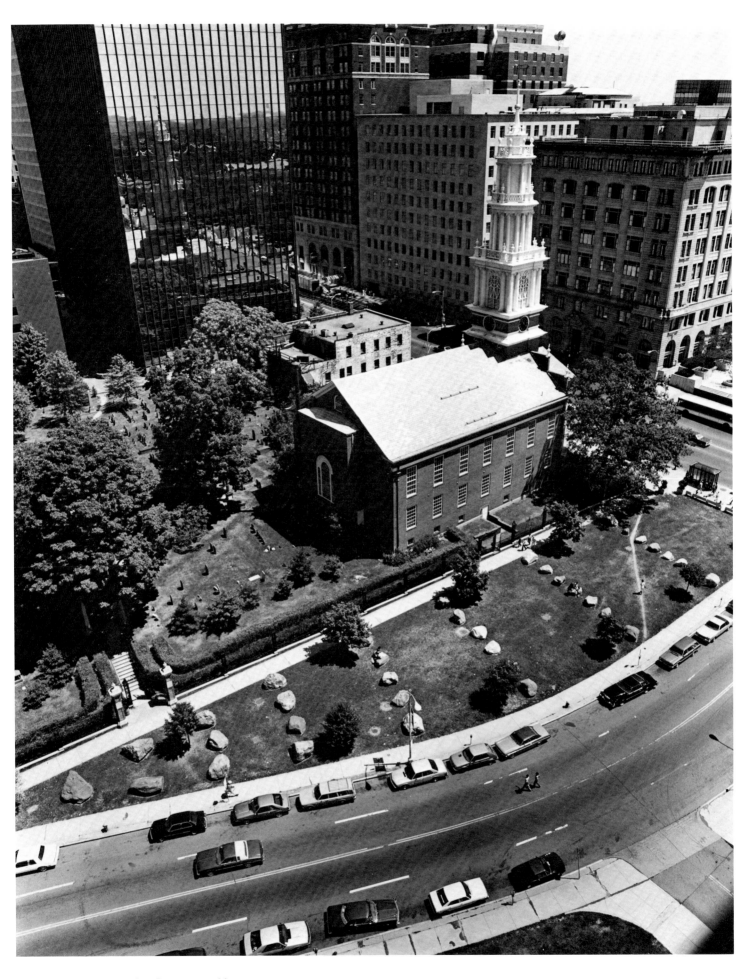

ABOVE AND OPPOSITE: Carl Andre, *Stone Field Sculpture*, 1977, Hartford, Connecticut, permanent installation.

Yvonne Rainer, *Grand Union Dreams*, 1970, performance, New York.

Minimalism may have provided a fulcrum for the next generation of artists, but it was the more interdisciplinary formats like performance and body work that pushed younger sculptors into real-time and real-space scenarios. By the late 1960s, the art world, like American culture itself, was being opened up to new ideas from internal revolutions. Electronic media began to have a broad impact on a diverse group of artists, and cross-over idioms that incorporated theater, dance, music, or literature seemed as appropriate a source material to many sculptors as did the mythologies of recent art history. Thus, you might just as likely find a group of visual artists (as either audience or participants) at a dance performance by Yvonne Rainer at the Judson Church or listening to a ninety-minute piece composed by Philip Glass at a well-known sculptor's loft as you would at any of the major museums or art galleries.

This newfound receptivity extended well beyond these conventional, albeit avant-garde resources of dance, theater, and music as new ideas flowed into the art world from every realm of social, scientific, and aesthetic investigation. As if to deny finally the hegemony of formalism, art makers might turn to television, advertising and other popular, mass appeal visual vocabularies. But this cultural raiding was not only on the vernacular level, as many artists between the mid-sixties and the early seventies were as likely to read and cull ideas from a text by Carl Jung, Claude Levi Strauss, Noam Chomsky or Mircea Eliade, as by a Clement Greenberg or a Harold Rosenberg. Film, popular culture, guerilla theater, political activism, archaeology, anthropology, linguistics—these were the precipitates of the next generation. Not only was the object disdained and the gallery abandoned but a new set of prerogatives—timely, active, real, responsive—had become the domain of the visual artist.

# Real Time—Actual Space

*It ain't what you make, it's what makes you do it.* —Dennis Oppenheim[1]

Vito Acconci, Dennis Oppenheim, Yvonne Rainer, and Scott Burton were four of the artists working during this period (from roughly 1966 through the mid-1970s) whose concerns were sculptural even as they reflected many of the ideas and influences mentioned above. While their dances, body art pieces, conceptual events and scenarios often seem at first glance to be at odds with the next generation's concrete, stone, steel and wood environments, architectural analogues and site related sculpture, many of the notions and assumptions developed by these four artists and their immediate contemporaries directly informed the sculpture of the next decade. It is not coincidence that all four have expanded their vocabularies into new areas since the late 1960s: Rainer has focused primarily on film making while Oppenheim, Acconci, and Burton have been continual presences in the areas of installed, participatory, and sited work.

Real time and actual space is what all of these efforts have in common. In many respects Yvonne Rainer opened up whole paths of possibilities when she explored these dynamic experiences through her choreographed pieces throughout the decade of the 1960s. While early work included short film pieces, by 1963 several of Rainer's dance works had been performed in New York. Performances like *Terrain*, 1963, begin to engage two spaces—that of the stage area itself and another space, described by Rainer herself as analogous to the out-of-bounds area on a basketball court—in other words, a real-life space on the periphery of an arena for fictive activity.[2] Consistently throughout the decade, her work made use of repeated movements, mundane details of locomotion, often carried on outside the context of a given "stage" or "performance platform." Her working areas often included figures and objects dispersed around a space. In *Grand Union Dreams*, performed on the gymnasium floor of the midtown YMCA, the various corners of the hall were filled with a set of stairs, a tape recorder, a pole, a suitcase, a screen, a wood box, signs, etc. The analogues here are best formulated as playing fields (one of her earliest films is of a volleyball game) or even more bellicose battle zones than traditional, proscenium staged dance. Her works engaged the architecture directly and as naturally as possible, perceivable only as the audience's attention endured through actual time. Again this notion of temporal experience has more to do with vernacular forms of entertainment than with the high-art theory of the theater or films. Rainer has written about this material: "As you see, I am talking mostly about behavior rather than execution of movement. . . . Only on TV does one see live 'behavior.' Never in the theater. I am sure it will all eventually take its proper place for me in relation to the learned material but right now I am luxuriating and marveling and 'wallowing' in these images."[3] Natural activity rather than learned convention, innocent happenstance rather than intentional staging of events—these are what Rainer

THEATER — SEPARATE AREAS: PERFORMANCE AREA, AUDIENCE AREA — HOUSE AND STAGE LIGHTS OUT — I STAND AT THE LEFT OF THE PERFORMANCE AREA, FACING THE AUDIENCE — TAKE A SNAPSHOT (INSTAMATIC CAMERA, FLASH CUBES) — STEP TO MY RIGHT, TAKE ANOTHER PHOTOGRAPH — STEP TO MY RIGHT, TAKE ANOTHER PHOTOGRAPH, ETC. — THE PIECE ENDS WHEN I FINISH THE ROLL OF FILM AND REACH THE RIGHT EDGE OF THE PERFORMANCE AREA.

Audience area (they look — they can't see)

Performance area (I don't look — I can see later, by means of photographs)

Black (limitless area)

Points of light

Moving limits (performer)

Black — Undifferentiated mass

Light — joining of performer and audience (I have them with me, in my camera)

How to face an audience: what to give them to face: ① They are looking anyway, prepared for a performance — I can allow them to look, by the light of the flash cube; ② I can take the stage — I can take the audience, I can have them to look at in the future, through photographs; ③ I might be afraid of an audience, I am 'in the dark' about them — I can control my fear, control the audience, by blinding them with the flash cube.

TWELVE PICTURES (THE THEATRE, NEW YORK, MAY 1969) — Vito Acconci

asked from herself and her performers and what was often seen by the audiences in attendance.

Two more clues to Rainer's presaging of later sculptural concerns can be found in a pair of projects of 1970, *WAR* and *Continuous Project—Altered Daily.* A written list of actions compiled before she settled on the final form of *WAR* reveals the bank of physical/communicative concepts that she would always employ, among them: converge, capture, support, hide, emerge, confront, close, shatter, threaten, escalate, sweep, occupy, collapse (cited twice), surround, spread, reinforce, advance, withdraw. The stuff of warfare (actually culled from military literature past and present) was translated into the sculptural rendering of thirty-one performers in a "non-competitive game" by Rainer.

Simultaneity was often a key factor in *WAR* as it was performed with another piece in an adjacent space. Like real-life experiences, these could only be seen piecemeal and not, of course, in toto. Each element became indeterminate, not precisely coordinated with the others but overland, so that the options, choices, and intentions employed in experiencing the works were as much a responsibility of the viewers as of the performers. This same kind of free-flowing experience—authentic, continuous, and always present—is at the core of work that engages its environment whether it be the interior of the Judson Church, a kind of surrogate outdoor gallery (like Artpark), a private estate, or a public plaza.[4]

Dennis Oppenheim, Vito Acconci and Scott Burton, like Yvonne Rainer, all experimented with performance activities during this transitional period, although each derived his or her motivations from different backgrounds. What is important here is not the degree of interchange between an Acconci and an Oppenheim, nor the myriad differences between them evident to careful and casual viewers alike, but again the sensibilities and attitudes present throughout their performance investigations. Regardless of individual tactics, each used ephemeral, unconventional means to define new spaces or to call closer attention to extant, ongoing situations.

From a background in poetry, Acconci moved off the written page and into a more graspable space when he began using his own persona, his own physical presence and its relationship to the viewer as the criteria through which a space could be charged. But his initial forays were not always in the neat confines of a gallery or lecture hall, already defined in terms of expected human activities. In 1969 Acconci performed in a number of New York spaces, as he shifted from the intimate realm of the paper page to the more engaged realm of place. He defined special places and mandated audience responses to those spaces by his own gestures, actions and movements, as well as through the use of various props and technical means: *Twelve Pictures*, 1969, where Acconci the performer photographed the audience, with Robert Smithson, Nancy Holt, Scott Burton, Michael Snow, Les Levine, and Marjorie Strider recognizable among those in attendance; or *A Situation Using Magnetic Tape, Voice, Reading Improvement* of the same year, which was the first of many ensembles where his own gravelly voice was a key element in the creation of a mood.

Some of this work employed pre-publicity to get viewers to the site where they became participants as well. In *Project for Pier 17*, 1971, Acconci lured his potential audience with the promise of a reward (he was to tell them something about himself that no one else knew) even as his choice of an old ramshackle and isolated industrial space both intrigued and threatened them by its particular character. His actions in various spaces also set up reverberations of enticement, danger, voyeurism, or duplicity with his public (*Trappings*, 1971, conversing with his penis; *Directions*, 1971, reversing passive role of performer by addressing the audience with orders and accusations; and the now famous *Seedbed*, 1972, where his audience precipitated his hidden masturbatory behavior by their presence in the gallery, charging the cool almost Zen-like emptiness of the spectator's space with a very different kind of suggestive relationship between artist and viewer).

Many of these earliest works avoided the expectable confines of gallery or theatrical chambers and occurred instead in unlikely art spaces—abandoned buildings, piers, closets, beaches, bars, and most often on the street. Distinguished from his announced performances, these activities included walking the street, using the buses, trains, public areas, and other pedestrians as his raw material. *Following Piece*, of 1969, in which he chose a fellow pedestrian and followed him until he reached a destination, was only the last and best-remembered of this year-long series of street events.

Spaces, both actual and symbolic, ephemeral social responses, habitual practices, observing and intersecting mundane systems—all suggested an anthropolog-

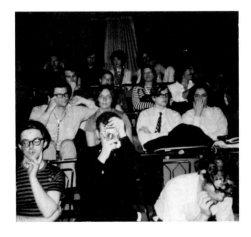

ABOVE AND OPPOSITE: Vito Acconci, *Twelve Pictures*, 1969, performance, New York, documentation with detail.

OPPOSITE, ABOVE: Vito Acconci, *Following Piece*, 1969, performance, New York.

ical bent that Acconci has himself acknowledged. He continued to write scripts for his voice-overs, terse axiomatic compilations of self-reflections, and cogently analytic rationales for his own art making. These, like the work itself, suggest his thinking is at first taxonomic, then synthetic as he explores the methods through which space affects our lives. Three such notations of 1978 so clearly reflect his own transformations from poet to performer to planner over the course of a decade that they read like a short history of sculpture in the 1970s:

If an art-place is a place for viewers, and if art is a gift from artist to viewer, then I can meet a viewer face to face. (But, then, as long as I'm there in person I present a personality to be focused on, by myself and by viewers, we make an intimate space that escapes from the world of causes outside . . . . )

If art makes an architectural space, a model-space, then I can withdraw my presence, leaving viewers room to move: the viewers become performers, the viewers take my place. But, then, if the space is a projection of me, the viewers have no place of their own, they inhabit a no-man's land, while I float away before-the-fact in a space neither mine nor theirs . . . .

If art can appear in different geographical locations, then a piece can derive from the place where it's done; if a physical place is part of a cultural space, then viewers come to an art-place with a history, in the news; if I do art from place to place, then I bring my own place wherever I go; if an art-place is a public-space, we can hold a public meeting . . . [5]

If Rainer and Acconci injected performance into the unexpected arena of real life, Scott Burton managed during the early seventies to make his art all but invisible. Like his aesthetic contemporaries Marjorie Strider, Lynda Benglis, Oppenheim, Acconci, et al., he shunned object and form in favor of a more engaged set of undertakings that flowed seamlessly with his surroundings. Robert Pincus-Witten explains these as actions "in which the events are so similar to daily street life or created seemingly the stuff of street life as to be near indecipherable from the very fabric of street life itself." Some of these activities Burton remembers as priming the pump for others to take the risk and confront their audiences directly, as when Burton appeared at an art opening in New York City only to become a kind of human fixture, garbed in loose-fitting clothes and drugged to sleep off in a corner.[6] Whether or not such experiences preceded or followed particular performances by other artists, Burton too had entered into a dialogue with his public in which the distance between the experience engendered by the artist and the viewing public had been eliminated. His costumed performances, his "behavior tableaux" and his furniture are each extrapolated from this elimination and serve as further evidence of how he has informed those artists (himself included) who now work directly on site.

Both Acconci and Burton have become involved with more recent avenues of sited sculpture—designing furniture for plazas, subways, or private homes (Burton) or concocting machine-like contraptions, set into motion by the viewer/activator (Acconci). These works, like so many of this generation's, demand the physical interaction of the audience but also require a more obvious collaboration in their actual creation. As have almost all the artists considered here, Acconci and Burton have turned to others for their fabrication-work. Thus, engineers, erectors, stone cutters, and other craftsmen are drawn into the artistic process in a more obvious way than in the work of earlier generations, although their presence has always been felt in large-scale sculptural work erected at the interface between private patronage and public commission.

While their contemporary Dennis Oppenheim has been associated with both the performance and the machine idioms of the era, he might best be categorized as the tactician of the decade, consciously exploring new ways of approaching theoretical, often romanticized goals. His raw materials have included his own body, his children's bodies, fireworks, plastic, animals dead or alive, shotguns, explosives, and the more traditional media of wood, metal, and glass. Oppenheim has expressed and reinvented his art attitudes by using his own body as a target for stone throwers; by performance pieces, often videotaped, that have sexualized and personalized the process of art making; by orchestrating spectacles in outdoor settings; and more recently, by engineering fantasy factories that have posited his art where it has always felt most complete, in the realm of metaphor. While his narrative, often sequential and image-referant mode was not adopted by most sculptors

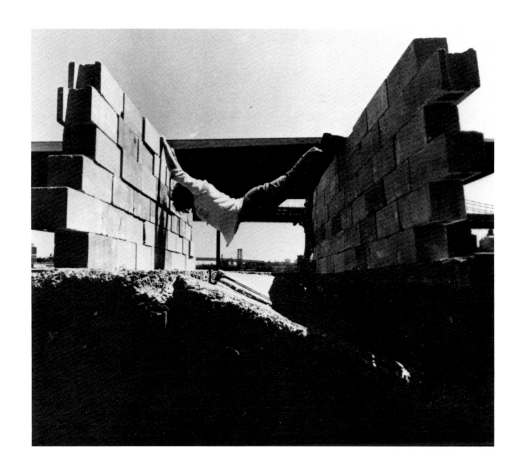

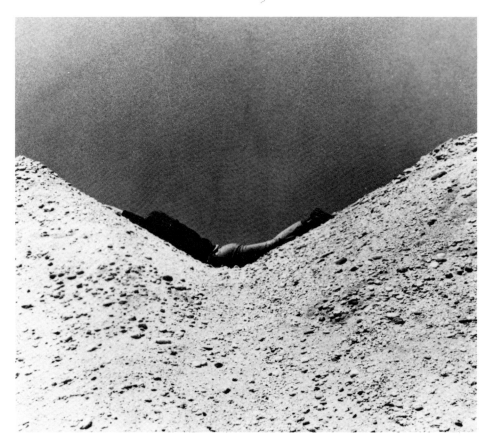

Dennis Oppenheim, *Parallel Stress*, 1970, performance, New York.

in the 1970s, there emerged a significant and influential undercurrent of story-telling and mythmaking in much of the work made during that period from the "threat-performances" of Chris Burden to the "future archaeologies" of Will Insley and the text related cities of Alice Aycock.

Oppenheim has, like Robert Morris, been remarkable in his ability to remain at the center of a succession of art-making vocabularies. He was one of the earliest artists to define, on site, the notion that an area could become an event—as in a work of 1967 in which he marked with stakes the boundaries of a field. He has continued to deal with issues of installation and sited work even as he has explored other idioms. From his involvement with the earliest earthworks of the sixties, with performance, and with a renewed interest in a kind of large-scale object making, he has been grouped variously with Smithson, Heizer and de Maria, more recently maintaining a dialogue with Acconci (since the late 1960s) and Aycock (in the late 1970s). Oppenheim's work, personality and attitudes, expressed at conferences, or in articles and catalogues, confirm that he is one of a few representatives of a Duchampian attitude working on a large scale today. His discussions with Acconci and Aycock have been literal—that is, direct, across-the-table give-and-takes. How much more lively these face-to-face trialogues must have been compared to the more publicized and published typewriter dialogues of Carl Andre and Hollis Frampton which seem by comparison self-consciously selective and cerebral.[7]

Oppenheim has articulated for almost two decades an uncompromising concern for artistic motivation, for imagination, and for "self" despite the increasing focus in the sited sculpture of the 1970s on social concerns and the making of pragmatic concessions (in the art of many sculptors working in the public arena) to commissioning agents, ecological or political constraints, or engineering realities.

Even as he was at the forefront of the various idioms of the sixties and seventies, his work seems ever more metaphoric, more symbolic, less engaged with real life, and thus less attached to outside manipulation than the work of so many of his contemporaries. In many respects, Oppenheim personifies the "performing self," so perceptively defined by Richard Poirier as a persona that cuts across the tangential boundaries of much recent art—be it literary, musical, or visual. As have few others, Oppenheim has helped to establish, in the iconoclastic mode of Marcel Duchamp, many of the givens for today's sculpture. He has done so whether his art has consisted of sunburning his body, laying a dead dog across the keyboard of an electric organ, making Rube Goldbergian contraptions, or cultivating a hay field. In fact, while many of the early works on the landscape entailed his laying out of boundaries to define an area equivalent to his art, he often asserted his own persona (or images derived from it) onto a site, equating ego with art.

Some of the earlier work involved unlikely raw materials, for example, *Protection*, 1971, in which Oppenheim employed twelve trained German shepherds staked out to demarcate an area of inaccessibility adjacent to the Boston Museum of Fine Arts; other pieces between 1968 and 1970 involved branding the landscape with footprints, walking patterns, powdered pigments or moving patterns, at least some of which were extrapolations from his own gestures and human-scaled activities. Still, his most innovative manipulations involved the superimposition of his own body onto a site as in *Parallel Stress*, 1970, as he replicated the same prone position in various outdoor situations. Perhaps his most literal superimposition of "self" onto the landscape was in *Identity Stretch* of 1970–75, in which overlapping fingerprints of the artist and his son were enlarged to the scale of Peruvian earth drawings and "imprinted" onto an extant industrial spoils pile by a truck spraying hot tar. A more personalized and iconoclastic piece of outdoor symbolism would be difficult to realize.

Acconci, Oppenheim, Burton, and Rainer are only four of the many artists whose work signified a revolution in the way we all think about art. Their generation made it possible for art to be participatory, to be active, to involve mundane spaces and situations, and most of all, to be responsive to a particular set of physical and psychological characteristics sometimes preordained but most often, like the art of Aycock, Fleischner, Miss and Trakas, related to the sites in which they work.
*Ronald J. Onorato*

■

Dennis Oppenheim, *Identity Stretch*, 1970–75,
Artpark, Lewiston, New York, temporary
installation.

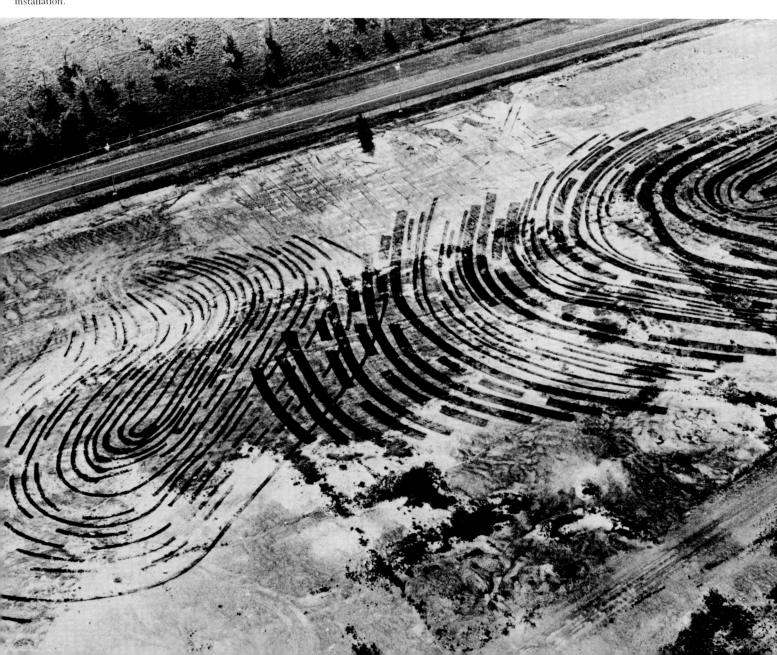

Richard Fleischner, *Wood Interior*, 1980, Museum
of Art, Rhode Island School of Design, Providence,
temporary installation.

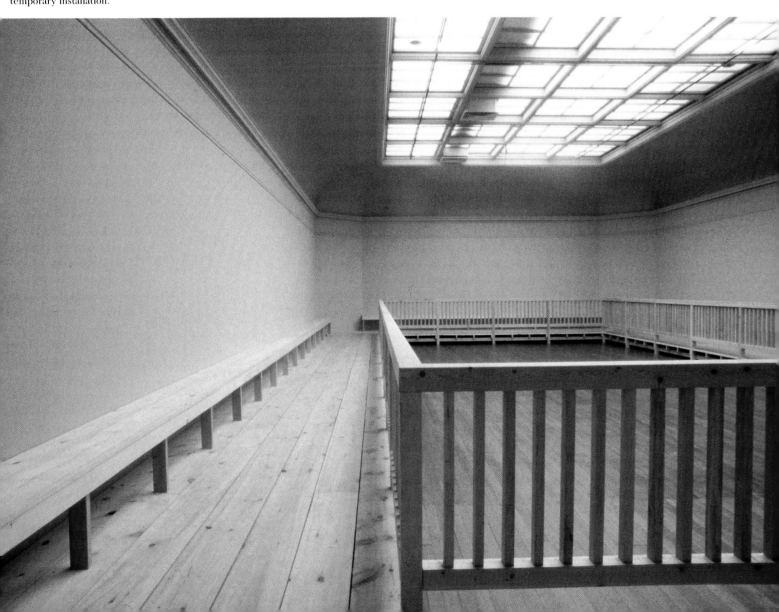

Mary Miss, *Laumeier Project*, 1985, Laumeier
Sculpture Park, St. Louis, Missouri, permanent
installation, detail.

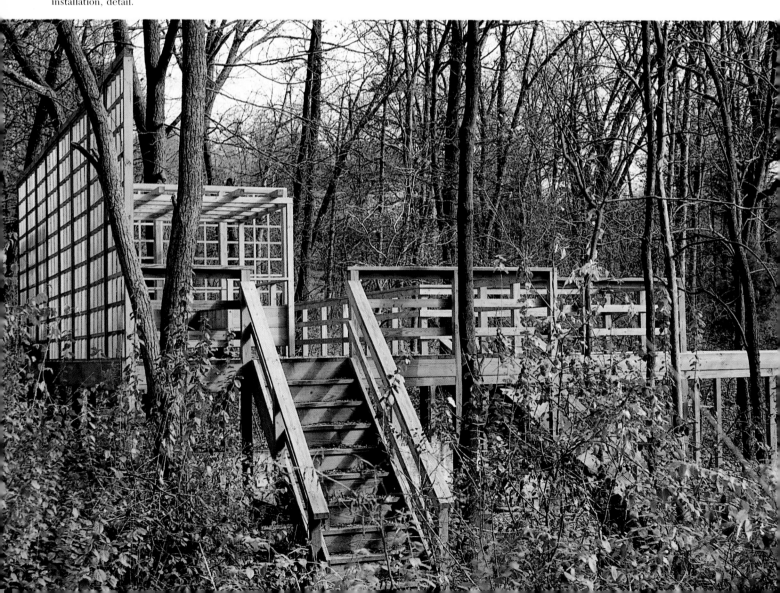

George Trakas, *Via de l'Amore*, 1982, Fattoria di
Celli, Pistoia, Italy, permanent installation, detail.

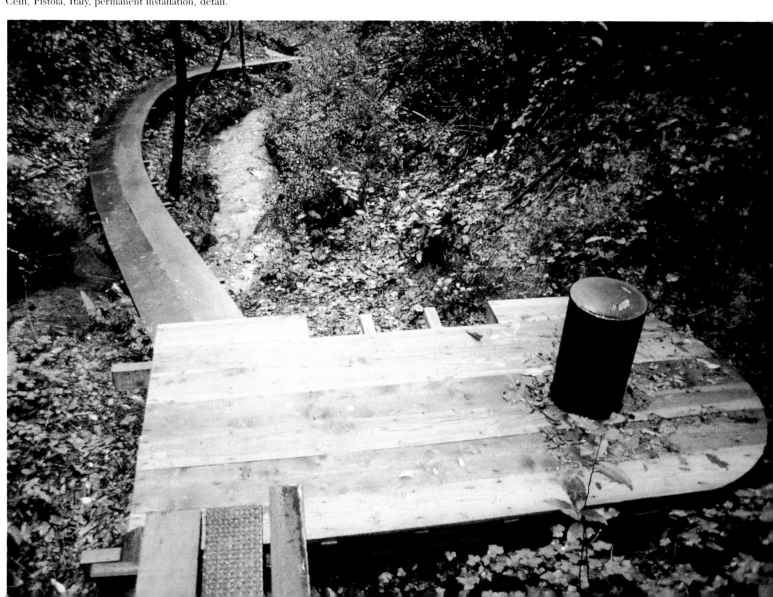

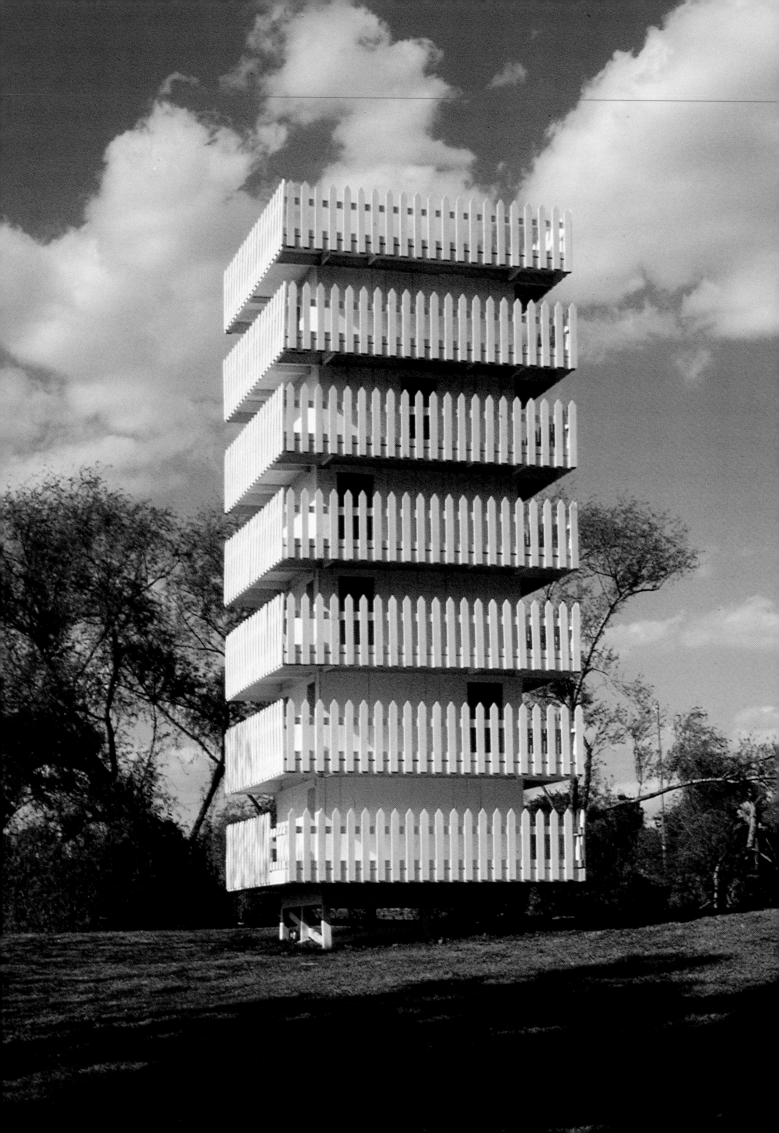

Alice Aycock, *The Hundred Small Rooms*, 1984,
Houston, temporary installation for the exhibition
*Bayou Show, The Houston Festival*.

*Low Building with Dirt Roof (for Mary)*, 1973,
Gibney Farm, New Kingston, Pennsylvania.

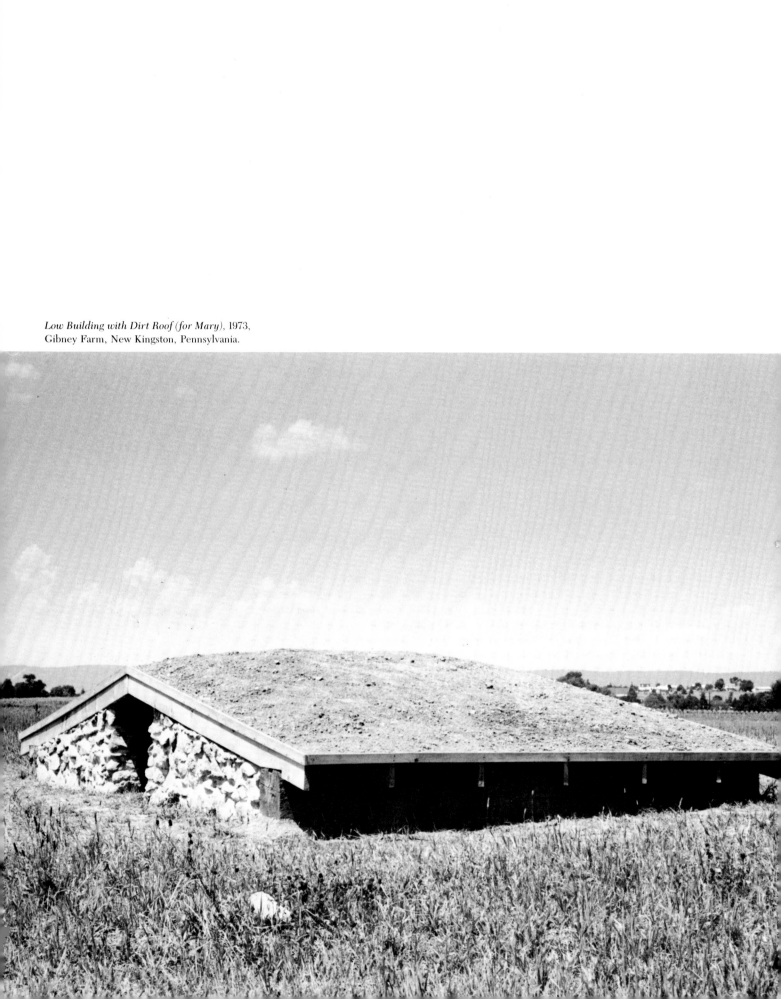

During the early 1970s, Alice Aycock planned and constructed buildings, platforms, tunnels, and other situations that provided her audience with a range of psychophysical experiences. Despite the artist's invitation to sensorially engage such works on this visceral level, her audience remained content, as they attempted to understand Aycock's work, to focus on the shape, materials, and siting of such completed structures as the early *Low Building with Dirt Roof (for Mary)* and the interior project *Stairs (These Stairs Can Be Climbed).*[2] The recapitulation of type-forms by Aycock's critics was constantly and redundantly assumed to explain what Aycock's structures meant by creating an architectural lineage involving ancient and medieval imagery, city planning systems, vernacular structures, and exotic scenarios. The historical sequence was often carried close to the present, as critics saw in her early work the contemporary concerns of scale, site, and participatory spaces established by Smithson, Morris, et al., in the late 1960s.

Each Aycock project is a single point in a continuum of thinking, doing, and perceiving. The artist's meanings, however, might not be best understood through the historical method—relating each new piece *ad libitum* to precedent forms and iconographies. Instead, her sense would be more fully apparent to the viewer who considers the corpus of Aycock's work, discerning patterns in the whole of her efforts which in effect constitute a personalized program. Such a reading demands that all explanations be considered tentative since the work of Aycock, like that of any living artist, is never static but changing with the execution of each new piece. Using such an approach, we can perceive a crucial shift in Aycock's recent work and, through it, we can sense the less accessible but more primary intentions that are significantly present in all her sculpture.

# Wonder in Aliceland
## Memory and Self in Aycock's Art

*The way we imagine is often more instructive than what we imagine.*—Gaston Bachelard, *The Psychoanalysis of Fire*[1]

In *Low Building, Stairs* and other early projects, Aycock always invited the audience to become physically involved. She developed a working vocabulary of forms and shapes as she built mostly unitary structures, invariably constructed (and in some cases over-constructed) of wood, stone and, later, cinderblock.

Aycock has always been open publicly about the formal sources which constitute her vocabulary. Between 1972 and 1975, she explored a number of motifs: farm buildings, military fortifications, and eventually the broad cultural banks of neolithic, Meso-American, and medieval architecture. Such openness left the artist unguarded against charges of facile eclecticism. In one sense, Aycock's aesthetic process is akin to scholarship, as she culls pertinent data from architectural or literary sources, eventually reconstructing her own ensemble from the disparate elements. Literature has always been a passion of Aycock's and here it plays a key role, informing her visual results.[3] This is not only true for the scenes and relationships evoked by mentors like Huysmans, Rilke and Borges, but for Aycock's own writings in the form of journals, essays, and imaginary plays.

Her critics have missed the point. Aycock's willingness to reveal certain sources of inspiration should not be misconstrued as a full public explanation. In effect, she allows her public the comfort and continuity of formal, surface relationships, diverting them from her primary motivations. A critical look at some of her texts and how they have changed in the past few years allows deeper meanings to emerge.

The small, closed dark spaces of the *Low Building* or the *Williams College Project*, the frustratingly multicursal path of *Maze* or the subterranean dankness of *Simple Network of Underground Wells and Tunnels*, all constructed before 1976, are not conceived for the sole purpose of producing an uncomfortable response in her audience although they do that quite effectively. Instead, these structured spaces are also meant to convey experiences from the artist's own past, a past reconstructed as myth and then interpreted once again in palpable form for her public.

The kind of narrative experience that informed some of these early works is partially revealed by the artist herself in the text "For Granny (1881–      ) Whose Lamps are Going Out: A Short Lecture on the Effects of Afterimages:"

> About 15 years ago I visited the house in which my great-great grandparents, Benjamin and Serena, lived and where my great grandfather, Francis, was born. It was a small wood frame house. I climbed alone into the attic where they slept and stood under the rafters. In the yard was the family cemetery. I remember the tombstone of Catherine, who died at age three. Years later I had the dream. My brother Billy came for me and took me to that same wooden house set into the hills of Greece like

a tholos tomb. I climbed the stairs again and behind a screen a young girl whose face I could not see lay dead. Then, sometime after that I built the *Low Building with Dirt Roof (for Mary)*. You, Margaret, knowing the story said it reminded you of an attic in the ground. And you, Perrine, said it reminded you of the houses which the poor people in the Midwest build. First, they built the basements, covered them with an A-Frame, and lived underground for a few years until they had the money to build the first story.[4]

Personal memories and dreams here commingled with architectural history, historical fancy, and stories told and retold by the artist and others. Using the past here is both intensely intimate and generously universal. If, as Edmund Leach declared, "Events in the historical past survive in our consciousness as myth . . . ," then we can begin to consider Aycock's works from this period as visual evidence of this theory.

The sense of time past—whether actual or mythic—is coupled in works constructed between 1971 and 1975 with experiences that occur primarily in the present mode. This sense of the now stems from the dominance in works like *Wooden Posts Surrounded by Fire Pits*, 1976, of participatory, fleeting sensations. The shifting experience of our own senses as we explore these structures changes constantly, enduring later only as memory. *Wooden Posts . . .*[5] has all the obligatory references to expected traditions—old fortifications, African village configurations, or dolmen sites—even as it incorporates the ephemeral, mystical phenomena of fire and smoke into its scenario. The flame and the even more evanescent elements of smoke and smell made this Aycock's most temporally unstable project while they embellished the strong primal connections to hearth, family, and ritual. The dominance of present time sensations here forces us to see the historical form referents as only a convenient armature for the more essential, quixotic elements.

Fire here heralds a dramatic shift in Aycock's life and career. Fire—mysterious, ill-defined, mythologized in primordial knowledge, a focal point for reverie, it is the flux of the present lifting us to a realm of fantasy. Gaston Bachelard expounds more fully:

> Fire is thus a privileged phenomenon which can explain anything. If all that changes slowly may be explained by life, all that changes quickly is explained by fire. Fire is the ultra-living element. It is intimate and it is universal. It lives in our heart. It lives in the sky. It rises from the depths of the substance and offers itself with the warmth of love. Or it can go back down into the substance and hide there, latent and pent-up, like hate and vengeance. Among all phenomena, it is really the only one to which there can be so definitely attributed the opposing values of good and evil. It shines in Paradise. It burns in hell. It is pleasure for the *good* child sitting prudently by the hearth; yet it punishes any disobedience when the child wishes to play too close to its flames. It is well-being and it is respect. It is a tutelary and a terrible divinity, both good and bad[6]

*Simple Network of Underground Wells and Tunnels*, 1975, Merriewold West, Far Hills, New Jersey, temporary installation for the exhibition *Projects in Nature*, interior and exterior.

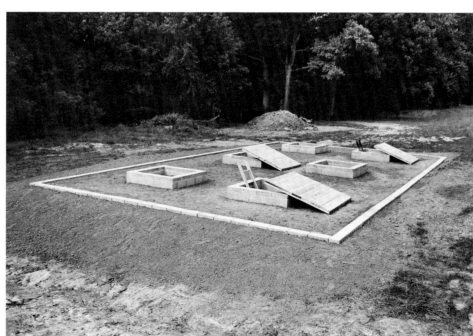

*Maze*, 1972, Gibney Farm, New Kingston, Pennsyl-
vania, temporary installation.

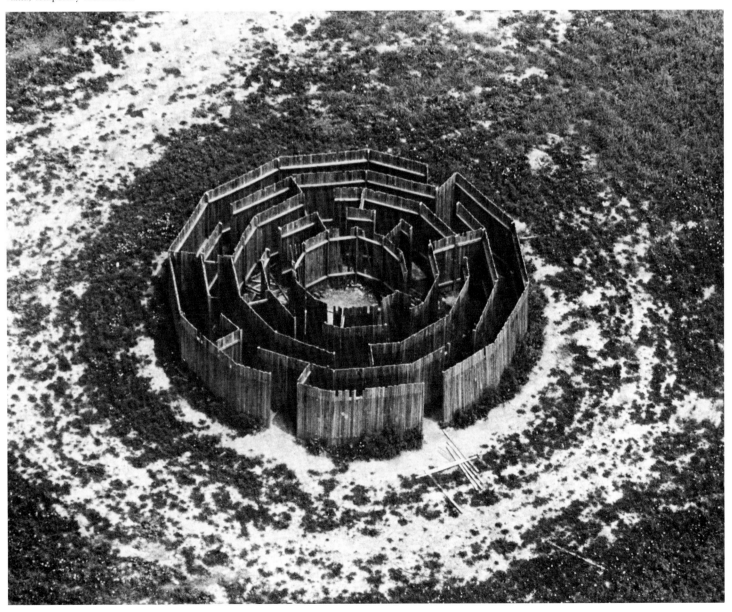

*Project for Wooden Posts Surrounded by Fire Pits (Isometric View)*, 1976, pencil on vellum, 36 x 50 inches, Collection John Weber.

*Wooden Posts Surrounded by Fire Pits*, 1976, Nassau County Museum of Fine Arts, Roslyn, New York, temporary installation for the exhibition *Sculpture Sited*.

Aycock's employment of fire is a conflated sign for a communally held set of experiences having as their essence the deepest of human emotions. Again Bachelard states it eloqently, "Love, death and fire are united at the same moment...," or even more specifically, "Fire is the love affair rather than the marriage, the conscious rather than the natural, the reverie not the dream."[7] This element gives Aycock a cathartic means for shifting her professional priorities, beginning again, starting anew. Another poet who contemplated fire, Gabriel d'Annunzio considers such a shift in different terms: "After having gained all through skill, through love or through violence you must give up all, you must annihilate yourself."[8] It is after the fires set around her *Wooden Posts...* that Aycock's work changes most emphatically—in look, sense, and intention—as she abandons her personal and public past.

In 1977, Aycock's voice shifts—that is, the inspirations which moved the artist to create her work are better expressed in a future vocabulary, rather than her customary past or present mode. One key clue to this shift occurred in the titles of her works. Those produced in 1977 no longer have the simple, declarative, descriptive labels of past work—*Stairs, Maze, Wooden Shacks...*, etc. Instead, the three major project titles of 1977 imply a new complexity—*The True and the False Project Entitled "The World is So Full of a Number of Things," "The Beginnings of a Complex...,"* and *Studies for a Town*—a complexity directly reflected in the multiplicity of forms and compositions the artist begins to construct.

*The House of the Stoics*, from the series entitled *"I Have Tried to Imagine the Kind of City...,"* 1984, International Contemporary Sculpture Symposium, Lake Biwa, Japan, temporary installation for the exhibition *Environment and Sculpture*.

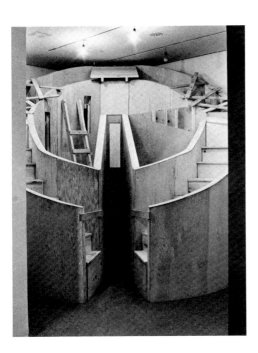

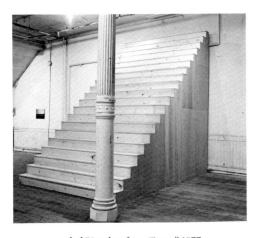

*Project Entitled "Studies for a Town,"* 1977, Museum of Modern Art, New York, temporary installation for a *Projects* exhibition, Collection Museum of Modern Art, New York.

*Stairs (These Stairs Can Be Climbed),* 1973–74, 112 Greene Street, New York, temporary installation.

*The True and the False Project . . .* announces the consciousness of self-doubt even as it suggests a new wondrous sensitivity to the world around us all. The piece was full of false doors, impossible climbs, a twisting, convoluted path, theatrically shallow facades, blind structures, or real construction emphasized by the rough finish of plaster or nail heads left untouched. *The True and False Project . . .* becomes the first in a series of fantasy lands created by (and for) the artist, encapsulating in microcosm all the real and contrived, actual and ideal dichotomies of everyday life. Its complexities and sham elements further cause each viewer to question his or her expected role when confronting the ensemble. Is the viewer to merely ponder, climb on, walk through, or touch the plasterboard and wood structures? We question our role as audience even as Aycock begins to question her own means and intentions. This split between public and private doubts, between intimate and universal concerns, is only hinted at in the "true" and "false" polarities but becomes more explicit through the projects, proposals, and texts of the next few years.

Equally informative, *"The Beginnings of a Complex . . ."* and *Studies for a Town* announce through their titles works that exist now and will be extended into a future time. "Studies" and "beginnings" are activities not yet brought to completion, real only in the mind, conditional, formed through fantasy, wishful thinking, imagination—concepts that appear with greater and greater frequency in Aycock's writings.[9]

The opening passages of a play, part of a set of proposal drawings of the next year for *Project Entitled "I Have Tried to Imagine the Kind of City You and I Could Live in as King and Queen,"* reiterate the artist's introspective concerns as they simultaneously elicit the childlike sense of that newfound fantasyland. The character Elizabeth worries at the outset: "Oh Mommy, mommy! Oh! Daddy, daddy! What's to become of me? I spend my life on platforms underground." Are these the pleas of a young, vulnerable woman or an artist incognito, voicing serious aesthetic concerns about the direction of her work? Perhaps it is a little of both. During the very years that the shift in Aycock's inspirational resources was made from events in her mythic past to hopes and dreams yet to be fulfilled, her personal life was undergoing a concomitant series of changes. Aycock's intention to express a less stable but so much more hopeful future life through her sculpture began to emerge fully, invigorating all her subsequent work. What the artist subsumes in her constructed work is clarified in her graphic plans and texts.

Not long after *Studies for a Town* was built as a temporary project at the Museum of Modern Art, Aycock made her state of thought explicit as she quoted a text from a popular song in conjunction with the proposal *Project Entitled "The City of the Walls,"* 1978, and later reproduced it on the invitation for an exhibition of two pieces at the John Weber Gallery:

The Theme Song:
> Don't know much about the Middle Ages
> Look at the pictures and I turn the pages
> Don't know much about no Rise and Fall
> Don't know nothing about nothing at all
> But I do know if you loved me
> What a wonderful, wonderful,
>     wonderful world this would be.[10]

Taken lightly by most, as a further indication of Aycock's surface eclecticism, what we have here instead is an exceptional admission of the artist's concerns. The first line serves as a self-evaluation of the process she uses to collect her form-types —flipping through volumes of architectural information and culling from it appropriately. Even more significant, however, is the fact that the words are from a song that played during the time of her show on AM radio but was itself a remake of a song from an earlier era. Like tonic chords, the first lines lead us inevitably to the conditional idealism of the final couplet.

As personal meaning has figured increasingly in her work, the issues of site specificity and public accessibility have for her diminished in importance. While all the earlier projects were invitations for activity, recent works have moved closer to the status of large-scale, hermetic objects—to be looked at, considered, but not entered. Beginning as early as the *True and False Project* of 1977, and emphasized by the cramped but brilliantly scaled installation at MoMA later in the same year, this object quality appears again and again in the works from the end of the decade. Some projects like the ramp and shanty pieces have actually had signs restraining her audience from encroaching into their space.

*The Queen's Complex*, 1978, pencil on vellum, 42 x
72½ inches, Collection Cincinnati Art Museum,
Gift of RSM Company.

*The Large Scale Dis/Integration of Microelec-
tronic Memories (A Newly Revised Shanty Town)*,
1980, Battery Park City landfill, New York, tempo-
rary installation.

46

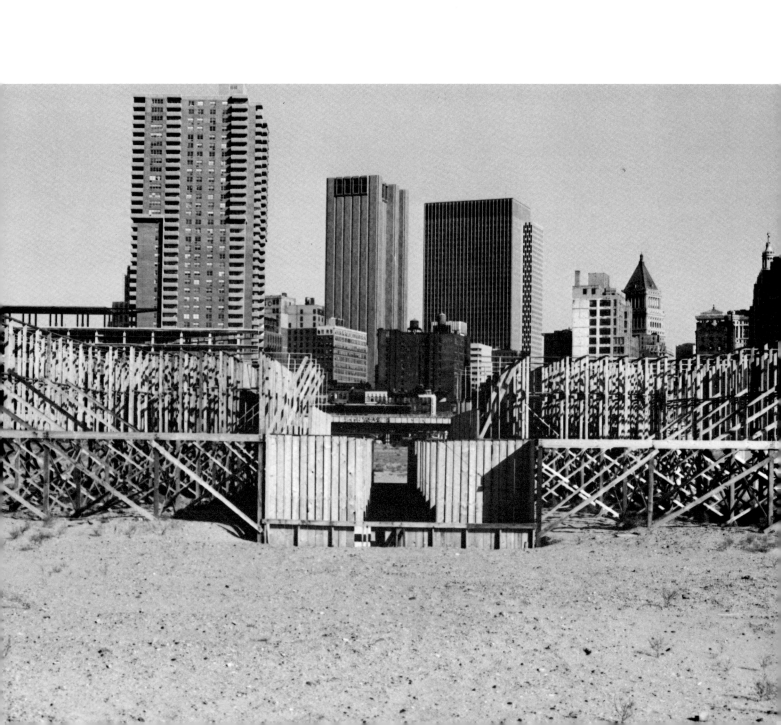

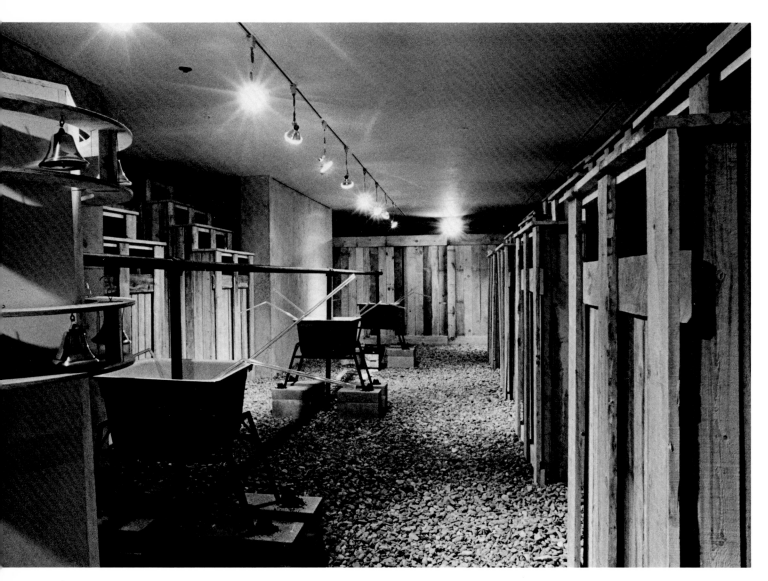

*Studies in Mesmerism, "An Eye in the Back of the Head,"* 1979, University Gallery, University of Massachusetts, Amherst, temporary installation.

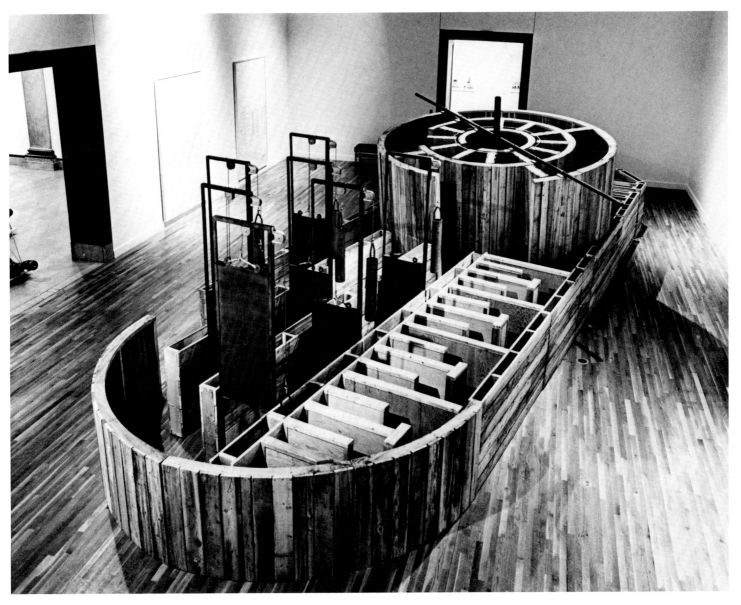

*The Machine that Makes the World*, 1979, John
Weber Gallery, New York, temporary installation.

49

In other works, access is blocked more effectively, as an integral part of the image, or as an element of the structure, like the platform with no ladder and the tall sealed shacks of *"The Sign on the Door Read the Sign on the Door...,"* 1978 (at the University of Rhode Island), or the staircase enclosed by a diagonal plane in *An Explanation for the Rainbow,* 1979 (Brown University), or the pit area in the New York City landfill structure, *The Large Scale Dis/Integration of Microelectronic Memories (A Newly Revised Shanty Town),* 1980.[11]

What has happened, in effect, is that Aycock, who initially worked with her sites as one of the key elements in her art, sometimes adjusting her installation to the place and at other times creating very special places for her audiences to traverse, begins to let other factors expand and augment her vocabulary. Issues such as audience participation, adjustments for the extant site and the myriad compromises necessary to construct site-responsive works diminish as major concerns, while her literary, metaphoric, and self-reflective interests become dominant. The ensembles that Aycock constructed between 1978 and 1982 attempted to combine this intentional distancing from her audience with the revelation that the textual fantasies often evoke. She has constructed several projects that simultaneously inhabit and create their own space; they are set off from the viewing public on platforms, circumscribed by arenas, gates or balustrades, and in effect they become multiple objects, put on stage. Her movement toward machine-like parts, metal spheres and containers, as well as electronic details (some of which work like turning motors) only added to the trepidation with which her audience could approach.

Many of Aycock's efforts of the late seventies reiterate the creation of a stage world—fantasy and machinery whose intention was to provide explanations. A number of her 1979 projects (*Explanation, An, of Spring and the Weight of Air* [Contemporary Arts Center, Cincinnati, Ohio] with its own staging; the more literal metaphor of *Machinations* [Washington, D.C.] with its metallic surfaces, pistons, rocker arms and engine-like look; or even her proposal drawings for *It Was a Schematic World in Which Nefarious Plots and Schemes Were Employed*) all retain raised platforms or bases which surround the artist's construction and distance her world from the viewer's space. But in these projects and later works, for example, the 1979 installation *Flights of Fancy* (built at the San Francisco Art Institute), Aycock utilized a given space as the armature for her inventions. There, the artist erected false walls, hanging wheels, suspension bridges, and the surprise of found objects (old doors, pulleys, buckets) into a total environment for body and mind. Once again thrust into an enveloping spatial experience, more literal but no less psychophysical than her earlier projects, the viewer again becomes a part of, a player in Aycock's nether world.

By the turn of the decade, then, Aycock's options had expanded. The individual forms and images of each project may differ as widely as the gravel floored alchemist's studio she created indoors at the University of Massachusetts, Amherst in 1979, and the oil refinery-like complex *Collected Ghost Stories from the Workhouse,* created at the University of South Florida, Tampa in 1980. Comfortable working inside or out, making objects or ensembles, things to be looked at or walked through, she made at this time both large-scale outdoor environments and interior constructions like that included in a three-artist show with Vito Acconci and Dennis Oppenheim entitled *Machineworks* at the Institute of Contemporary Art at the University of Pennsylvania in 1981.[12] While she can shift between public access and arcane symbolism, the more recent work reveals an aspect of her artistic personality that has been at work since she conceived her earliest structures—the artist as director. The *mise-en-scène* of her private meanings now most often precludes any direct audience participation in this personal world.

Her recent works have evolved into more distinct object-like machines that operate within their own systematic patterns. Along with the geography of game boards or the schematics of military battle plans, Aycock has added orreries, electrical generators, pneumatic pumps, and the artifice of back stage machinery to her visual repertoire. These works, like *The DNA Cutter,* 1984, and the machinery from the series *How to Catch and Manufacture Ghosts,* 1980, are independent machines that in effect create themselves through a preordained program causing arms to slash, cylinders to turn, and sparks to fly. While most are autonomous, there are still considerations of site in many of Aycock's works, as her installations take into account the scale, vantage points, or other architectural aspects of working on site. A good recent example of this genre is her 1986 installation at the La Jolla Museum of Contemporary Art. She designed *The Glass Bead Game: Circling 'Round the Ka'ba* taking the specific dimensions of the gallery site and the configuration of its

*The Game of Flyers,* 1980, Washington Project for the Arts, Washington, D.C., temporary installation.

entry stairs into consideration. First, the viewer sees from above the entire layout of the house-like structure surrounded by circular elements and gaming pieces. This plan-view is then lost when the gallery space itself is entered, as the mass and detailing of the large, architectonic contraption force the viewer to circumnavigate its outer perimeter. Based on elements which appear in a number of earlier drawings—ranging from images of buildings in *A Shanty Town . . .*, 1978, to those in a 1985 watercolor, pastel, and pencil drawing with the same title as the built La Jolla project—*The Glass Bead Game: Circling 'Round the Ka'ba* exemplifies the way in which Aycock transforms drawing into structure and given site into a place of her own making. Architectural references abound in all these works but now they seem to be absorbed into the work itself, not unlike the way in which her earlier drawings combined borrowed forms with those of her own creation. These hybrid devices, then, synthesize aspects of her constructed work (issues of site response, scale, and movement through real time and space) with her drawings which have always been the breeding grounds for her most fertile ideas.

In her most recent drawings and built environments, there is a hint of a different level of consciousness, an internalized set of mental processes that comes close to what was once called a "memory palace." In drawings like *The Rosetta Stone City*, 1985, Aycock condenses her main interests—in language, drawing, and the built environment of architecture. Its dominant shape, reminiscent of a bird's-eye view of Manhattan, is actually an isometric enlargement of the actual Rosetta Stone— that archaeological find that enabled us to translate Egyptian hieroglyphics for the first time. Carefully transcribing each of the incised letters and symbols of the actual Rosetta Stone in her wall-size drawing, Aycock transforms each cipher into an illusionistically raised edifice; drawing becomes language becoming architecture.

The architecture here and in other drawings like *Indian World View*, 1985, and built projects such as her towering *The Hundred Small Rooms*, 1984, are not so much erected of wood and steel as they are constructions of the mind. It is not unlike the ancient memory systems in which a long list of information is remembered by first constructing a small plain room and mentally placing an image of what is to be remembered within. Through a slow process of accretion, complexity and spaces are added until the initial room has evolved into a formidable memory palace—a warren of particular spaces, each with its own character, each containing a bit of a remembered past, the whole retaining the sum total of our labyrinthine consciousness. This finally is not only the image but the method and intention of what Aycock's art is all about.[13]

All combined, the effect of her works addresses the inner, fantasy, future world as intentionally and powerfully as her early pieces moved us, her audience, in a physical way. Perhaps it is a function of this artist's self-involvement, and the catharsis of her work, that in turn enables her to construct and write about the vagaries of a private mental world so effectively. The text here, the act of writing these literal memories, committed to syntax and made public, is so central to what Aycock means that we must begin to see in her writing a strong element of fabrication—a fabrication of place, of an as yet unknown life, of feelings and anxieties, thus a literal building of a self. This concept of self-revelation, of self-centrality, has been significantly explored earlier in the decade by the literary critic Richard Poirier. In one of the chapters of the collection of essays *The Performing Self*, he addresses the need in everyone to "Escape to the Future:"

> The future induces even more sentimentality than does the past about
> which we can at least know something. So that it's perhaps not surprising
> that the future should now be a haven for those who refuse to feel or,
> where they can beneficially do so, actively protest against present condi-
> tions. There is a notably increasing need to imagine not what we are . . .
> but rather what we nonetheless expect to be in some later stage of social,
> political, and even physical evolution.[14]

It is this escape, or rather the entrance into an aesthetic as yet uncharted, that Aycock has exposed over the course of the past fifteen years, and in distinguishing her concerns from those involved with issues of site specificity she has redirected herself and her public toward the eternal and universal promise of that unknown.

*Ronald J. Onorato*

■

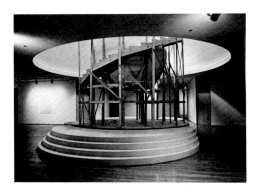

*Explanation, An, of Spring and the Weight of Air,* 1979, Contemporary Arts Center, Cincinnati, Ohio, temporary installation.

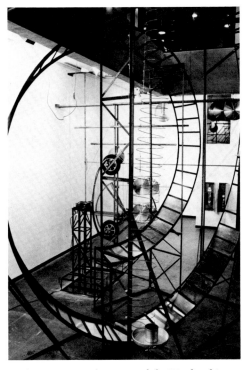

*Mock Suns and Halos 'Round the Moon,'* from the series entitled *The Miraculating Machine,* 1981, Institute of Contemporary Art, University of Pennsylvania, Philadelphia, temporary installation for the exhibition *Machineworks.*

*La Jolla Project*, 1982–84, Stuart Collection, University of California, San Diego, permanent installation, detail.

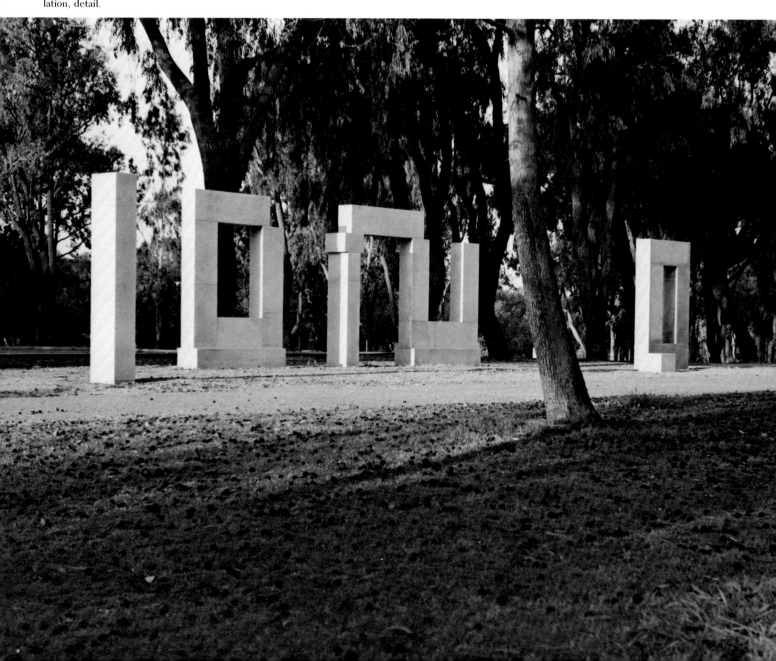

A lawn bounded by eucalyptus trees is activated by rectilinear posts and lintels of rose and grey granite, dispersed around its edges like the ruins of some ancient city. Classically proportioned and pristinely hewn, the abstract geometric elements at once seem a sort of spectral architecture and a Minimal sculpture gone prolific. The clustered and dispersed structures that compose *La Jolla Project* charge the open space—larger than a football field—in front of the Humanities-Library Building of the University of California, San Diego. Approached on three sides from the relatively populated realms of the library/classroom building and parking lots, the work becomes most mysterious as it is glimpsed from the grove of trees down the slope to the east of its most complex passage. In demarking an expansive visual field *La Jolla Project*, 1982–84, is akin to other works built by Richard Fleischner in the past seven years, among them *The Baltimore Project* and *Fence-Covered Fence* in Lake Placid. The landscape is both framed by and backdrop for the doorways, windows, and colonnades which the viewer conjures from the horizontal and vertical elements. The lawn is made alluring and coherent by the sense of intention and incident conveyed by the expansive composition.

While the creation of a compelling sense of place has persisted for two decades in Fleischner's work, the carefully wrought and enveloping dispersal of elements in La Jolla is far from the compact self-containment of Fleischner's first environmental work, which more literally took its form from architecture. In 1966 Fleischner purchased a secondhand diner in Providence and moved it to an isolated field near the ocean at Barrington, Rhode Island. He had been making life-size cast figurative works of fiber glass and plaster and conceived the idea of creating a controlled environment that would sustain a mood and complement the figures, protecting them from the distractions and visual vagaries of exhibition spaces.[1] This endeavor—on which he worked into 1968—was undeniably related to George Segal's work, but Fleischner was at the time unaware of Kienholz's *The Beanery*. The *Diner* was a long, narrow space with a low, curved ceiling and a single counter running its length. Seven figures were unified by their relationship to the counter or backbone of the building. Six figures physically touched the counter—either seated on stools or standing leaning against it—while the seventh stood conspicuously apart.

Fleischner's initial preoccupation with the figures was gradually superseded by an interest in the environment they populated. The two years spent working with the *Diner* were a gestation period during which he clarified many of the sculptural ideas that have emerged in later works. The interior of the *Diner* was a well-proportioned, intimate space, as are the environmental interiors he has since constructed. The bare metal frame of a pie rack containing the skeleton of a bird, while similar to Duchamp's found object *Bottlerack*, became Fleischner's homage to Giacometti's *The Palace at 4 A.M*. The exhaust fan hood projected from the wall like a Judd box, and the rectilinear modular panels of the exterior related to other Minimal works. The *Diner* was equipped with fluorescent lights, and Fleischner spent hours observing the transition of illumination from the variety of warm tonalities of daylight, to the even, cool fluorescent lighting of night.

From the outset Fleischner was conscious of the *Diner*'s alien or surreal presence far removed from its urban context. Situated in a field against a tall stand of trees, it was in hearing distance of the ocean. Given its diminutive scale in this rural context, it read as an object placed on a vast horizontal field. *Untitled Terra-Cotta Landscape* of 1966 codified Fleischner's response to this situation of an object on a landscape. The arcade in the background echoes the rhythmic fenestration of the *Diner* and as a man-made geometric structure in a landscape alludes to ancient aqueducts. The scumbled clay in the foreground represents the sea. The horizontal plane of this uninhabited de Chirico-like space is interrupted by a staircase leading nowhere. The geometric staircase descending below the surface of the sculptural plane and the illusion of vast scale created in this piece recur in the cast sculpture made throughout the next decade.

While the exterior appearance of the *Diner* as an object in a landscape provided impetus for Fleischner's small cast pieces, its field setting led to his involvement with environmental scale. In 1971 Fleischner purchased a large quantity of hay bales, inexpensive modular blocks, for use in two adjacent fields on a farm in Rehoboth, Massachusetts. The first piece he constructed, *Hay Line*, 1971, consisted simply of a continuous line of hay bales placed end to end describing an axis in the two-acre field. This 355-foot hay line was an initial gesture which allowed Fleischner to

# Richard Fleischner
## The Bedouin in the Orchard

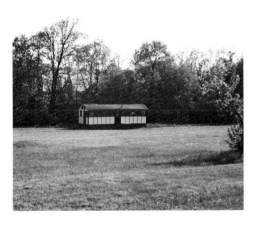

*Diner*, 1966–68, Barrington, Rhode Island, temporary installation.

*Untitled Terra-Cotta Landscape*, 1966, terra-cotta, 2½ x 20 x 11 inches, Collection of the artist.

come to terms with the scale of his new medium. This piece was essentially a three-dimensional straight line drawn on a flat plane. Fleischner then constructed two parallel lines of hay bales 7 feet apart and 100 feet long, describing a *Hay Corridor,* 1971, which culminated in a hay archway.

In 1968 he had spent six months travelling and working in Europe, visiting among other sites the Etruscan tombs in Cerveteri. For Fleischner the appeal of these simple geometric structures was enhanced by the porous quality of the stone which assumed a rich patina from the vegetation it supported. Shortly after the *Hay Corridor* Fleischner built a rectilinear roofless interior using the hay bales as surrogate stone blocks. In this unicursal *Hay Maze,* 1971, a three-bale-high column guarded the entrance to a four-walled structure of the same height.[2] Inside, one walked through a corridor formed by the walls that enclosed a central space containing a rectilinear pallet a single bale high with a two-bale-high "headboard" at the entrance end. In 1973 the piece was realized in tufa stone at the Rockefeller estate in Pocantico Hills, New York. From a distance it reads as a Minimal stone cube, a transplanted Etruscan tomb, assuming the most basic maze configuration. Fleischner hand-picked the tufa blocks in Italy and took precautions to preserve the subtle vegetation they supported. Back in the United States he worked for several months with a stone mason to ensure the precise abutment of the blocks which derived their proportions from the modular unit of a hay bale.

The final hay piece, *Hay Interior,* 1971, had been laid out and proportioned in string in Fleischner's studio more than a year before its actual construction using a reinforced wood structure. Its interior dimensions were seven feet high by seven feet wide by ten feet, ten inches long. While the preoccupation with constructing an interior volume came from the *Diner* experience, the actual form, structure, and proportions of the *Hay Interior* were very much influenced by Etruscan tombs. The space was entered by descending a staircase reminiscent of the *Untitled Terra-Cotta Landscape* and the small cast metal pieces. To the left and right, running the length of the interior, were facing benches or pallets each one bale high. Fleischner dismisses womb/tomb comparisons, emphasizing the comfortable and classical proportions of the space. The qualities of the material, and of the changing light filtering through the doorway, contributed to the unique ambience of this interior. The aroma of hay and the crickets that inhabited his material were unanticipated assets. The delicate graphic quality and subtle tonalities of the hay walls relate to the meticulously achieved patinas of the cast metal pieces.

In 1967 Fleischner embarked on a series of small cast bronze, lead, and pewter sculptures. With the exception of a very few wall pieces, they are composed on a horizontal plane, never measuring more than twenty-four inches on the longest side. This plateau-like plane is raised on two-inch-high sides that are modelled and organic in appearance, as if the pieces were isolated landscape vignettes—mesas from some desert of the earth's surface. As in Giacometti's *City Squares,* vast scale is evoked. A towering freestanding wall, a pyramid, or occasionally a miniature seated or standing figure endow the earlier pieces with the quality of tableaux. *Figure on a Bench,* 1967, consists of a solitary figure seated with his back to a ponderous freestanding wall which rises more than ten times his height. Concealed from the figure, scumbled waves, like those of *Untitled Terra-Cotta Landscape,* crash against the far side of the wall. The surreal juxtaposition of elements and the feeling of existential solitude call to mind such small sculptural works by Giacometti as *The Palace at 4 A.M.,* a talisman for Fleischner for many years.

The vast space imagined in many of Fleischner's cast sculptures is dealt with directly in his concurrent environmental pieces. The Sudan grass installations of 1972 were created in the fields in Rehoboth where he had constructed the hay pieces the previous summer. During the intervening year Fleischner had visited Egypt, and his experience of long corridors leading to intimate enclosures in the pyramids paralleled the nonfunctional spatial axes and enclosed spaces he had created in the *Hay Corridor, Hay Line,* and *Hay Interior.* The Sudan grass pieces were in fact triggered by the *Diner's* interior sense of scale, and the fortuitous reflection of the geometric floor tile pattern on a window overlooking long waving grass. Both *Bluff* and *Zig Zag* are the result of a literal conjugation of the severe, geometric configuration of the *Diner's* tile floor with long waving grass.

*Bluff* was a 2½-foot-wide, 400-foot-long corridor through 8-foot-high Sudan grass culminating in a small grass-enclosed chamber. The piece was constructed by laying down masonite and plastic sheets to prevent the growth of the seeded grass in the corridor and chamber. Once the grass had attained its full height of 8 feet, the masonite and plastic were removed. Sudan grass was selected because it grows

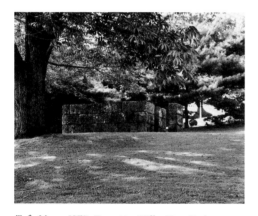

*Tufa Maze,* 1973, Pocantico Hills, New York, permanent installation.

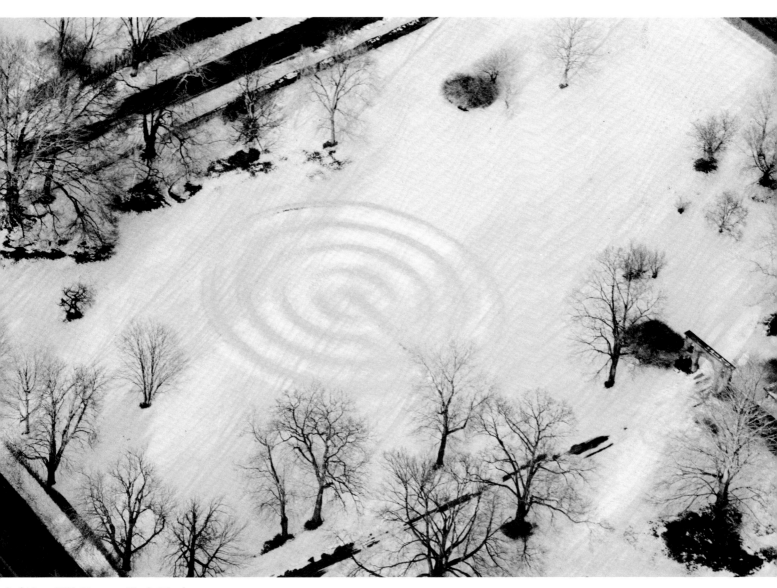

*Sod Maze*, 1974, Newport, Rhode Island, permanent installation for the exhibition *Monumenta*.

rapidly, densely and vertically, and has good memory or resilience when disturbed by wind or people. Fleischner describes the disorienting experience of having the wind rise while traversing the corridor; the grass would wave and bend completely, concealing the path and, as the wind subsided, would reassume its corridor shape. *Zig Zag*, similarly constructed of selectively planted 8-foot-high Sudan grass, presented a 2-foot-wide, 370-foot-long corridor. The viewer proceeded up the entire length of this straight corridor and then returned via a zig-zagging 3-foot-wide path on a route parallel to the entrance corridor. *Bluff* and *Zig Zag* are both unicursal mazes which compel the participant to experience space as directed by the sculptor. In *Bluff* the tunnel experience of the corridor is countered by the intimate containment of the chamber. In *Zig Zag* the release of the straight corridor is followed by the compression of the repeated 10-foot corridors zig-zagging at right angles, and returning the viewer over a considerably longer route to the point of entry. In both pieces the initial corridor vista culminates in a radically more intimate spatial experience which cannot be anticipated at the outset. Though the gestalt of the simplified Greek key motif of *Zig Zag* is clear after several corners, the plan requires the participant to complete physically the spatial experience.

The *Sod Maze*, a permanent installation on the grounds of Chateau-sur-Mer in Newport, Rhode Island, was installed as part of the *Monumenta* exhibition of large-scale outdoor sculpture held in the summer of 1974. It is similar to the Sudan grass pieces only in being a unicursal maze constructed of grass. While the Sudan grass mazes literally contained the participant and thereby established a single route of passage, the *Sod Maze*, constructed of four concentric gently sloping mounds of sod-covered earth, merely proposes a course which may be followed or abandoned at will. While a maze in plan, it has no feeling of confinement and blends with the surrounding gardens unpretentiously. The concentric rings barely ripple the surface of the lawn as if a pebble had been dropped in still water. Fleischner describes the process, in conception if not actual execution, as pushing up the earth from beneath the sod. Following the route of the maze's design, the viewer is presented with a succession of panoramic views of the surrounding lawns, gardens, house, and trees. Unlike the Sudan grass mazes, the exit route retraces the route into the center.

The *Sod Maze* may be considered the first of three, three-dimensional "sod drawings." These "sod drawings" relate to prehistoric fortifications and burial grounds, eighteenth-century formal gardens and ha-has, as well as to contemporary golf tees and greens which are similarly manicured. *Sod Drawing*, 1975, installed as part of the *Projects in Nature* exhibition in Far Hills, New Jersey, was located on a grass lawn on the site of an old orchard. A steel channel 2 inches wide, 6 inches deep, and 255 feet long was inlaid in the lawn paralleling the axis of the few trees that remained in the orchard. Five 13-inch-high, sod-covered mounds were placed around the channel in alignment with the vestigial rows of trees. A third *Sod Drawing* was installed as part of the exhibition *Sculpture 76* held in Greenwich, Connecticut in 1976.

These low-relief, large-scale sod sculptures duplicate the effect if not the process of embossings. An aerial photograph of the *Sod Maze* in snow prompted Fleischner to embark on a series of embossed prints during the winter of 1975–76. *Sod Drawing* at Greenwich of the following summer is in fact a modified version of an embossed print. The series of *Lead Drawings* created between 1973 and 1975 also relate to this form of relief draughtsmanship. The dozen or more *Lead Drawings* each began as a rolled out slab of clay 11 by 9¼ inches—roughly the dimensions of a standard pad of paper. Each surface was then scribed with eleven equidistant ruled lines and an 8-inch circle drawn with a compass centered on the slab. Having neatly and geometrically ordered the surface, Fleischner then imprinted a sequence of finger, hand, and fist impressions. These direct hand marks run the gamut from light fingertip touches to punching of the clay slab with the closed fist. If at times the hand gestures appear impulsive or random, they are in fact the result of a methodical exploration and digital progression.

During the summer of 1976, Fleischner executed four major environmental works, two composed in sod. Along with the Greenwich piece, a second *Sod Construction*, designed as a temporary installation for Hammarskjold Plaza, was envisaged as a ribbon of sod, an elevated grass ramp with the impelling spatial quality of the Sudan grass corridors. Rather than designing a work that would perch sedately on the small sculpture terrace/pedestal provided by the architect, Fleischner virtually redefined Hammarskjold Plaza. The five-foot-wide by ninety-five-foot-long ramp and its trestle support soared to a height of ten feet far beyond the confining low terrace wall and paralleled the arcade of trees on 47th Street. Upon seeing the

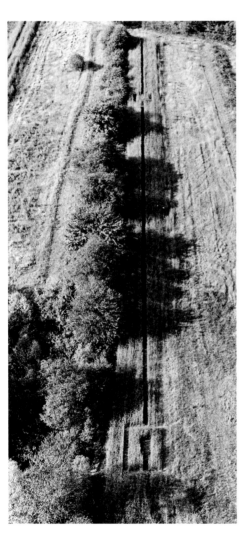

*Bluff*, 1972, Rehoboth, Massachusetts, temporary installation.

effect of the completed work, Fleischner regretted the romantic aspect of implanting lush sod in the heart of New York City. While the trestle construction had initially been employed as a means of supporting the grass, for Fleischner its transparent volume of interlaced four-by-four timbers became the most successful aspect of the piece. In addition to creating an inclined axis of sod, Fleischner temporarily restructured the normal means of access to the building. The presence of this obstacle to be negotiated compelled the building occupants and plaza visitors to reconsider the normal spatial configuration.

In the two other pieces completed that summer, at Artpark in Lewiston, New York and at the Nassau County Museum of Fine Arts on Long Island, Fleischner, prompted in part by circumstances of the working situation, departed from familiar materials and approaches. He had visited Artpark the previous winter and had tentatively planned a trestle structure similar to, but larger than, the Hammarskjold piece. The intended site covered with several feet of snow must have had an expansive plateau effect and uniform surface appeal similar to that which Fleischner had evoked in small cast pieces. Returning in the summer Fleischner found the rough soil site to be inhospitable in scale, texture, and color to the intended trestle. He reconceived his project and constructed a more solid, less expansive object to be placed in this brown landscape.

*Wood Interior* was in many ways similar to the *Tufa Maze*. Reading from a distance as a cube, here of wood rather than stone, it was a rectilinear unicursal maze. Twenty-nine feet square by twelve feet high, it consisted of an interior volume reached and contained by four surrounding corridors. The piece was motivated by Fleischner's interest in controlling both space and illumination. Light entered the first three corridors only from the initial entrance, and the fourth corridor glowed slightly as light leaked from the interior room. The roof was suspended above the wall structure, allowing light to enter the interior room through a continuous 1¼-inch gap between ceiling and walls. The illumination of this space changed with the time of day; at midday the overhead sun projected through the narrow ceiling gap creating bands of neon-like light on the floor and walls. Similar to the *Tufa Maze*, and derived from tombs at Sakkara, the interior chamber was occupied by a 4½-foot-high closed wooden box centered in the space to create a second set of four surrounding corridors. Drawing on the experience of previous environmental works, *Wood Interior* adds the element of illumination to the corridors of the Sudan grass pieces and the intimate, well-proportioned interiors of *Bluff, Hay Interior*, and *Tufa Maze*. The impetus for a controlled environment that had originally motivated the *Diner* had been completely achieved in this wooden interior. Except for its quality as an object in the landscape, *Wood Interior* had very little to do with its Artpark site.

The final project of this exhausting summer was Fleischner's most conceptual piece to date. *Sited Works*, installed for the exhibition *Sculpture Sited* at the Nassau County Museum of Fine Arts, was in a sense composed of sketches for seventeen environmental ideas. During the preceding year Fleischner had visited the museum grounds more than a dozen times in attempting to come up with a piece. Over the years, like many other artists, he has collected photographic images, and while wandering through the grounds certain of these images repeatedly imposed themselves on his mind as he confronted particular sites. Rather than allowing this daydreaming process to suggest a single physical construction, he elected to preserve the primary experience by literally juxtaposing seventeen photographic images or events with their chosen sites on the lush, rolling estate of Nassau County. The photographs ranged from content laden images—both humorous and tragic—to purely formal linear expressions. In the final presentation, the imposed photographic image and a photograph of the site were paired, framed under glass, and mounted on bent wood stands placed at the points where the seventeen site photographs had been taken. In the museum Fleischner presented two maps, an azimuthal map of the world centered at New York City, and a map of the estate, with colored pins in each indicating the respective sites of the paired images. In complete contrast to the controlled environment and single mood of Artpark, the Nassau County piece demanded of the viewer mental interaction rather than physical involvement. The process of pairing was the only link between the seventeen disparate stands.

Perhaps the clearest correspondence was achieved by the pairing of an informal access route leading from the entrance drive to the estate's pond with a desert road in Texas. The two photographs share a formal compositional diagonal and reiterate the corridor axis prevalent in Fleischner's environmental work. Beyond

this there is the obvious contrast between the respective natural settings of these two man-made utilitarian thoroughfares. The majority of the seventeen selected photographs were conceived by Fleischner, like the Texas road, primarily as formal comparisons—mostly graphic and occasionally sculptural. Graphic, two-dimensional images included delicately tracered anti-aircraft fire, a lace-like spider web, triple-pronged lightning, and a sinuous Burma mountain road. Sculptural images were a row of man-sized termite nests arrayed on a north-south axis, an ancient necropolis, and an English prehistoric double ditch fort which bears a marked resemblance to Fleischner's own *Sod Maze*. The image of a herd of zebras clustered at the edge of a watering hole was humorously appropriate to the estate pond site and graphically appealing as a collage of black and white striped elements. There was nothing formal about the photograph of a Nazi officer holding a pistol at the head of a Polish prisoner on the edge of a mass grave. Placed in the quiet, rural setting, this shocking tableau was a disturbing monument.

*Sited Works* marks an extreme of physical insubstantiality in Fleischner's oeuvre. Two years later he probed the evanescent appearance of a notoriously tangible material. The *Chain Link Maze*, realized for the University of Massachusetts, Amherst in 1978–79, incorporates many preoccupations of his previous environmental work. This multicursal maze is sited on an open field against a stand of trees in a situation reminiscent of the *Diner*. Eight feet high and more than sixty feet square, it appears from a distance to be a solid, silver-colored Minimalist mass. Commencing with four corridors describing the perimeter of the work in the manner of the Artpark piece, the participant must then negotiate a perplexing variety of corridors before discovering the successful route to the eight-foot cube space at the heart of the labyrinth. The negotiation of the maze is further complicated by the transparency of the chain link fencing material which confounds depth perception. Both from the exterior and the interior, the successive superimposed layers of mesh create delicate moiré patterns, their veil-like quality defying the usually severe associations of this industrial material.[3] An almost stroboscopic effect occurs as spectral figures passing through the pathways emerge and disappear behind overlapping layers of transparent metal fabric. Like Fleischner's earliest hay and Sudan grass works, the *Chain Link Maze* frames vistas and orchestrates spatial experience. In such other works of the past decade as the *Cow Island*, *Baltimore* and *La Jolla Projects*, maze configurations give way to the stone or steel markers that shape the viewer's sense of place.

*Hugh M. Davies*

*Chain Link Maze*, 1978–79, University of Massachusetts, Amherst.

■

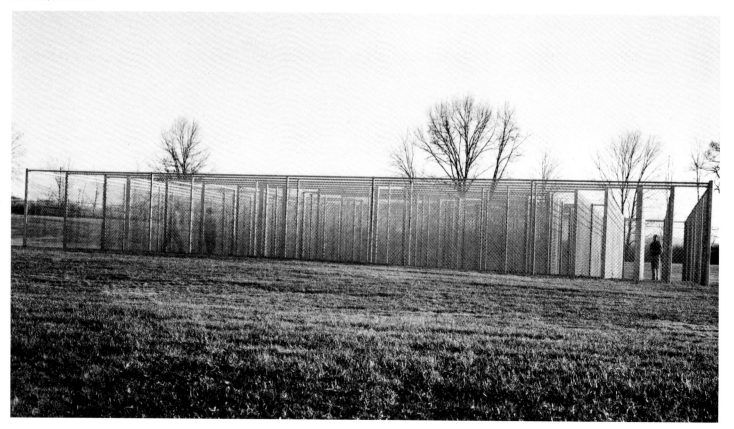

During 1978–80, Fleischner built a large, involved project that reveals how much his work over the last few years has been generated by an understanding of place.

In an expansive wooded grove adjacent to a new federal building (a computer center for the Social Security Administration) on the outskirts of Baltimore, Fleischner defined a working area some 300 feet square. Five major elements or sets of elements were distributed within this working area according to the following schematic plan:

|  | door |  |
|---|---|---|
|  | bench |  |
| cube / screen | table | implied / threshold cubes |
|  | column wall |  |
|  | column wall |  |
|  | federal building |  |

The only elements evident as one approaches the wood from the building complex are two large column walls towering some thirty feet over our heads. Constructed of Cor-ten steel, the russet skin color of columns, capitals, and lintels contrasts with the grey, brown, green, and blue hues of the natural background. The first of these walls stands in the clearing between building and wooded grove, the second is less exposed, standing just inside the tree line and partially enmeshed by the similarly scaled trunks and foliage that surround it.

As we walk beneath this structure and between its columns (actually I-beams), the interior of the grove becomes more discernible as proximity allows us to begin a visual exploration of the foliage in the filtered light of its depths. What appears as a uniform wall of trees from the vantage point of the building grows more complexly spatial and dimensional as we "enter" the bounds of Fleischner's project, crossing through the first of the column walls.

At least one expansive element can be seen from the entry area. A large horizontal plane likewise constructed of Cor-ten steel plates and legs—what the artist refers to as a "table"—is positioned beyond several large tree trunks well within the confines of the wood, towards, but not at, the center of Fleischner's working area. Of course "center" means little to the on-site viewer as the various elements are discovered processionally while walking through the thicket; no "total" evaluation is possible except after such an exploratory process. The project's geometries become clear only after investigating the entire array of single and clustered forms.

It is around this crucial table that the whole of Fleischner's piece coheres. Standing on the table with the column walls behind, we can see the three other major groups: to the left is the large, multipaneled screen wall. Through the narrow gaps between panels is the slightest suggestion of a large mass—a granite cube hidden from view.

Directly ahead of the table is a low "bench" marker and a U-shaped arrangement of doorsill and jambs, all cut of clean, retangular Concord grey granite slabs. Although barely visible from the central table position, one more set of markers is placed deep within the grove of trees to the right. Here, two right angles of the same grey stone suggest a pair of low cubes. When we approach them more closely, we realize that only two of the six cube sides are present for each (actually three are present if we count the ground). The artist succinctly calls these his "implied" cubes, their planes suggesting both mass and volume. The final element on the right flank is perhaps the subtlest of all—a threshold bar of granite inset flat at ground level, just beyond and between the two implied cubes. Only this threshold, the doorsill, and the outermost of the two column walls are on the perimeter of his otherwise unmarked outer boundary. All other elements reside within his working area and simultaneously in its coterminous tree-covered grove.

Discoveries and shifting perceptions of color, light, and mass occur throughout *The Baltimore Project*. While the Cor-ten looks softly aged, the grey granite seems to coincide superbly with the bark tones of the dominant species at the site— beeches, tuliptrees, oaks, and dogwoods. The mottled shadows cast onto many elements from the canopy of branches and foliage are perhaps a clue to Fleischner's intent here in the grove. The full clearing above the table, the streaks of light that beam through the greenery to strike the implied cubes at sunset, or the surface tones of the screen wall as the light wanes are a catalogue of light and shadow possibilities usually found in the woods.

*The Baltimore Project*, 1978–80, Woodlawn, Mary-
land, permanent installation, details.

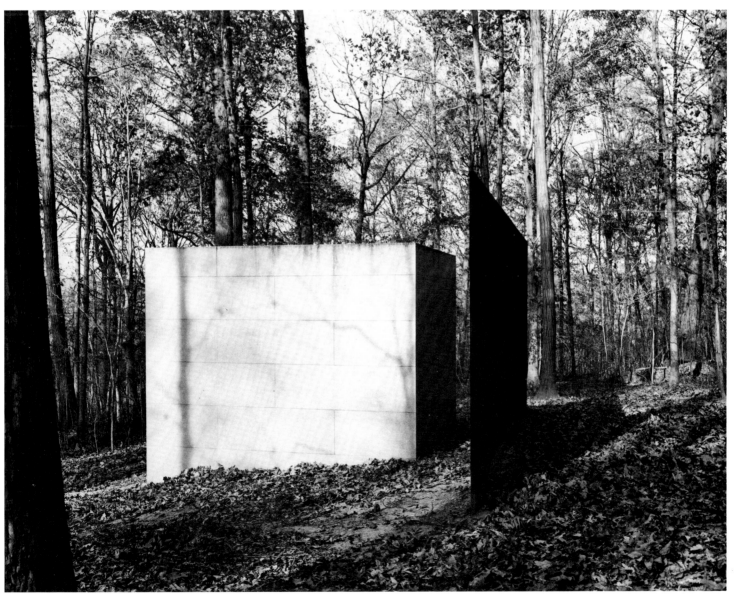

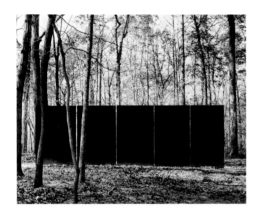

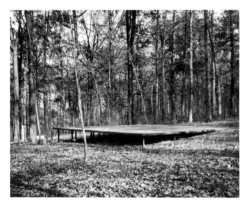

ABOVE AND OPPOSITE: *The Baltimore Project*, 1978–80, Woodlawn, Maryland, permanent installation, details.

The multiplicity of qualities of light is thus reiterated for his audience; the initial experience of natural effects is simultaneously doubled through the artist's sensitive reading of context and place. The effects are not just those of light, however, as color, distance, screening, scale and other internal, natural phenomena are also present on the site, within the relationships set up by Fleischner among his elements and also between the elements and the place. Here, the taking in of the forest and the taking in of the art are totally congruent, interwoven experiences that are, in fact, perceptually coincident.

Two works completed earlier in the year reflect this same outlook. The *Fence-Covered Fence*, created for the Lake Placid Winter Olympics, is as much about its tree-bounded field site as the Baltimore work is about a wooded grove. At Lake Placid, a field is bounded by trees, an extant fence, and a fence built by Fleischner. We look at the field from outside rather than entering its space as we do a wooded grove, not because it is any less inviting but because its totality can be seen from the periphery.

Similarly, the wooden installation at the Museum of Art, Rhode Island School of Design, 1980, perfectly scaled and toned to the large gallery space on the bottom floor of that institution, made us aware of that room in unexpected ways. Again, the act of entering and perambulating the room was taken into account; our habitual actions in a museum space are to circumnavigate the rooms' open floor space staying close to the walls where most "art looking" occurs. Fleischner left the walls bare and provided us with a slightly elevated platform walkway, replete with benches down its sides and a railing that encloses the vacant center of the room with its bare wood floor. All measurements and dimensions were established by the artist, informed by existing details in the chamber; for example, the open central space directly reflects the perimeter of an extant ceiling grid above, while a subtly curved transition between wall and ceiling suddenly becomes more prominent as the wall is shortened and we are elevated on the walkway. Earlier work also seemed focused on controlled pathways (sod mazes, wooden interiors, chain-link environments), but now this railed platform is not about a directional path but instead the context through which that path is inserted. There is a masterful and ironic switch here, as Fleischner's structure gets us to look at the "natural" confines of the architecture. In his stark, contemplative interior, we re-experience the real room often hidden by exhibited works of art, museum furnishings, crowds of people.

Similarly, *The Baltimore Project* enables us to "track" the actuality of a forest experience. We enter into an implied pact with the artist when we attempt to see his recent work; in this case, the most important aspect of this unspoken agreement is that we ingest the forest as well as the art with our sensory participation. We move beyond forest as schema, symbol, or replication as we confront its presence through Fleischner's catalytic cues.

Yet Fleischner is not playing tour guide, not cajoling us to see only what he has seen or what he wants us to see. After completing the Baltimore work, Fleischner returned from a trip abroad and recounted an experience that helps explain the attitudes present on the project site. It was not the art or the exotic foreign land that intrigued him but the way in which a bedouin had inhabited an orchard, creating his own domestic spaces within the confines of the stand of trees that Fleischner vividly remembered. Fleischner was able to visit the grove and observe the traces of that habitation—one area with its clay oven, another with its scooped-out "stove," yet another where a ground depression marked the former position of a tent. Perhaps it was the harmonious interaction between nature and culture that attracted the artist. Neither aspect of the site competes with the other, but one has a natural, given precedence. In many respects Fleischner has acted like that bedouin in the landscape. We share that experience, at least vicariously, through the remnants that he has left behind.

Much art during the past two decades has (re)embraced nature. This may partially be attributed to breaking out of the traditional formats provided by museum, gallery, wall and base, but might also be viewed as an attempt to recapture "the original virgin territory battling against the corrupt, excessively structured social sphere."[4] Either way, nature gets aligned with politics in recent work as artists move out of the gallery context and into the streets and fields. In our encounter with Fleischner's *Baltimore Project*, we are cast back into nature—not for its cleansing effect or its innocent appeal but because we can no longer experience it as is. We come back, through Fleischner's sensibility, to see it again.

As John Berger has said, "seeing comes before words."[5] This positions Fleischner's work at Baltimore precisely: it is preverbal, pre-architectural, pre-analytical

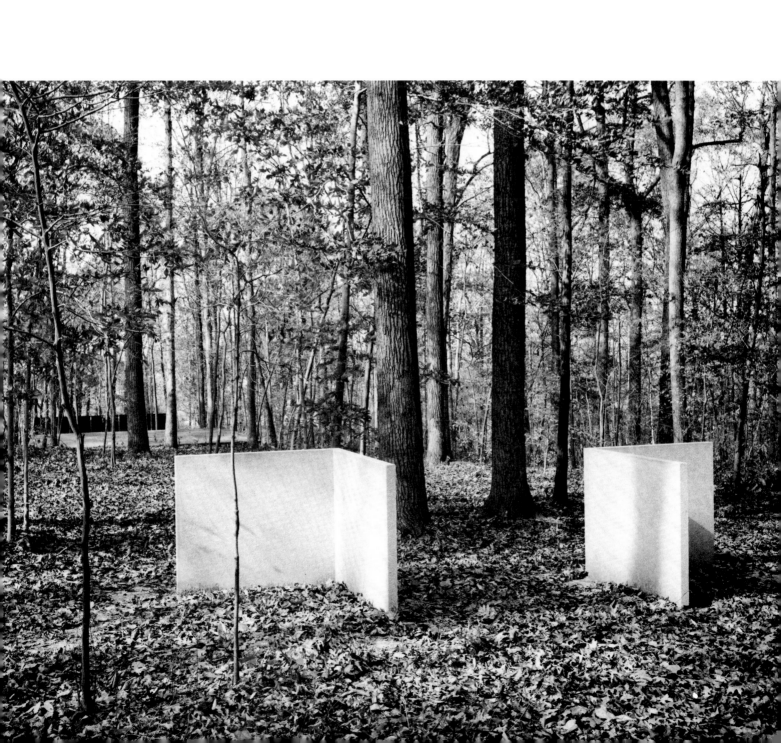

*Fence-Covered Fence*, 1980, Lake Placid, New York,
temporary installation for the Winter Olympics.

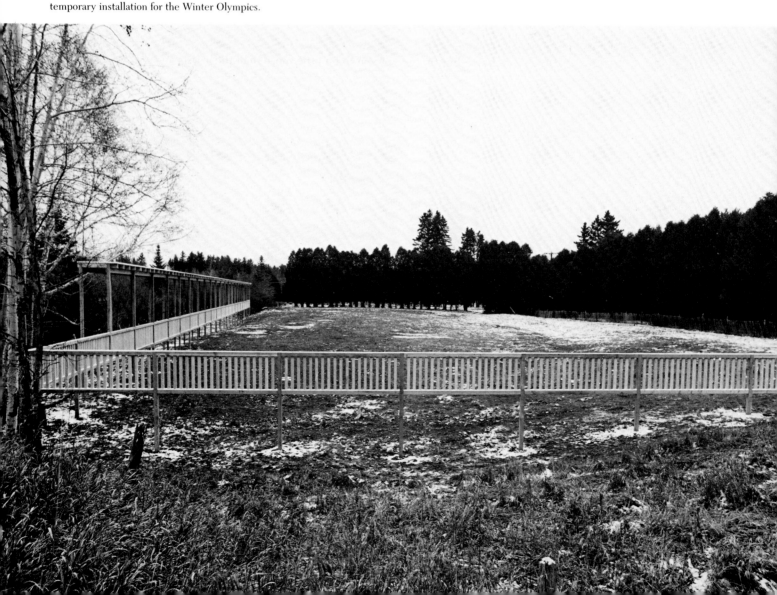

even as it remains structured in and sensitized to the present tense. More about "real" sense/time/space/place than about attributed, secondary characteristics, the steel and granite in that wooded grove is about looking and seeing, not about representing and commenting. Fleischner has ceded (or superceded) the sociocultural underpinnings of public art to achieve for us all a more primary visual experience—not just the pleasures of art but the essential sensations of a natural milieu.

If Fleischner is at home in nature, he has also been remarkable in his ability to work in concert with architecture. He, more than any other artist of the past decade, has shifted from the theoretical ideal of creating a dialogue between art and architecture and has made it a matter of practice. Since the early 1980s, architects I. M. Pei, Romaldo Giurgola, Edward Larrabee Barnes, and others have treated Fleischner as an independent design force, working with the myriad factors affecting the overall character of a building, its siting, and its environs. These interactions have enabled Fleischner to work in a space which is both literally and figuratively between art and architecture. It is this hypothetical place that is given much publicity, but is rarely, if ever, a reality in the twentieth century; in this arena the artist is allowed to become part of a design team, working on an equal basis with the architects, landscape designers, engineers and patrons, not as decorator but as co-composer.

Others have asserted the need for this type of architect/artist collaboration in the past decade but few have achieved it. One notable exception is the artist Isamu Noguchi who as early as 1960 began working on a number of projects that were realized in harmony with buildings designed by Gordon Bunshaft of Skidmore, Owings and Merrill. While such works as Noguchi's *Chase Manhattan Bank Plaza Garden*, 1961–64, in New York, his *Beinecke Library Garden*, 1960–64, in New Haven, or his *Red Cube* at the Marine Midland Building, 1968, in Manhattan, have been seen as true collaborations, they too may have been affected by the priorities of the architect over those of the artist. The architectural critic Paul Goldberger has written of the latest of these historic efforts: "Bunshaft and Noguchi worked in true collaboration here; they tried several versions of the work, and it was Bunshaft who selected the single large cube on end after rejecting arrangements of smaller cubes."[6] Yet such one-sided selection falls short of true collaboration. Many others have set up similar circumstances where intercourse between artists and architects has been mandated by reason of a special exhibition or encouraged by a personal contact; but these too seem to be little more than the artists and architects working simultaneously on the same site, each doing things separately, with different assumptions, and rarely entering into a two-part synthesis of approaches. Goldberger himself admits: "What we have seen is juxtaposition more than collaboration."[7]

Unlike the efforts of Fleischner and his architect colleagues, these more publicized attempts rarely allow artist and architect the consideration of each other's visual and spatial concerns as equals in a design process.[8] Fleischner now occupies a singular position in the world of contemporary art. In no fewer than a dozen projects, about half of which have recently been realized, Fleischner (cum architects) has imbued the design of real buildings with a special sense of spatial experience while marking a significant footnote in the history of architectural workshop practices. The list of projects started since the late 1970s is long. Following the Baltimore piece and two unrealized proposals for a gravel pit reclamation, initiated under the aegis of the Seattle "Earthworks" symposium in 1979, Fleischner expanded his intentions and ambitions to the scale of functional buildings. Between 1980 and 1985 he designed the plaza between two buildings at MIT in Cambridge (with Giurgola and Pei); in 1981, the Dallas Museum of Art Courtyard (with Barnes, completed 1983); working with the Giurgola office he has made proposals for the environs of the new Australian parliament houses, the new Paris opera, 1983, and an urban subway plaza at the entrance to Temple University in Philadelphia, 1982.

In keeping with Fleischner's own interests and vocabulary, many of these projects involve his manipulation of the open spaces around or between the new buildings and the extant structures. In each case, Fleischner has worked with the ground plane and the arrangement of plazas, paths, entries, viewpoints, markers, axes, and boundaries that cross or inhabit the space in question. Perhaps the most dramatic example of these attitudes is ironically from one of the few large-scale proposals made by Fleischner since 1979 that will not be built—a design developed for the Battery Park City World Financial Center Plaza in lower Manhattan.

Here the givens were impressive indeed—high-rise skyscrapers and hotels edging the Hudson River, the hub of a new city being built on landfill, with some streets and esplanades already in place. One central portion of the complex de-

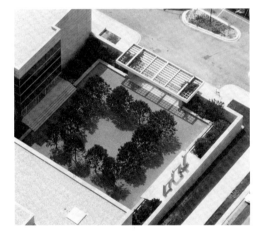

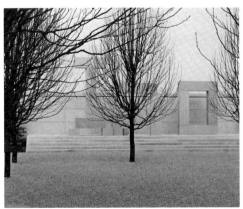

*Courtyard Project for the Dallas Museum of Art,* 1981–83, Dallas, permanent installation, Commissioned to honor Minnie and Albert Susman.

signed by Cesar Pelli visually dominated the rest—a glass enclosed Winter Garden whose monumental arched facade recalled commercial arcades, aviaries, and crystal palaces. Fleischner saw all too quickly the faults that were inherent in the givens; the space between buildings and water was neither useful as a living space that could accommodate such multivalent functions as a pedestrian esplanade, a cafe, fountains and foliage shaded areas, nor coherent in its relationship to the buildings or to potential pedestrian use.

Fleischner's plan for this urban setting was as simple as it was elaborate. He would literally create a new land area by shifting the seawalls of a lagoon located toward the center of the project. This single but costly shift entailed erecting a ground plane where none existed but it helped realize several key changes on the site that would allow spaces, building motifs, and other elements to cohere visually and rationally. The shift of the cove edge, by augmenting the space before the Winter Garden, permitted Fleischner to produce a major axis rounding the corner of one high-rise building and leading up to what was obviously the crowning drama of Pelli's glazed Winter Garden. The same shift gave enough breadth of space to provide for a slightly depressed plaza where outdoor dining could occur. To make each of these areas special and to mark the vantage points and sightlines that he had established, Fleischner designed various street objects, plantings, and furnishings. Fleischner would have choreographed the placement and basic scale of the major elements, which included two fountains, a clock and bell tower, site furniture, a large plane recalling a porch or arcade, and granite inlays under a bosk of trees. But to insure the autonomy of the elements as individual works of art rather than design, each was to be created by a different artist or architect.

Paving patterns, reminiscent of both ancient decoration and contemporary quilt grids, would have delineated separate but linked spaces, as they do at MIT and in the Chandler Plaza proposal for Arizona. Finally, large stone elements, like Minimalist sculptures intended for the studio or gallery, might also have been used by Fleischner as they have been on sites in Cambridge, Philadelphia, and La Jolla. These sculptures of limestone or granite evolved in the early 1980s. Fleischner developed a series of building blocks, modular construction elements, first of wood and later translated into stone. What was important to Fleischner about these wood blocks was that they allowed him to erect and reconstruct and in effect play with various configurations at full scale in his studio. The concerns of adjustment, scale, and rational arrangement are the same for this artist whether he is working with sod elements, hay bales, wooden structures, or landscape-sized gestures. These blocks readjusted to each site then become smaller gestures within the larger moves. The shifts he orchestrates are a reassertion of his sculptural attitudes initiated during the 1960s but expanded and diversified into on-site actions by the end of the 1970s.

In almost everything he does, whether it be creating his own private garden or working with budgets, buildings and patrons on a corporate level, Fleischner seems to know innately what the writer Guy Davenport once observed of the creative process: "Art is the replacing of indifference with attention." Fleischner's attention has produced places of remarkable presence and resonance for us all to see and to inhabit.

*Ronald J. Onorato*

■

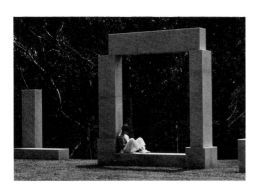

*Battery Park Proposal I (Axonometric Plan)*, 1983 graphite on paper, 35¾ x 48 inches, Collection of the artist.

*La Jolla Project*, 1982–84, Stuart Collection, University of California, San Diego, permanent installation, detail.

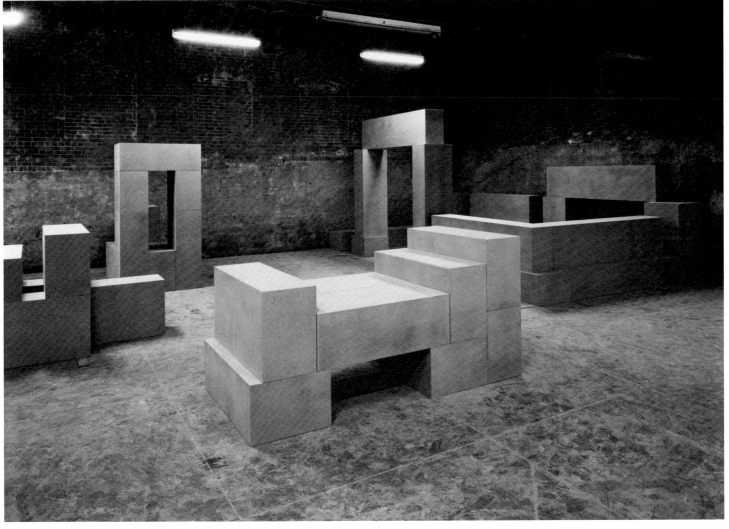

Informal installation of various *Modular Block Con-*
*structions*, 1981, in the artist's studio.

Untitled, 1973, Battery Park City landfill, New
York, temporary installation.

For almost two decades Mary Miss has conceived and constructed a variety of singular works that in certain respects are akin to the life-size maps of Borges's mythical Empire. Her works are more situations than objects, in that they do not depend on visual perception alone but chart a more thorough multisensory experience, the apprehension of space.

In the mid-1960s Miss began to explore and discover a sculptural vocabulary involving material densities, weights, strengths, and other physical properties. One of these early pieces, a wire mesh screen titled *Filter*, 1967, suggests the directions in which Miss would later move, using, in that case, the specific physical characteristics of the wire mesh to address other issues. Thus, the screen sets up a translucent barrier outdoors, allowing us to appreciate several spatial dichotomies simultaneously: the nebulous mesh wall can be looked at and through, tracing a broken line even as it remains a flat vertical plane. In a powerful manipulation, the artist folds the plane of the wall back onto itself, creating a single form that is both inside and outside, this side and that side, an impenetrable translucency and yet a perforated solid.[2]

Relatively simple objects, these early works seem to have been linked visually to Minimalist dogma, but Miss disdained an interest in critical theories and philosophies.[3] While her later activity did not shift toward more sensate spatial concerns, this choice of physical rather than abstract or conceptual assumptions has remained a constant in her career.

# Battlefields and Gardens
## The Illusive Spaces of Mary Miss

In a short text, "Of Exactitude in Science," Jorge Luis Borges recounts the tale of an Empire where... *the craft of Cartography attained such Perfection that the Map of a Single province covered the space of an entire City, and the Map of the Empire itself an entire Province. In the course of Time, these extensive maps were found somehow wanting, and so the College of Cartographers evolved a map of the Empire that was of the same Scale as the Empire and that coincided with it point for point.*[1]

Projects and pieces completed after 1968—like several interior fence structures built in a roughly finished basement studio where Miss worked in the late 1960s—afford a confrontation between viewer and space. The viewer/participant finds his or her path blocked, the space filled by reduplicated forms: picket barriers, leaning ladders, or chicken wire structures. As an intentional and controlled undercurrent, this confrontation encourages her audience to deal with the space, to consider its parameters, and to regard its potential for movement. Enclosed space is easier to handle, articulated space easier to read. Miss makes her constructions as a means to an end: they are the vehicle for drawing attention to a given, that is, the environment within which they are built. Although her later works become more complex, setting up extended passages through space, they too retain (what the artist regards as) this functional aspect—directing her audience's attention to the given space and changing it into a special, unfolding experience.

A few outdoor works from this time—like several stake and rope pieces in Baltimore, 1968, and on Ward's Island, New York, 1969, and a series of "V" markers placed at 75-foot intervals in a New Jersey field the same year—echo this familiar theme of path and obstruction, extending it into open, less defined natural spaces. The material used during this period was ephemeral; others have noted the "temporary, quixotic, vulnerable" look that much of that work evoked, with its mundane strips of wooden lath, corrugated cardboard, or twine.[4] These materials were chosen as much for economic reasons as for their aesthetic characteristics—they were what the artist could afford at the time. To see the works only in terms of these particular materials and the qualities they evoke, then, is to place them in the very aesthetic-critical system of Minimalism which the artist herself denied. More significantly, however, to do so undermines the import of situations which the artist set up, for her works rarely read as single images (precious objects) but instead engender diachronic, linear consideration, as they are experiences through space and across time.

A famous, if short-lived, project erected in Manhattan during the winter of 1973 on Hudson River landfill was a particularly effective example of how the artist used static elements in an ensemble that changed visually as the viewer walked around and through those elements. Shifting viewpoint, multifaceted situation, and ever-changing audience perceptions are all factors that continually inform Miss's work. Sometimes, this participatory fluidity is enhanced by the nature of the site. In both the New Jersey field piece and the Hudson River landfill project, open, unbounded flat sites further reinforced the freedom of viewers to see the work on their own terms.

The landfill sculpture consisted of five heavy plank walls, arranged one behind the other at approximately 50-foot intervals. Each wall had a circular cut-out, centered left to right but varying from a full circle whose top was tangential with the upper edge of the front wall, through a series of intermediate positions to the last

*Staged Gates*, 1979, Dayton, Ohio, temporary
installation.

wall with its low, semicircular opening barely above the ground. From the side we might read straight lines or coarsely hewn barrier; from the other vantage points new experiences were evoked. Some of these were wonderfully described by Lucy Lippard:

> This piece happens when you get there and stand in front of it. Its identity changes abruptly.... The experience is telescopic. As the modestly sized holes (and the adjacent walls that these holes incorporate into your vision) are perceived, they expand into an immense interior space.... The plank fences, only false facades nailed to supporting posts on the back, become what they are—not the sculpture but the vehicle for the experience of the sculpture, which in fact exists in thin air, or rather in distance crystallized.[5]

Such crystallizations, whether rough wood beams or cardboard strips—so temporary and fragile—are only conduits for the communication of physical and psychological experiences—looking, seeing, walking into and through. We return to the common denominator of space and its myriad perceptual possibilities whatever the nuances of a particular piece. This use of space as a positive factor, a dynamic presence, a generator of sensate details—rather than a negation of mass—distinguishes the work of Mary Miss. Simultaneously, this relates her work to those contemporaries, like Trakas, Fleischner and Aycock, who deal with sculpture as a total environment, although each has a distinct set of priorities and interests that affects the eventual look and reading of his or her work.

Lippard's on-site description hints at a working format that is later confirmed in much of Miss's work from the late 1970s and early 1980s—the primacy of a strong, directional frontality. Even as her efforts toward the end of the decade grew in scale and structural elaboration (Lake Placid's *Veiled Landscape*, 1979, or the Fogg Museum's installation *Mirror Way*, 1980), one is struck by the constant, perhaps original vision of the experience as being orchestrated to begin from a single, prime starting point. This characteristic experience in Miss's work is present in many of the interior and exterior pieces she has created (other examples include *Sapping* of 1975, *Box/Set* of 1976, and the 42nd Street Park proposal of 1981).[6] It is as if the viewer is setting out through a gate and down a garden path. From the start, sighting down the path, the whole passage is seemingly perceived in a momentary, perspectival illusion. It is only after the walk has begun, however, that subsequent investigations take the viewer comprehensively around the space to savor the fullness of the experience from various, personal vantage points. Such is the richness of experience possible from Miss's sculpture, with the space itself metamorphosing as the viewer investigates each piece. This perceptual unveiling is strongest in works like the *Box/Set* (originally an Untitled environment created for a *Projects* exhibition at the Museum of Modern Art) or a structure built at Artpark, Lewiston, New York, during the summer of the same year.

ABOVE: *Glass*, 1967, wood, glass, string, and lead, 3½ x 5 x 3 feet, Collection La Jolla Museum of Contemporary Art. *Sapping*, 1975, wood, steel, and paint, 6 x 3 x 20 feet, Collection of the artist.

RIGHT: *Mirror Way*, 1980, Fogg Art Museum, Harvard University, Cambridge, Massachusetts, temporary installation.

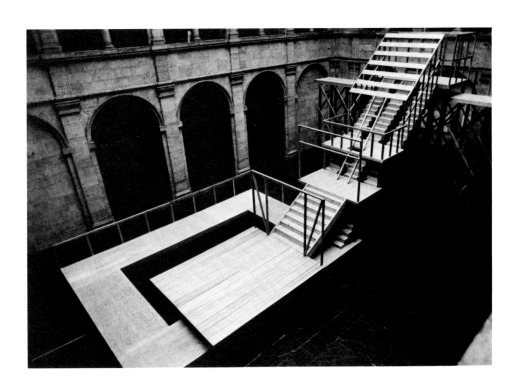

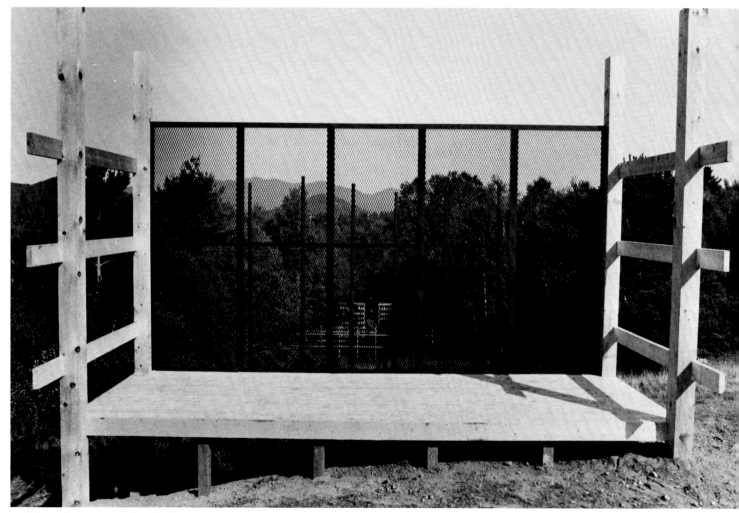

*Veiled Landscape*, 1979, Lake Placid, New York,
temporary installation for the Winter Olympics,
details.

72

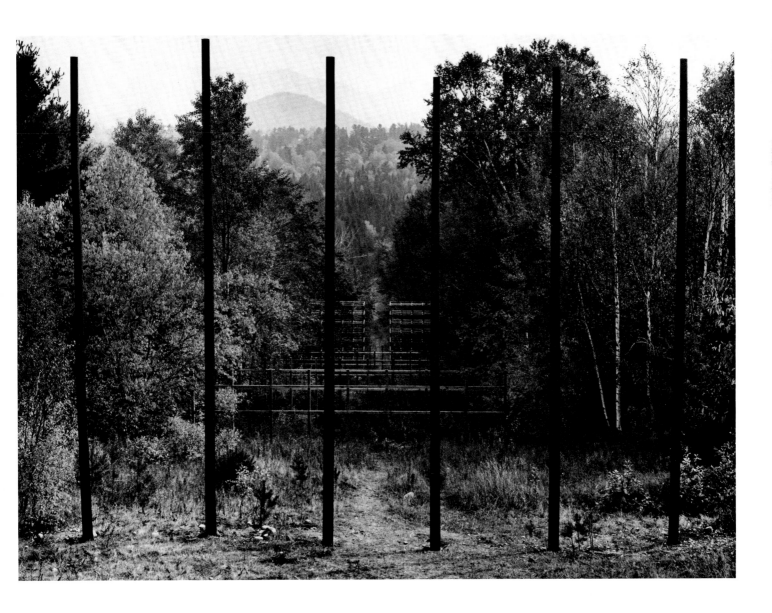

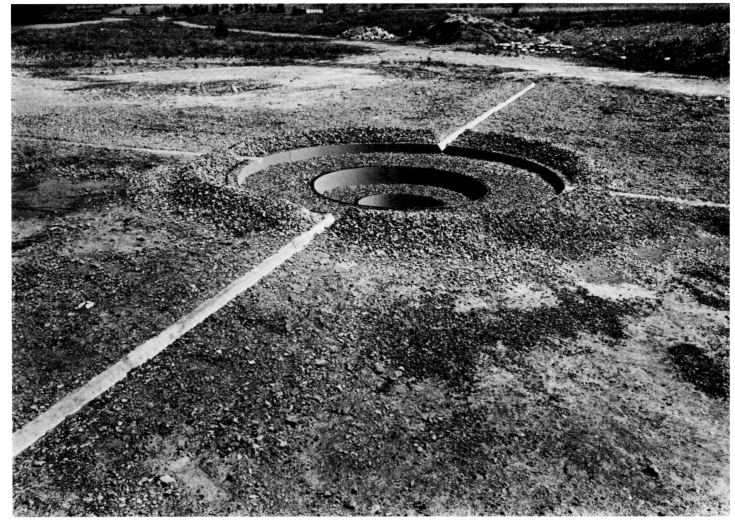

*Blind*, 1976, Artpark, Lewiston, New York, temporary installation.

At the Modern, the viewer was allowed to enter a discrete, intimate chamber slowly conflating through a series of adjusted plywood baffles. Raising the structure a few inches off the ground, and painting it a metallic color,[7] set it off from the rest of the museum interior, so that although it obviously had no kinetic elements, the piece could activate the space as we moved through it (here too Miss concentrated on the internal dimensions of the *Box*). The silvery sheen, reducing the sense of mass and solidity, together with the front opening, made our entrance into the interior almost inevitable as we initially read the entry surface as a pierced plane rather than a volumetric solid.

This same perceptual unfolding is found in the stepped descent of the large Artpark structure, *Blind*, built during 1976. A participant walking into and out of the pit of concentric circles was allowed constantly changing views of his or her environment. At the lowest level, only the sky above was evident; later, as one stepped up, triangular channels cut into the lip of the circles offered gun-sight views of some surrounding details. Finally, the entire panorama of the landscape became visible on the uppermost pier. Having "space-within" thus correlated with "space-without" caused parallel shifts in our visual awareness.

Another theme reflected in much of the work during the 1970s and '80s entails the definition and enclosure of refuge spaces that are partially segregated from the rest of their surroundings—private places separating the viewer from the environment.[8] These may be as succinct as *Sunken Pool*, a walled metal cylinder built on an overgrown path in Greenwich, Connecticut, 1974, or as open as the Artpark site. "In the center of the garden let there be a pavilion in which to sit, and with vistas on all sides": this is how Miss herself describes one such sanctuary in her notes. Rooms are defined within rooms (as at MoMA), or spaces distinguished with natural material in the open air, like the trench and wall in *Cut-Off*, 1974–75. These works strongly suggest a place for the contemplative, mental activity required for considering Miss's own works, just as they are the passive complement to the climbing, walking, exploring, or stretching which we are asked to perform in these spaces. "I guess the combination of a battlefield and a garden would be my ideal space."[9] Embodying the contemplative and its antithesis—the active, the threatening, the real world—these artful sanctuaries provide respite from external diversion. Controlling what the viewer sees of her own spaces and of their settings, Miss combines acting, choreography, and camerawork rolled into a single visual directive to her audience.

The metaphor of cinematic action aptly captures the experience that Miss wants for her audience. This is evident to the artist as well; her notebooks are filled with directorial notations linked to specific works, either imagined or executed. Several pieces, including *Cut-Off* and *Blind*, were actually created to be filmed.[10] In *Cut-Off*, the process of digging a ditch and using earth from the trench to fill a wall of snow-fence cylinders can only be seen through time. The finished elements —positive-negative of ditch and wall—are only the static remnants of the whole procedure. Since the theme here is process, the work can only be fully appreciated through chronometric reproduction. This cinematic experience—camera as viewer's eye, assuming myriad angles, moving through, into, peering out of *Cut-Off*— gives us what the "insidious trivializing of experience perpetrated by photography" can never give its audience.[11] These cinematic excursions provide the closest resemblance to both the intent and the sensibility of the actual works.

Much of the richness of her structures is drawn from two interrelated mental activities: perceptions of space and conceptions of remembered images. This peripheral imagery is sometimes evoked by the vocabulary of forms chosen. This is true of the Greenwich *Sunken Pool*, whose metal sides and skeletal gridding are reminiscent of the far larger storage tanks lining industrial highways, and equally so for the Artpark observatory, where Miss parallels or distills a spectrum of sources including Indian medicine wheels (part of the landscape imagery of the western United States, where Miss has lived much of her life), neolithic structures in Europe, and works by contemporary artists.

Still other pieces like *Sapping* and *Cut-Off* recall military imagery, engineering techniques, or building configurations familiar to Miss since early childhood, as she listened to stories recounted by her career officer father. Travels around Europe and elsewhere further complicated the artist's vocabulary. From those trips are recalled historical sites, old German keeps or forts whose sense of enclosure informs much of Miss's approach to space. Her notebooks are full of key words reflecting these disparate sources—the architecture of Italy, Islam or Sixth Avenue, Japanese gates, Chinese wells, camouflage, crenelated walls, bastions, homestead gardens,

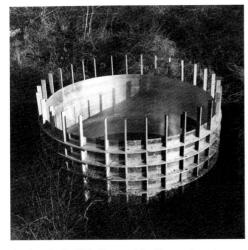

*Sunken Pool*, 1974, Greenwich, Connecticut, temporary installation.

castle windows, parks, quarries, Northwest Coast vernacular structures, barriers, and embankments. These enclyclopedic motifs are her raw expressive forms.

Such images/referents are not facile one-to-one reiterations of places and things that interest the artist, but are operational elements, functioning like the shapes and surfaces described by the child psychologist Jean Piaget:

> The visual image of a plane figure, a tridimensional shape seen in perspective, a projection, a section... involves, when it is all accurate, many more movements on the part of the subject (viewer) than is generally realized.
> It is really an image of potential action relative to these shapes rather than purely visual intuition.
>
> Even in the case of everyday images, is it at all possible to imagine a landscape, a house, or other familiar object without the aid, as essential components, of the scheme of the various roads traversed, the actions performed, or the changes of position commanding different perspectives.[12]

And so it is with the images of Miss. Her chosen shapes, materials, details and volumes work in concert, embellishing her spatial notions, just as they do in the mundane sphere.

"Layering," a term frequently mentioned in Miss's speech and notes, evokes the subliminal, stratified aspect of her imagery (it is even part of the artist's gestures as her hand moves parallel to the ground at several heights, suggesting an overlap in forms or ideas). Layering becomes literal in many works, often occurring beneath the surface of the site, as in a small project at Oberlin, 1973, where lath strips are crisscrossed into a grid pattern across a ditch exposing only a section of a much larger system extending in all subterranean directions. Spaces are layered horizontally, vertically, or within the depths of individual pieces by plywood baffles (as in the Museum of Modern Art installation), circles of gravel (as in Artpark's *Blind*), various screening systems *(Veiled Landscape*, Lake Placid, 1979), slotted wooden steps *(Sapping)*, or concentric cardboard rings (Untitled, 1971).

In an entirely different fashion, the space between and around her structures, the site, the natural or man-made environs, the details of construction and all their interrelationships, are the dovetailed phonemes enticing us through our own memories—personal, private, communal. Our recollections of other places, different times, are triggered by our rational awareness of Miss's space as much as they are informed by our viewing the interlocked shapes and motifs that she has chosen.

Toward the end of the 1970s Miss turned her attention to conceiving and composing ambitious ensembles of many parts. Some, like the 1979 project for reclaiming a buffer strip into a kind of park adjacent to the Seattle-Tacoma Airport, were fully developed from initial sketches, through consultations with local officials and sponsoring agencies and on-site work, to a finished design stage, only to be left unbuilt.[13] The project that sets the tone for Miss's work over the last eight years, however, was built in 1978 on the grounds of the Nassau County Museum of Fine Arts in Roslyn, Long Island. As one of her physically largest, most visually complicated pieces, *Perimeters/Pavilions/Decoys* was notable for the sheer fact of its having been built. So many of the themes flowing in her earlier work figure in the Long Island complex that it should inevitably come to be considered the artist's own intentionally self-reflective expansion of her major concerns in the 1970s as well as a prelude of things to come in more recent efforts.[14]

In order to see the work at all, a viewer had to find it first. A small dirt road cuts through a thick screen of bramble and trees ringing the site. Once on the other side of the dense foliage, the viewer stood at the edge of a rolling, grassy slope, about halfway between an area below to the left and a plateau above on the right, the whole almost entirely encircled by the tree wall. The discrete complex had distinct parts interacting visually and spatially in, and around, the natural arena. A semicircular embankment of dirt, some five feet high, was immediately apparent from our initial vantage point of entry; this divided the upper plateau from the rest of the field and from three prominent elements in the lower field: wooden and screen towers of various sizes that support multileveled platforms. These were places in the near, middle, and far distance as judged from the entrance.

Far more understated at first glance was the flat, upper field, visible only through a walk-channel cut into the dirt embankment. Toward its center, if we looked carefully, we could see the top of a ladder, sticking (so it seemed) out of the sod itself.

The upper lawn was unarticulated, except for the subtle ladder-projection which served visually to herald what was the third feature (and perhaps the most

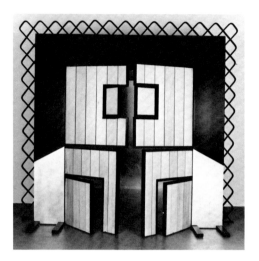

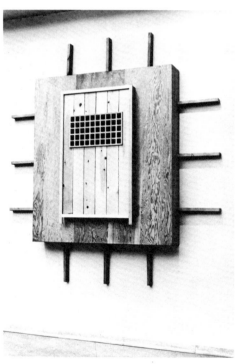

*Door Mask*, 1984, steel, wood, and paint, 9 x 10 x 4⅙ feet, Collection of the artist.

Untitled, 1977, wood, 9 x 9½ x 1 feet, Collection Solomon R. Guggenheim Museum, New York.

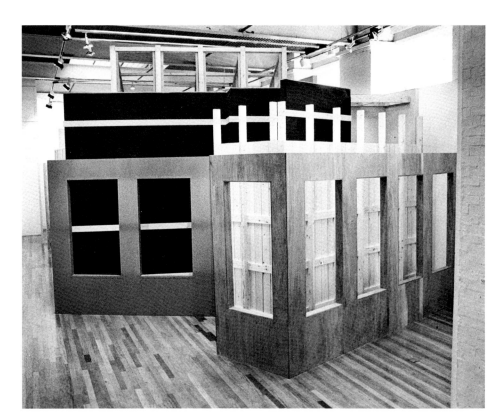

*Study for a Courtyard: Approach to a Stepped Pool*, 1983, Institute of Contemporary Arts, London, England, temporary installation for the exhibition *Art and Architecture*.

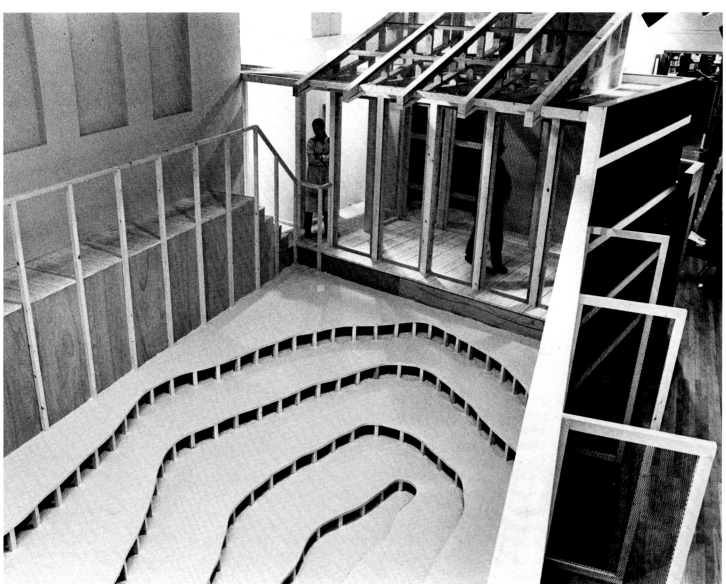

*Perimeters/Pavilions/Decoys*, 1978, Nassau County
Museum of Fine Arts, Roslyn, New York, tempo-
rary installation, details.

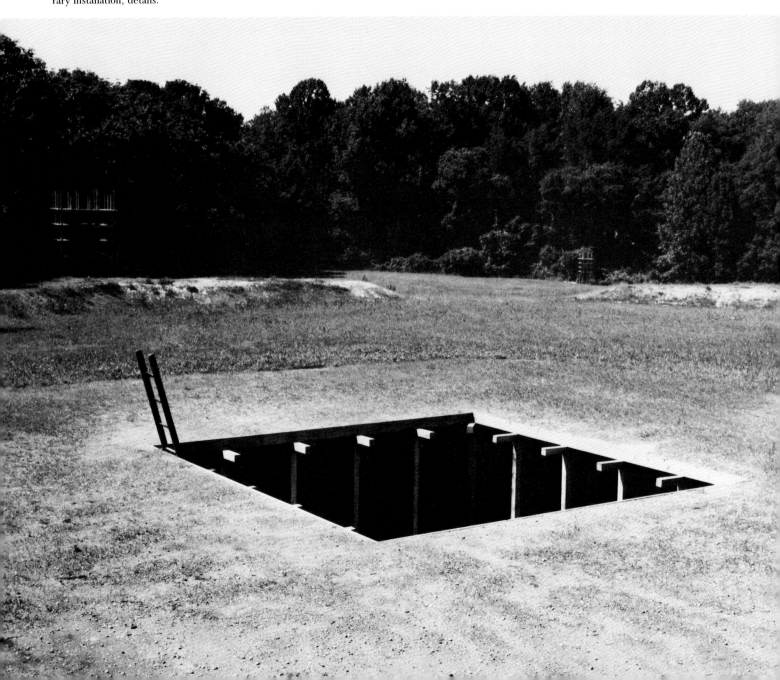

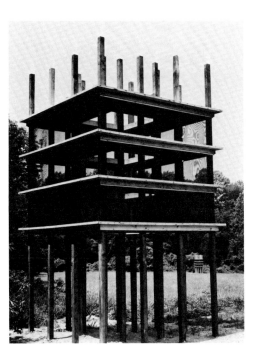

complex) of the entire group—a partly covered subterranean enclave with an atrium-like central pit about seven feet deep.

Miss began to think about the constituents of the Long Island complex on her initial visit to the museum-estate in January of 1977. She saw a variety of extant forms, some natural, others man-made, and noted them in her spiral-bound book. Along with the prominent beaux arts mansion, she recorded the following list of features that characterized for her the old Frick estate: tennis courts, clumps of trees, pine grove, old fire tower, bear pit, bird cage (both remnants of a private menagerie), formal gardens, teak trellis, layers, stairs, rooms. She even remarked that the idea of some structures "up on stilts off the ground is appealing." She was naturally attracted, with her other interests, to the gardens; vernacular structures and natural surroundings provided on-site material from which she would eventually distill her final sited product—keyed to its environs both through the senses and the intellect.

Another notebook, dated May–October 1976, reveals much of Miss's concerns as she was about to embark on the Long Island project. Different from her other notes (which tend to be loosely jotted phrases and sketches in a stream-of-consciousness linkage), the May–October journal reflects a deeper, denser pattern of thoughts and plans. Loaded with both references and concept, the book provides surprisingly succinct clues on both the artist's approach to, and the expressed meaning of, the tripartite Long Island ensemble.[15]

On several crucial pages, designated by the phrase "Another kind of construction," Miss explicitly laid out the evolution of her thoughts just prior to the onset of work at Roslyn. She wrote of what would become the multi-elemental format:

> Putting several short sequences together, so that a total narrative comes thru. This avoids having to come up with a single construction/structure.
>     (As in changing stage sets)
>
> Circular Japanese set—different "scene" in each third

Miss jots down further thoughts on the relationship of constructed elements to the chosen site:

> Using camouflage—apparatus sort of like stage sets
>
> On its setting naturally into the environs
>
> Something slowly becoming apparent—blending in from a distance, at close range the artificial is very apparent
>
> Dispersion vs. grouping
>
> Orderly rows vs. random layout

In the completed work, her site and its contents were sequestered from open view, nestled into a quiet corner of the museum estate, far from the main house, surrounded by the foliage screen. Even when we were standing on her field of activity, some of the elements (the ladder and pit) remained surprisingly hidden from casual sight, while others (towers) retained their man-made, artificial presence at any distance.

Ideas, preconceptions, and issues of illusion and perception were woven through the work, dovetailing with the artist's choice of site, orientation of the structures, her use of materials, and the particular forms chosen. Camouflage/stage set/becoming/appearing/blending/dispersion constitute a perceptual vocabulary of nouns and verbs; many of these concepts were activated in the focal arena of her site—the subterranean structure.

The pit was, in many ways, the crucial image of *Perimeters/Pavilions/Decoys*. The towers were, however, more prominent, being above ground, in an open field, accessible to all. They gauged our abilities to appreciate size and relative scale at various distances, with and without other measurement cues. Their primary rationale was, however, as the logical, lofty, and obvious complements to the manifestly complicated below-ground structure where Miss concentrated her planning and construction efforts and which, in turn, demanded the most from her audience's energies.

As we approached the excavated area through the blind of the dirt embankment, it initially appeared to be a clean-cut hole out of which the top of the entry ladder projected. By the time we peered over its edge, we realized that the expected packed earth walls were cut back beneath the ground on which we were standing.

*Field Rotation*, 1981, Governors State University,
Park Forest South, Illinois, permanent installation.
OPPOSITE: detail.

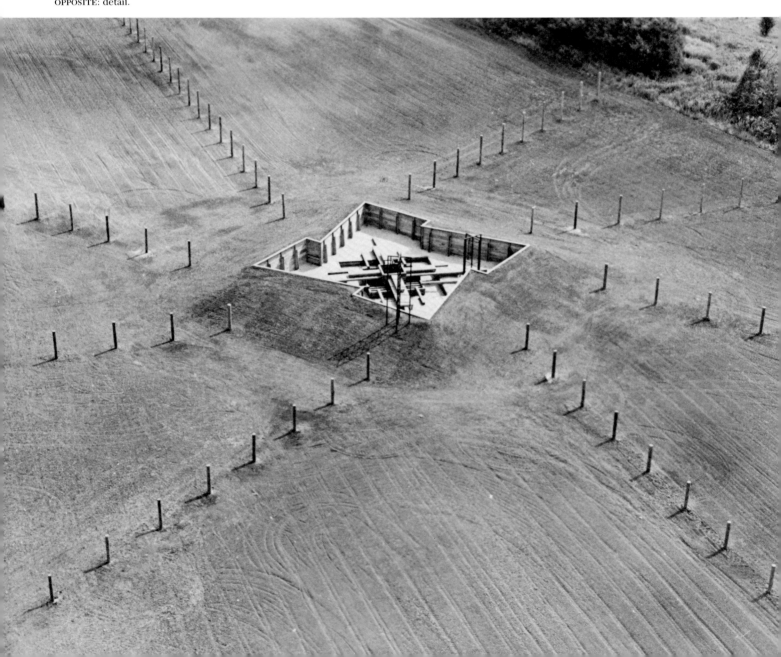

A much larger subterranean space was thus defined under a cantilevered roof of earth and wood. Once on the bottom rung, we saw that the roof projected over two areas, distinct from the open pit itself—a series of orderly vertical members supporting the cantilever and a corridor behind a plain wood wall. And within this wall were cut central openings (doors? windows?) on each side, allowing us to see through or walk into the space behind. Dimly lit, except at the points of aperture, this corridor circled the entire structure. Its back wall had additional slots that connected the walkway space with black, empty voids. We could see into these deepest, rear openings but they were too small for entry.

The pit revealed its complexities as we descended the ladder, stood in the center of the open area, and proceeded to move through its various phases, perhaps cautiously at first. It was a structure filled with fluctuating dualities—dichotomies that were commingled in our perceptions. We have seen these before if we know Miss's earlier works: inside/outside, above/below, light/dark, open/closed, nature/artifice. Other experiences are fluid, ever-changing senses reacting to a vantage point that shifted up and down, cut off now by the edge of the overhang, clearing sightlines to the sky and treetops above, or dimming view in the darkened inner corridor. Space and its plural manifestations thus acted directly upon our visual capabilities.

What Miss provided in the excavated pit was a complex multiplicity of layers—three-dimensional stratifications back and forth, up and down, left and right. Only in the center of the pit was there any sense of stasis or repose. Her quadripartite composition directed us cardinally in any of these directions—out of the pit or toward one of the dark slots cut into the blank wood wall that surrounded us. We were left alone in this central opening to decide on the future course of what we would experience. Should we climb out of the undergound chamber or explore it further, moving toward areas which were even darker, less known, still less accessible? The final effect then was a cerebral condensation as we stood on the focal point of a Mary Miss space and chose how it would in turn affect us. The pit then was the crux of the ensemble, as it heightened our sensitivity to all spaces—given, remembered, created, or natural. Such nuanced variety is surely the antithesis of the preceding generation's Minimalist doctrines.

*Perimeters/Pavilions/Decoys*, so central to our understanding of 1970s sculptural attitudes, remained in place for a year—temporary like so many other works commissioned for the surrogate outdoor gallery spaces that developed in the 1970s (Artpark, Wave Hill, Nassau County, various short-lived support projects, et. al.). There are, however, aspects of this work in several later projects by Miss—the layered visual and processional platforms and gates stepped up a hilly path in a bucolic park environ in Dayton, Ohio, 1979; the viewing stages and screens of her Lake Placid ensemble, created in conjunction with the 1980 Winter Olympics; and pieces that are now permanent: *Field Rotation*, 1981, created for the campus of Governors State University, Illinois, and the *Laumeier Project*, St. Louis, Missouri, finished in 1985.

These two, along with the proposal generated in 1985 for the second phase of Battery Park City in Manhattan, which occupies the same landfill where Miss created her series of wooden walls in 1973, have a multi-elemental, dovetailed nature like the *Perimeters/Pavilions/Decoys* complex, with an even greater set of physical dimensions making use of excavated areas, ramps, connecting paths, and other aspects of her by now established building vocabulary.

In *Field Rotation*, constructed of wood and steel elements, Miss stretches her established formats, meshing her pavilions, towers, and other markers into the expanse of the field itself so that the site is no longer the tabula rasa where her orchestrated events can occur but is, instead, now coterminous with the effects. In this sense, one knowledgable critic was particularly accurate when he described Miss's intention to convince the viewer to accept "her constructed landscape as very plausible and very real."[16] Her overlay of constructed forms onto older building ruins at Laumeier and into the complexity of a functioning urban waterfront at Battery Park only confirm how closely Miss now works with the extant landscape toward a resolution of both site and the built environment.

This ultimate overlay illusion then lies at the heart of all her sculpture, but what finally are these ensembles about? While many passages from the artist's notes trace the course of her designing process or remind us of her myriad interests, there is a singular page in her notebook that, perhaps more than any other, reveals the fundamental significance of her motivations, ideas that were ultimately best expressed in that wooden and earth enclosure on Long Island. She writes of Ameri-

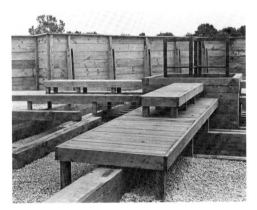

can Indian games played in silence or accompanied by singing and drumming:

> The Indian chance games may be divided into dice games and guessing games—that is, into those in which the hazard depends upon the random fall of certain implements employed like dice, and those in which it depends on the guess or choice of the player; the one is objective, the other subjective.[17]

Miss invariably presents us with situations that are very like the theatrical games she describes. Her scenarios are the pretend stage sets of very real spaces combining randomness of format (her choice) with the open-ended decision making each individual player/actor/viewer is capable of achieving. Hers is a space of praxis, not of theory. She gives us the parameters, the cues, the opportunities that allow us to tap our own memories, to hone our awareness, to re-create our own repertoire of idiosyncratic spaces. When fully developed in size and area, like the Manhattan landfill piece, the Long Island complex or the Illinois construction, such works span the active and passive spheres of human perception, blazing a trail that is both objective and subjective for her audience. That they do so primarily through the dynamics of a spatial dialogue may make them more difficult to perceive since, like Borges's Empire-size maps, they are at once created and natural, each point encapsulating reality and artifice.

Perhaps the closest metaphor in everyday experience to Miss's work would be the garden. She herself talks of many kinds of gardens—occidental and oriental, planned and informal. The equation of her work with a garden path (mentioned above) goes beyond the mere sequential exploration of her works but entails aspects of tailoring the artificial to appear natural and cultivating the natural into intentional configurations. Gardens have layered screens of foliage, plantings, earthworks; they ask us, as do Miss's best works, to use our senses in simultaneous perceptions as we focus on their physical layout to enjoy their more ephemeral offerings—like the smell of a flower or the passing shadows of a cool enclave.

In all her art, Mary Miss focuses on space as a primary physical reality. Hers is not the illusionistic-symbol depth of painting, the primarily metaphoric space of sculpture, or the functional enclosure of architecture. Although her work partially partakes of all these, her space is real before it is anything else: real in that it is experienced directly by our senses as a facet of the spatial continuum existing around each of us; real in that our reading of referential imagery is much less emphatic than our innate comprehension of situations created for us with walls, doors, fences, and ditches. In the artist's own self-reflective words: "When I keep talking about reality—questioning its limits—I guess I'm also saying that I want these works, seeing them, to be a real, absolute, concrete experience—not just mental tracking, storytelling—even though that experience may be a very illusive one."[18] Once these illusive spaces are entered, ambiguities dissolve as her work becomes reshaped in the senses, her intentions conveyed through our own cognition.

*Ronald J. Onorato*

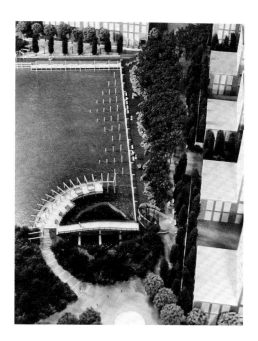

Project for Battery Park City Esplanade III—South Cove, model, 1985, for permanent installation under construction in New York.

*Laumeier Project*, 1985, Laumeier Sculpture Park, St. Louis, Missouri, permanent installation, detail.

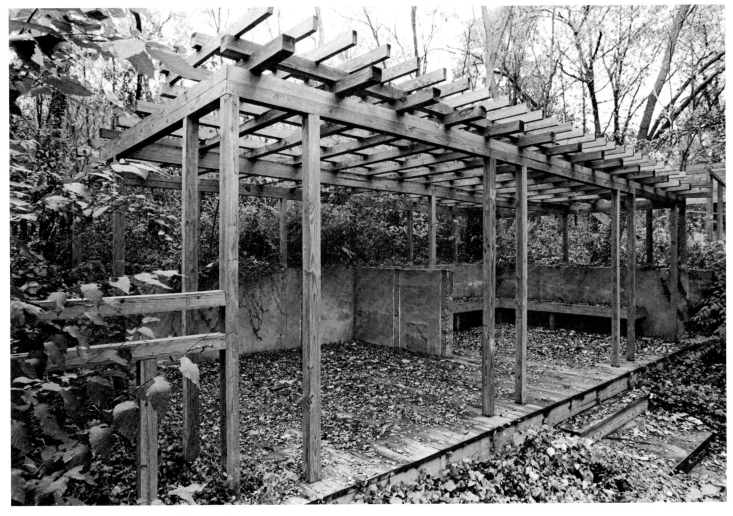

*Laumeier Project*, 1985, Laumeier Sculpture Park,
St. Louis, Missouri, permanent installation, detail.

# George Trakas
## Passion in Public Places

⇕ *(The piece that went through the floor)*, 1970, 112 Greene Street, New York, temporary installation. ABOVE: during installation.

In a German forest early on a spring morning an explosion ripped apart two bridges, unearthing fragments of pottery, shells and other objects relating to the wars and completing a sculpture. *Union Pass*, like many of George Trakas's works, guided the viewer from the clarity of a brightly illuminated, domesticated landscape through the depths of a mysterious wood and into a "secret" clearing. The journey was an archetypal one, from the familiar to the unknown. The experience was one of tension and release as the viewer's passage through a dark, untamed realm culminated at the threshold of the sunlit blast site. There is a common misconception that contemporary site-related sculptures are formal, abstract assemblages conceived for their sites but as removed from their audience as any other non-figurative art. Trakas's work, like site-related sculpture generally, involves the viewer in the landscape in outdoor pieces and with surrounding space in indoor situations. Aligned with rocks, trees, hydroplants, palaces, or other significant topographic elements, the paired bridges or walkways—one wood and one steel—for which Trakas is most widely known, channel mind and movement as they draw the viewer forward and probe the history embedded in a place.

Though awed by the energy that the large and geometrically permuted Minimal works of the sixties imparted to a space, Trakas felt at odds with their stubborn stasis and overwhelming indifference to the spectator's presence.[1] Pristine and austere, Minimal sculptures function autonomously, independent of the viewer, deriving power from an impression of timeless permanence, an aloof anonymity of form and surface, and often, the defiance of gravity. Trakas's body-scaled structures emphatically reveal the artist's hand and are predicated on the viewer's presence, and indeed active participation. That permanence is a wistful illusion is restated in collapsed or dynamited passages of Trakas's works, which underscore the reality that everything changes in time, returned to the earth by gravity and oxygen. Defying stillness and closure, his art involves the discontinuities of life.

While the Minimalists engaged the dictates of a site as a factor in determining the form of their sculptures, in two works of 1970 Trakas took the next step of altering our understanding of a space as he broke through the architectural envelope. ⇆*(The piece that went through the window)* and ⇕ *(The piece that went through the floor)*, constructed at 112 Greene Street, extended physical forms beyond the confines of the room, operating at once within and without. ⇆*(The piece that went through the window)* was inspired as much by painting as by sculpture. Trakas has long admired Titian's *Venus and the Lute Player*, c. 1565–70 (Metropolitan Museum of Art, New York) in which the lute illusionistically projects through the window as a visual bridge across a body of water into the exterior landscape.[2] The tension in Trakas's piece derived from the movement of a rope, contracting in wet weather and expanding in sunlight, much like the strings of a lute. A 64-inch-high sheet of glass and two-legged prow-shaped wooden form inside the room were held upright by the rope that attached them to a stone outside the window. Its compositional and physically counterbalancing force far surpassing its slight mass, the delicate stone invoked for Trakas the prologue of Thomas Wolfe's *Look Homeward, Angel*: "Remembering speechlessly we seek the great forgotten language, the lost lane-end into heaven, a stone, a leaf, an unfound door."[3] The interior structure almost "yearned," the artist felt, to move into the exterior realm to which it pointed. During a torrential rainstorm late one evening the rope swelled and contracted sufficiently in length to pull down the glass and both consummate and terminate the art work.

While this "completion" of ⇆*(The piece that went through the window)* recalls the chance fracturing in transit of Marcel Duchamp's *Large Glass (The Bride Stripped Bare by Her Bachelors, Even)*, more tellingly it also suggests the life led by materials independent of human design. The rope was positioned at pelvic or waist level. Felt as a live force, responsive to humidity in the air, its tension seemed to the viewer to "tug at the gut." For Trakas the body not only nurtures life in its pelvic center, but also here finds physical balance and apprehends space—an outlook supported by his involvement with dance in the late sixties and early seventies and by his readings in phenomenology and mythology.[4] ⇕ *(The piece that went through the floor)* involved a tension of cantilevered materials similar to that of its companion piece, and an even more radical transgression of the normal gallery space as the spectator was confronted with a hole in the floor and an art work that seemingly "of its own will" rose up "rudely" from the basement into the ground story.[5] As indicated by photographs of the artist installing this work, the dimensions of the constituent elements were very much determined by human proportions.

⇆ *(The piece that went through the window)*, 1970, 112 Greene Street, New York, temporary installation.

*Locomotive and Shack*, 1971, Solomon R. Guggenheim Museum, New York, temporary installation for the exhibition *Ten Young Artists: The Theodoron Awards*.

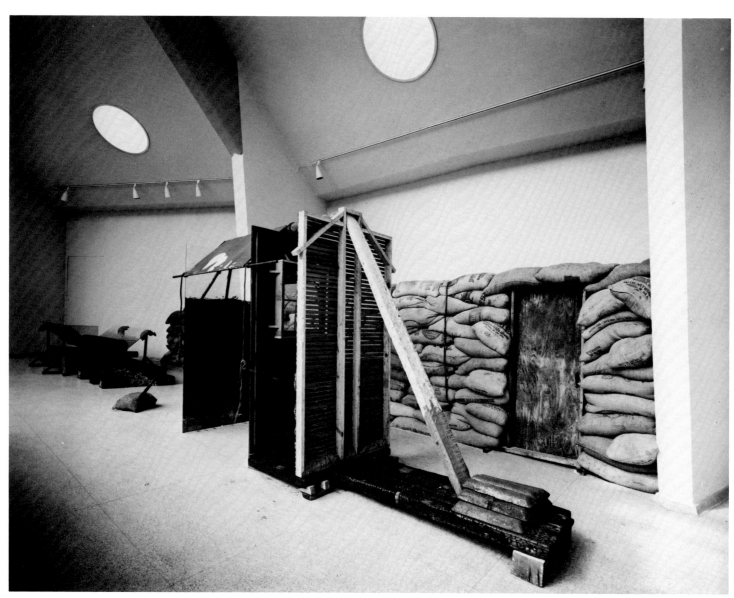

⇆ *(The piece that went through the window)* and ⇕ *(The piece that went through the floor)* included themes with which Trakas has dealt throughout his career. The dualities indicated by the arrows of the titles, which echo the symbolism used in chemistry to express balanced equations and dynamic equilibrium, are paralleled in subsequent works by pairs of bridges or axes; by the relationship of wood and steel, which for Trakas represent the organic above the ground and the inorganic from below; and by the opposition of horizontal and vertical elements. The interest in extending and projecting axes revealed at Greene Street has continued in Trakas's work, which defies customary boundaries, leading the viewer well off the beaten path.

*Locomotive and Shack*, composed of two formally discrete but conceptually linked constructions installed at the Guggenheim Museum in 1971, was related pointedly to its site on the curved ramp. A single, ¾-inch Manila rope restrained *Locomotive* from rolling down the incline and crashing into *Shack*. The confrontation of the two elements established yet another set of dualities which Trakas has plumbed in subsequent work: *Locomotive* introduced the extended track, movement, passage, and adventure; *Shack* the prototypical shelter, home or enclosed space, with its implications of stasis and security. Its paired forms are an intuitive embodiment of the masculine and feminine archetypes described by Jung in the essay "Mind and Earth:" the maternal qualities of "warmth, protection, and nourishment" are linked with "the hearth, the sheltering cave or hut, and the surrounding vegetation" while the father "goes about..., travels, makes war..., and at the behest of invisible thoughts... suddenly changes the whole situation like a tempest. He is... the cause of all changes...."[6] *Locomotive and Shack* seemed to the artist quintessentially American; the railroad, which has both penetrated and violated the frontier, was at the heart of the "American dream." The expectancy evoked by the train had for Trakas been conveyed compellingly in another novel by Wolfe, *Of Time and the River*, which opens on the platform of a railway station, charged with the "thrill and menace of the coming train" which will carry the novel's protagonist from a provincial town in the hills of western Catawba to New York and Harvard.[7]

Dovetailing with his reflections on America, the imagery of Trakas's childhood along the Saint Lawrence River in a rural area of Canada replete with mills and mines fed into the themes of axial motion and enclosure. Extracted from the earth, raw materials were shipped away by train or used in local building. With its crushed rock bed, wooden ties and steel rails, a train track was at once a product of and vehicle for stone, lumber, and iron ore. Propelled horizontally across the land by coal and oil drawn vertically from deep within the earth, the train—the life line, an artery of transport, a means of escape—was a romantic image that found its way into the abstract forms and titles of such works as *Union Station*, 1975, *Transit Junction*, 1976, *Union Pass*, 1977, and *Locomotive and Shack*.

The train as literal vehicle of escape had figured unforgettably for Trakas in the closing sequence of Robert Bresson's film *A Man Condemned to Death Escapes*, in which the protagonist Fontaine completes his flight to freedom by jumping from a bridge onto the roof of a passing train. Both figure and train disappear in the engine's cloud of smoke, as we hear the sound of the train fading into the distance. Probably more important than the appeal of this imagery for Trakas was the projection of the film's action into the audience's space. For the train is moving toward us as Fontaine waits, and must surely recede behind us, moving beyond the theater walls rather than into the screen's illusionistic space.[8] Implicitly a medium of duration, film encouraged Trakas's own commitment to engaging time, as well as actual movement through space, in his work.

As in the Greene Street pieces, the proportions of the Guggenheim Museum work were deliberately scaled to the human figure. The glass panel at the entrance of *Shack* was mirror-coated up to neck level so that the viewer outside the structure was confronted with a reflection of his or her own body with a head belonging to the viewer inside. The insinuation of the viewer into Trakas's imagery signalled a crucial departure from previous sculpture. We move through his work as much as around it, measuring ourselves physically in terms of height, width and stride, and psychologically in terms of the associations drawn up. Trakas observes that "the very simple physical world, depending on how you construct and sense it, can draw from our perceptions associative well-springs of our pasts more powerfully than any literary or symbolic mode of communication,"[9] a view that aligns with Vincent Scully's belief that "the major vehicle of meaning... is physical experience."[10]

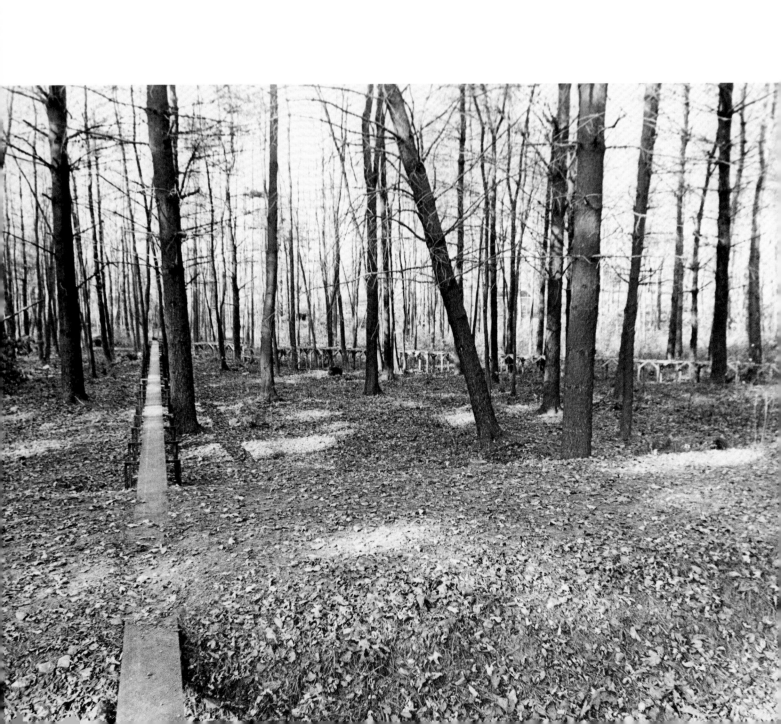

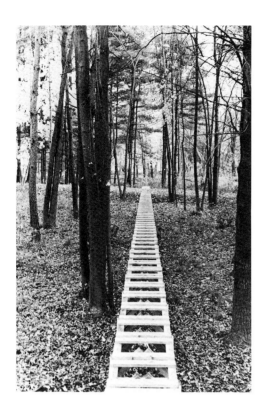

Trakas's first major outdoor work was built in 1975 for *Projects in Nature*, a temporary group exhibition at Merriewold West in Far Hills, New Jersey. As the title suggests, *Union Station* extended the locomotive implications of the Guggenheim piece. Two raised bridges departed from an elevated road and converged in a sapling forest. While the bridges initially functioned like the painterly devices that lead the viewer's eye from foreground to background,[11] the work was navigable. The regular spacing of the wood bridge's paired treads and the eleven-inch gaps between them recalled the structure of railroad bridges and guided the pedestrian's pace. The twenty-two-inch stride here established was measured from natural movement and related to the distance between our shoulders. The continuous channel of the steel bridge—its ten-inch width in part extrapolated from the breadth of feet and pelvic dimensions[12]—was sufficiently narrow to engender caution as one foot was deliberately placed in front of the other. While the wood bridge instilled a consciousness of the length of stride, in navigating the steel bridge the pedestrian's sense of left-right motion was sharpened, some viewers instinctively enlisting their arms for balance. Walking through *Union Station*, the viewer constantly shifted focus, contemplating the forest and the bridges converging while paying careful attention to the structure underfoot. A visual concentration on construction details was complemented by a sense of the portentous ties between sculpture and landscape. Trakas's materials willfully lineate to their natural origins. Leading past the saplings, the vertical posts of *Union Station*'s wood bridge retained bark on their edges. Left unpainted, the steel bridge, which passed over an area of red clay and red shale, rusted, intimating the bridge's link to the earth—the artist's palette of clay, shale, and rusted steel all product of the oxidation of iron. But "this is not necessary to *know* literally, the relationship of the colors creates the known with much more magic than words can tell."[13]

Just as wood and steel were linked with the site of *Union Station*, so the work's triangular plan related to the grid arrangement of the trees, taking as its base a stretch of Merriewold West's rectilinear entry road. As the bridges approached each other, viewers discovered a small pool some twenty feet in diameter. The broken final stretches of the bridges were, like the pond itself, formed by the detonation of dynamite at the right angle intersection of the paths. Trakas reflected at the time that "to manifest the contrast in materiality of the two bridges and to reveal more explicitly the elements and substructure of the soil, the blast functions as a catalytic inclusion."[14] In incorporating water as a central element, Trakas here as in many other works invokes its essential life-nurturing role. As in folk tales and mythology, the woods of *Union Station* and subsequent pieces are charged with a feeling of elemental power.

Trakas enlists not only the physical characteristics but also the history of his sites. The Far Hills site, chosen for its psychological atmosphere more than for its physical details, was a reforested area that had been planted to reclaim a marsh. The blast, in revealing the proximity of the water table as the pit that it produced quickly became a pool, indicated the recent natural history of the place, and reflected the artist's awareness of the relatively temporal nature of any art work and the ongoing history of any site.

The two bridges of *Union Pass*, constructed in 1977 for *Documenta 6* in Kassel, functioned on one level as time lines leading from the Baroque garden into the forest. While the steel bridge was on axis with the central door of the Orangerie and was a link to the Baroque era, the wood one was parallel to this leisure palace built by Kaiser Wilhelm and was meant to signify the present. Far from the orderly gardens whose 200-year-old design expressed power over nature and by implication over man, the collapsed bridges, dynamited at their juncture, symbolized for Trakas the night in April 1945 when the town was extensively bombed by Allied planes. In excavating the footings for his piece, Trakas regularly uncovered shards related to the site's previous history, including shrapnel dating from the Second World War. The common use of blasting in construction "to tap into bedrock, eliminate roots, or to access through an obstruction" was here transformed into metaphor as the explosion in the earth sought to break through the impasse of this memory.[15] While art critics had trouble dealing with the blast on a formal level, older residents of Kassel understood its relationship to their recent and distant past as an essential element of the work's meaning. One of Trakas's vivid school memories is of a remarkable chemistry teacher roving through the classroom of transfixed students carrying a container of nitroglycerine, explaining that were it dropped, the whole school would explode,[16] and indelibly impressing on Trakas's imagination the ultimately fragile structure and fleeting existence of all phenomena.

*Union Pass*, 1977, Kassel, Germany, temporary installation for the exhibition *Documenta 6*, detail of bridges before the blast.

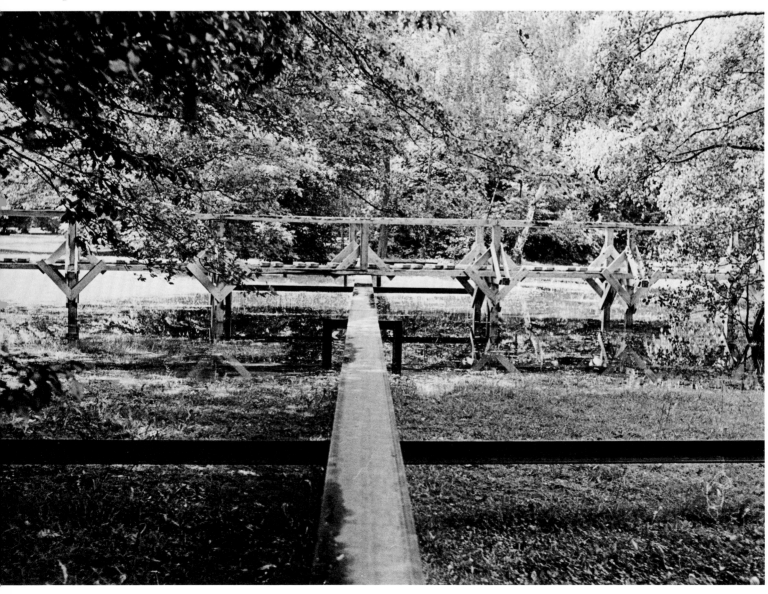

Detail of bridges after the blast.

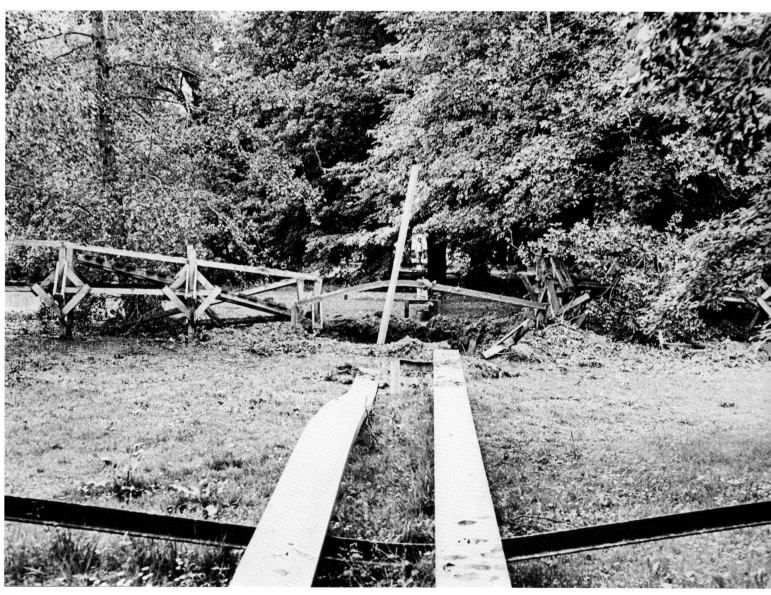

*Union Pass*, like *Union Station*, led away from the relatively public settings shared by other artists included in the *Projects and Nature* and *Documenta 6* exhibitions. It was Trakas's intention that these works be encountered more privately, within a context of real rather than aesthetic experience. Two years after *Union Pass*, Trakas built at Emory University a bipartite work that functioned both in the bustling realm of the Atlanta campus's quadrangle and in a ravine next to it. Set on an open lawn, *The Quad Piece* evoked the processional ceremonies that punctuate university life in its three component elements—"Bridge," "Arch," and "Passage." In counterpoint to a flagpole in the center of the quadrangle, their axes guided the viewer toward a pine tree that long predates many of the buildings around it. *The Gulch Piece* (which has since been made permanent and retitled *Route Source*) leads downhill via a pair of bridges toward its heart, a large rhododendron on the edge of the stream running through the tree-canopied ravine. Here, where the stream broadens into a beach, steps descend to the bedrock bared by the stream. The exposure of geological history is paralleled by evidence of human efforts to glean nature's energy. As Catherine Howett has beautifully recounted:

> The remains of an old brick wall and some curious piping near the "station" survive from the time when an Emory professor tried to harness the stream for electricity to light the campus. The ruined wall in the stream reminded George Trakas of the wall behind the figures in Giorgione's *Tempest* supporting a broken antique column....Telephone wires, the wall, the incredible story of "the light that failed"..., the memory of a painting full of "meanings"—these layers of human making lead down and back to the simpler place where the water has washed away layers of soil and rock.[17]

*Route Source*, like ⇆(*The piece that went through the window*), *Union Station* and *Union Pass*, deals with life's continuum of change. Made alert by the adventure on which they had embarked, viewers mused as they walked the paths at Atlanta, Far Hills, and Kassel. The height of platforms, width of staircases, spacing of the planks of bridges, and spring and sounds of metal or wooden walkways to some extent "choreograph" the viewer's progression through the works, the subtle unfamiliarity of motion engaging the imagination. Trakas has orchestrated not only the tenor of movement, but also has set the scene for the interaction of viewers in works from the late seventies onward. The platforms of *Log Mass: Mass Curve*, 1980, the decks of *Berth Haven*, 1983, and the "*piazzatina*" of *Via de l'Amore*, 1982, become meeting places—tiny town squares or private porches to which the bridges, walkways, and stairs lead. In *Rock River Union*, 1976, *Via de l'Amore*, and to some extent in *Isle of View*, 1981–85, figures passing in opposite directions on the paths would naturally touch.

Passersby on the walkways of *Rock River Union*, built at Artpark in Lewiston, New York, had either to help each other or momentarily step away from the structure. Visually reiterating the swift movement of the Niagara River and cascading of the falls, the sloping steel bridge and wood and concrete "cascade" staircase led the viewer on a cautious but exhilarating descent to the river at the bottom of the gorge. The site chosen by Trakas allowed him to focus explicitly on the geological past. The inclusion of pylons, cables, power plants, and bridges in the breathtaking natural vistas surrounding Niagara Falls and visible from *Rock River Union* is hardly fortuitous. Writ in the stone, past which the viewer was slowly and ceremoniously guided, is the story of the falls' genesis, a story that foreshadows the industrial development that has grown around it.

Trakas touched on the intersections of human and natural history in *Route Point*, 1977, installed at the Walker Art Center the next year. Steel and wood bridges led toward the stump of an old, recently felled elm tree, while a skeletal steel house structure was built on the corner foundations, excavated by Trakas, of a 1904 armory that had been leveled in 1934. The archetypal shelter here suggested assumes primordial form in a number of drawings made since 1972 for *Baie d'Eternité* (Plates 13, 14), conceived for the rough headland cliffs along the Saguenay River, a tributary of the Saint Lawrence, territory of the artist's youth. Still in process, the work will create an interior space by blasting into the base of the cliff at water's edge. This cave-like place, with its "conscious sense of being within material and being surrounded by it" recalls the dwelling of Bellini's *Saint Francis* (in the Frick Collection, New York), a painting that has for years entranced Trakas.[18] The enclosed space will open onto a stone pier, surmounted by a schematic roof shape, and from there into "a shape that resembles the hull of a boat in dry-dock (a reversed roof)"[19]—mirror images denoting primal forms of shelter and passage.

*Rock River Union*, 1976, Artpark, Lewiston, New York, temporary installation, detail.

92

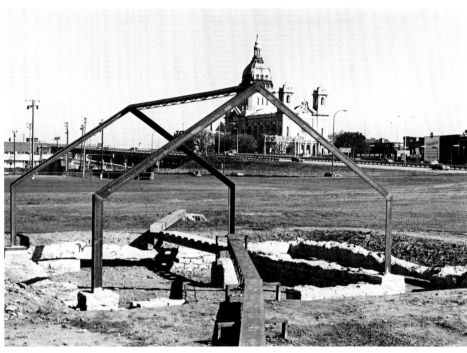

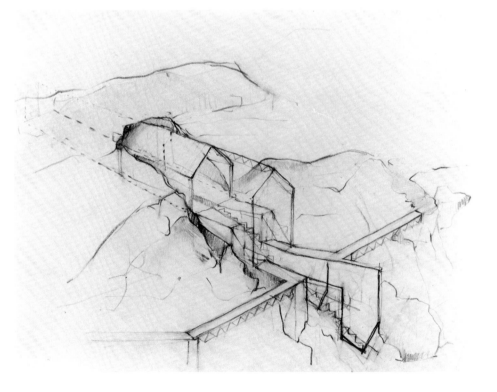

ABOVE: Site of *Baie d'Eternité*, under construction in the cliffs along the Saguenay River, Quebec. Giovanni Bellini, *Saint Francis in Ecstasy*, c. 1485, Copyright The Frick Collection, New York.

RIGHT: *Route Point*, 1977, Walker Art Center, Minneapolis, Minnesota, temporary installation for the exhibition *Scale and Environment: 10 Sculptors*, detail. *Study for Cap Trinité, Baie d'Eternité, Québec*, 1978, pencil on paper, 9 x 12 inches, Private collection.

The linking of interior and exterior space, first stated in ⇆ (*The piece that went through the window*), attains mystery in *Baie d'Eternité*, and underlies the composition of *Log Mass: Mass Curve*, a temporary installation of 1980 at the University of Massachusetts, Amherst. For an artist who has worked so successfully in the landscape, the University Gallery was particularly challenging. An artificially lit, underground space with concrete walls and ceiling, its most salient feature is the group of four cylindrical, concrete columns, each two feet in diameter, that support the ceiling. Trakas's achievement in *Log Mass: Mass Curve* was to humanize this obdurate space by, in Delilah-like fashion, coaxing the columns into collaboration rather than wrestling with them in a futile, Samson-like struggle. Regarding the columns as symbolic of their structural origin as tree trunks, Trakas introduced fourteen more, actual tree trunks, joining the gallery poetically with outdoor space. A floorbound curve of steel that took as its center point a tree on the island in the pond just beyond the gallery entrance conceptually tied the cavernous interior to the landscape and subsequent site of *Isle of View*.

Perhaps in response to the three adjacent spaces that housed *Log Mass: Mass Curve*, Trakas departed from his usual dualistic approach. While the materials were limited to wood and steel, he established a dialogue of three platforms, three staircases, three trusses, and three arches. The main, west, and lower galleries presented dramatically different moods. The main gallery was a park-like public arena, its variety of levels and clustering of columns subtly shaping the viewer's promenade into a classical figurative composition akin to Cézanne. Adjacent to the university's Rand Theater, the west gallery assumed the more traditional configuration of a proscenium theater. As in a Claudian composition of spatial compression and release, two freestanding concrete walls concealed off-stage wings—protected enclosures flanking a narrow connecting bridge that read as a stage. On the near side of these concrete baffles, a hidden, dimly lit space to the right and a solitary standing log to the left created a feeling of secretive intimacy. In the lower gallery, Trakas built drawing tables and used end-cuts from the logs for stools, creating a more casual private area in which, it seemed, the work as a whole might have been germinated. Partially below ground level, this narrow, low-ceilinged space functioned as a retreat, evoking the study of Saint Jerome of so many Renaissance paintings or the cave of Bellini's *Saint Francis*.

Rather than emphasizing the history of the site, *Log Mass: Mass Curve*'s imagery of transformation elucidated the growth and progression of wood from the forest through the saw mill to its dressed state as construction lumber. The first log confronted at the entrance to the gallery, at fourteen feet, was the tallest. Freestanding, it retained all its bark and continued to bleed sap. As the work unfolded, logs were progressively more refined, the residue of the milling process piled in the lower room. Populating the space like totemic personages, the logs possessed a raw force in comparison with the hewn boards. In all platform surfaces and walls, Trakas carefully reconstituted the order of planks sliced from each log. The pattern of knots and grain became a narrative device, like the strata of *Rock River Union* recording change over time.

*Isle of View*, a permanent commission completed in 1985, surrounds the tree that had served as a fulcrum for *Log Mass: Mass Curve*'s inclusion of landscape, the relationship of the two works abundantly clear in a drawing of 1982, *Mass Aftermath Isle of View* involved the reclamation of a paradoxical site, at the center of the campus but entirely neglected. Completed in 1974, the monumental Fine Arts Center that houses the gallery encloses the south end of the campus pond on three sides with a concrete embankment walkway. By raising the water level, construction of the complex created and stranded an island. While an island *per se* is an attractive landscape feature, this one was inaccessible, its vegetation was unkempt, and its location and narrow elliptical shape were restricting water flow and causing pungent stagnation.

Trakas expedited the awkward transition from architecture to landscape by redesigning the area both ecologically and visually. The island was reduced in size, its new perimeter shored up with a reinforcing wall framed in steel and faced with hardwood boards. This graceful bulwark promotes water flow, its subtle organic curve a sculptural counterpoint to the severe rectilinear geometry of the building. Vegetation compatible with the moist soil conditions has been planted, trees have been pruned, and grass reseeded. A forty-foot stepped steel bridge, arching subtly, and twenty-eight-foot granite slab bridge allow visitors to walk to the island. While the constructed south side of the island acknowledges the surrounding architecture, the north side remains natural as it meets the pond, this juncture of land and water

*Log Mass: Mass Curve*, 1980, University Gallery, University of Massachusetts, Amherst, temporary installation.

*Mass Aftermath*, 1982, pencil and charcoal on paper, 42¼ x 84⅝ inches, Collection University Gallery, University of Massachusetts, Amherst.

*Isle of View*, 1981–85, University Gallery, Univer-
sity of Massachusetts, Amherst, permanent
installation.

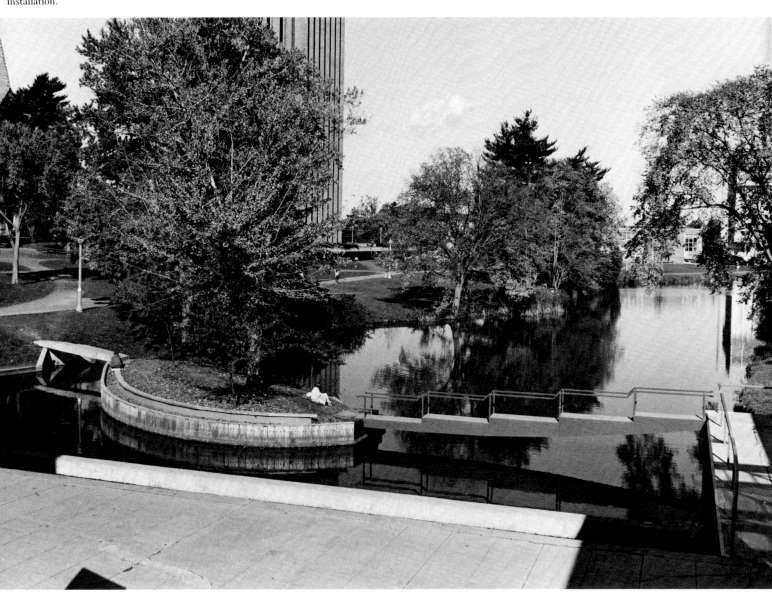

defined by a curving slab of granite sliced from the stone that serves as the western bridge. Along the northeastern shore of the island three two-foot-wide steel steps descend into the water, echoing the concrete steps that lead from the building toward the water but conclude anticlimactically in a three-foot-high concrete wall. The title *Isle of View* stems from the playful courtship vocabulary of Trakas's childhood, when boys invited girls on outings to islands in the river.[20] Its punning allusion to love perhaps also bespeaks the artist's admiration for Marcel Duchamp's *Notes for the Large Glass* and *Etant donnés*. Duchamp's images of love, and titles, are nonetheless decidedly more ironic than Trakas's. In Amherst, Trakas has cajoled from a site in disarray a place of idyll invoking the amorous daydream world of Watteau's *Departure from the Island of Cythera*, 1717. But the pastoral mood is subject to the bustling rhythms of campus life, and *Isle of View* becomes a thoroughfare between classes.

The suggestion of romantic encounters figures in Trakas's work of the past four years as walkways meander side by side in *Via de l'Amore*, a permanent work built in 1982 in Pistoia, Italy, and allow passage to the reverie of *Isle of View*. The emblematic structure and sharp dualities of Trakas's earlier outdoor works have developed to include the more complex compositions and evocations that have characterized his indoor work from the outset. In comparison with the emotional resonance and formal richness of *Via de l'Amore*, the bridges of *Union Station* seven years earlier appear almost headstrong, thrusting through the sapling forest. The rhythmic motion of the viewer's walk through *Union Station* evolves into the variety and even courtly grace of the visitor's movement through *Via de l'Amore*, set in Tuscany with its centuries of lush human history.

Two narrow staircases are the only signals to the traveller on the circuitous unpaved road leading through the Villa Celli that there is something more in the wooded ravine beyond view. But descending either the wood or steel staircase, the viewer begins to discover the scope of *Via de l'Amore* which eventually runs more than 300 feet down the valley. So discrete as to go almost unnoticed, the steps nonetheless establish the major themes and dualities of the piece, which are elaborated as *Via de l'Amore* develops symphonic complexity and culminates sonorously in an explosive image of regeneration. Paralleling the narrative potential of music, the essentially abstract forms of *Via de l'Amore* become at once a stage and a metaphor for a story of love.

*Via de l'Amore* is located on an estate whose architectural layers date back as far as the Middle Ages. The landscape, designed in the eighteenth century, incorporates picturesque ruins and follies, its gardens, meadows, and woods planted and pruned to suggest the wildness, and ultimately overpowering force of nature. The wood and steel steps set off some 100 feet apart, bracketing a rustic fountain across the road. The quietly bubbling fountain, created to accommodate the road, feeds underground into a stream flowing down the hill. From this relatively sedate starting point, the steel, and in the artist's thinking, "masculine" walkway rampages impetuously down the stream bed, while the "feminine,"[21] wood path delicately and more judiciously picks its way along the slope, at one point narrowing so that a dainty cross-step is required to navigate stairs made of clay. Composed of bridges, platforms and steps, the paired paths, conceived as virtually personified protagonists, approach each other, united finally in a steel and wood bridge. This leads to a *"piazzatina,"* a two-meter square floor plane of wood pierced vertically by a steel cylinder. From this place of meeting and of pause, the imaginary "lovers"—Tristan and Isolde, Orpheus and Eurydice, or Romeo and Juliet perhaps, as they are viewed by the artist[22]—continue side by side along and barely above the stream that rushes mellifluously ahead.

Past the diminutive "town square" the paths separate, descending toward a dam surrounded by a six-foot-high, woven steel seine. This net was linked with Trakas's memories of fisheries built of branches and twigs on the exposed tidal flats of coves. It is undoubtedly significant that this image of enclosure was made not by the artist himself, like virtually every other detail of all of his works, but by several female assistants. At this point of intersection a charge of dynamite bent back the sides of the net, intermingling steel, wood, clay, earth, and water. Toppled by the blast, a board rests in the pool created by the dam, echoing a fallen tree allowed to remain next to the fountain above. In explaining the necessity of dynamite to his Italian hosts, Trakas pointed to its role as "priming or getting the heart to pump."[23] This passage of *Via de l'Amore* seems not so much an image of devastation as of primordial creation, calling to mind Gaea, fertile goddess of the earth, and invoking ancient mythology. In cosmology since prehistory the "female powers dwell not

only in ponds, springs, streams and swamps, but also in the earth, in mountains, hills, cliffs. . . . And above all, the mixture of the elements water and earth is primordially feminine; it is the swamp, . . . in whose uroboric nature the water may equally be experienced as male and engendering and as female and lifegiving."[24] Beyond the dam, an old stone aqueduct completes a kind of thematic symmetry as it passes across the water.

Entering the forests of Kassel and Far Hills, and following along streams flowing down into tree-covered ravines in Atlanta and Pistoia, the viewer is guided into a space like Yeats's "half-light"[25] where familiar distinctions of night and day seem no more discernible than the edge between inside and outside in ⇆(*The piece that went through the window*). Rational thought is here overtaken by the forces beyond comprehension that envelop the viewer. "To go from a very clear area into a rough, wild area will mean your thinking will change from more orderly to more stream-of-consciousness. You enter an uncharted, almost a sleep realm."[26]

Embracing the gently lapping waves of Lake Washington, *Berth Haven*, completed the summer after *Via de l'Amore*, invokes the natural rhythms that guide the oceans as well as our cycles of creation and birth. Built for the National Oceanic and Atmospheric Administration in Seattle, the soft curves of *Berth Haven*'s platforms, surrounded by downy foliage, provide a place for contemplation and a foil from which to swim or boat. Its forms, like its title, call to mind those safe harbors where ships anchor in almost womb-like protection, and for the artist the piece has a "sense of spirit in the Northwest Indian cultural sense of respect for the power of the source: water and in this latter context 'Berth Haven' implies birthing place of original human spirit and vision."[27] The placid harmonies and hospitable grace of *Berth Haven* (Plate 15) contrast with the rough shelter of a temporary summer project built in 1970 in Mountainville, Maine. The site of *Crotch Dock* was a small inlet carved into the coastline by the artist and defined by retaining walls of unhewn sticks and rocks. This landing was approached from the water as a boat made by Trakas glided into the pine tree at its apex. Its composition of a vertical tree flanked by earthen horizontal forms anticipated the central passage of steel plates and pipe of *Berth Haven*. A shelter cut into the land where it meets water, *Crotch Dock* pointed the way for *Baie d'Eternité*.

ABOVE: *Crotch Dock*, 1970, Mountainville, Maine, temporary installation.

OPPOSITE AND RIGHT: *Berth Haven*, 1983, National Oceanic and Atmospheric Administration (NOAA), Seattle, Washington, permanent installation.

The shaded, interior landscapes through which streams flow in *Gulch* and *Via de l'Amore* might be linked with the setting in Thiers, France of *Le Pont d'Epée* (Plate 16), a permanent work still under construction. The local epithet for its site, at the falls of a river raging through a valley so deep that sunlight never eludes its shadow, is *"Le Creux d'Enfer"* ("The Pit of Hell"). Driven by energy captured from the river, hammers and grinding stones pounded infernally in two knife factories built here on rock outcrops in the nineteenth century and since abandoned. Furnaces blazed, fueled by bellows that drew their breath from the furor of the water. *Le Pont d'Epée*'s paths and bridges lead along and over the river, in a space that seems not to belong fully either to nature or man. They culminate in a terrace at the edge of the falls from which departs a "sword-bridge"—a steel truss structure encased in polished stainless steel. The sides of the bridge, which is diamond-shaped in section, its top open, are chest-high, protecting the viewer from the treacherous waters which for Trakas recalled an Arthurian story recounted in Heinrich Zimmer's *The King and the Corpse*. In their quest to rescue Guinevere from the kingdom of death, Lancelot and Gawain must cross into the netherworld either by a bridge under water, or worse yet, by a perilous sword-bridge: "...the water cascading beneath...a 'wicked-looking stream, as swift and raging, as black and turgid, as fierce and terrible as if it were the devil's stream'...."[28]

Unlike *Le Creux d'Enfer* with its curtailed vistas, the Eden-like setting of *Pacific Union*, a permanent work of 1986, opens onto the Pacific Ocean. Two staircases leading from the sidewalk up to the site, on an elevated triangular lot at the southwest corner of the La Jolla Museum of Contemporary Art grounds, were excavated by the artist and date from around 1916. Demarking two of the work's corners, the steps had long since been buried and the site accordingly inaccessible, just as the house to which they once led, designed by Irving Gill for Ellen Browning Scripps, has been embedded in the overlays of successive renovations of the museum. A path setting off from the third corner breaks through a wall, as do the other axes, in order to permit entrance to the site. Like nearly all of Trakas's works, *Pacific Union* involves the relationship of interior and exterior spaces. Slabs of granite, their curving contours wave-like, at once are a place to relax by the ocean, and roof the more sheltered spaces beneath them, each one reached like a landing or station as the viewer ascends or descends one of the paths. Trakas has included many plantings—from tall palm trees to fragrant daphnes and lilacs. Bounded on its street sides by retaining walls made more than half a century ago from stones gathered at a nearby beach, *Pacific Union* overlooks the rolling surf that fashioned their rounded forms.

From *Union Station* and *Rock River Union* to *Via de l'Amore*, *Le Pont d'Epée* and *Pacific Union*, the fearsome or pastoral beauty of nature is inflected with a sense of time's passage and life's cycles. Just as the strata of rock record time beyond human existence, and the lapping of waves speaks of rhythms of celestial design, so a mulchy pond invokes the processes of destruction and regeneration that underlie the earth's fecundity. Dualities of organic and inorganic, present and past, masculine and feminine, tap into our psyches. In a period that has nurtured the genre of artistic accommodation, as sculptors and painters turn to the design of seating areas, signage and sculptural logos, Trakas aspires to "passion in public places."[29] While he has often refurbished beleaguered sites and intends that the viewer sit on the decks, cross the bridges, and walk the paths that draw on a structural vocabulary of docks, overpasses, railroads and roofs, his works operate mythically as well as practically. Transcending specificity of allusion, they become metaphors of movement and of shelter, images of the temporal and material flux through which we daily promenade.

*Hugh M. Davies and Sally Yard*

■

*Le Pont d'Epée (Le Creux d'Enfer)*, 1985–86, Thiers, France, permanent installation under construction.

*The Sword Bridge*, from a French manuscript of the twelfth century, reproduced in Heinrich Zimmer's *The King and the Corpse*, 1948.

George Trakas, *Isle of View*, 1981–85, University
Gallery, University of Massachusetts, Amherst,
permanent installation.

Mary Miss, *Field Rotation*, 1981, Governors State
University, Park Forest South, Illinois, permanent
installation, detail.

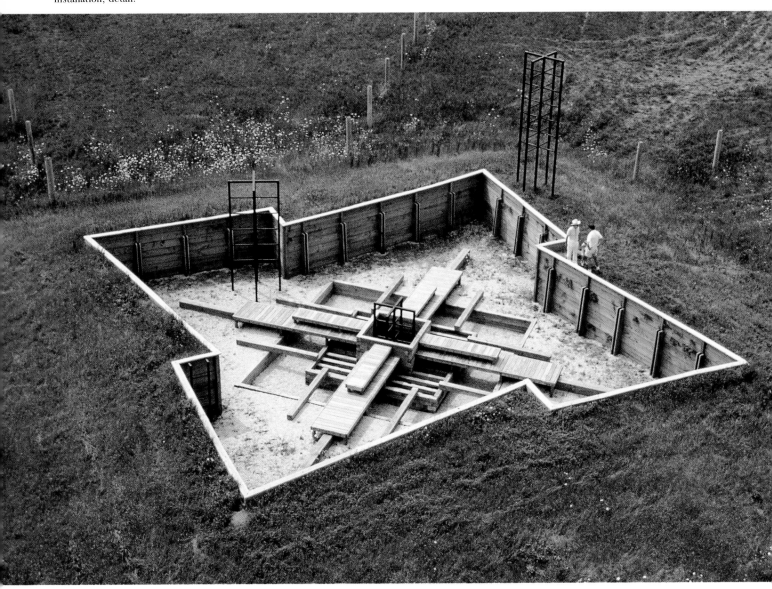

Alice Aycock, *The Glass Bead Game: Circling 'Round the Ka'ba*, 1985, pencil, pastel, and watercolor on paper, 57½ x 83 inches, Private collection, New York.

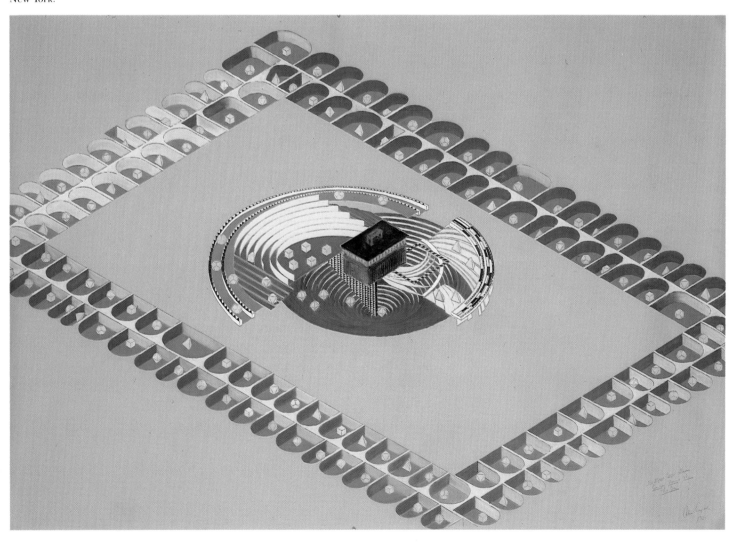

OVERLEAF: Richard Fleischner, *MIT Project*, 1980–85, Massachusetts Institute of Technology, Cambridge, permanent installation, detail.

## On Drawings

**HD**   Are your drawings always related to the projects you're working on?

**RF**   It depends on the drawings. Some are a means to an end and others are an end in themselves. Some are after-the-fact representations of projects.

**GT**   I'm sure we all don't only do blueprint type drawings. I have been playing with size within the spatial format of the sheet. Some have themes: one set of four deals with a kind of pulsing space and has to do with the way I draw; others are more like routes through my pieces, almost a kind of narrative. I keep a lot of them for myself.

**RO**   How about you, Alice, and the way you use isometrics? Does that originate in a formal school training?

**AA**   Partly, but I think what happened was I really didn't know how to draw and so I taught myself isometrics in order to see pieces ahead of time, to see what they were *going* to look like. I just bought myself a book and taught myself the whole thing. It was like magic when they came out on paper because it would be there for me to see. It was especially important to me in the beginning of my career when I couldn't build the pieces. My three-dimensional thinking would merge with the two dimensions of the drawing and I felt I had it, it made it real. It also allowed me to figure out many of the specific problems with constructing the piece ahead of time. I bought all those Audel manuals of carpentry and then drew what I wanted to happen. Now, I consider it a way of organizing, defining different ways of seeing the world. Almost like philosophical drawings.

# Round Table Discussions

On Saturday and Sunday, October 27 and 28, 1984, Alice Aycock, Richard Fleischner, Mary Miss, George Trakas, Hugh Davies, and Ronald Onorato met for two days of round table discussions in New York City. Starting at Aycock's loft, throughout dinner on Saturday night and continuing the next morning at Trakas's studio, more than six hours of discourse — part professional, part personal — was taped. Distilled from these dialogues, the following texts center on the drawn and built works the four have created over the past twenty years and the contexts — conceptual and physical — within which they have all worked.

**GT**   In many ways our drawing can be read as a history of ideas.

**MM**   Drawings are for me more of a means to an end. It's like when you are digging a hole, you get all this dirt at the side. That's the kind of relation I see between my construction works and my drawings.

**HD**   So the act of drawing is a by-product of the project?

**MM**   That's true, but the first drawing I ever did of anything was a drawing of the elements for Nassau County.

**RO**   Really? What about all your earlier projects and your notebooks?

**MM**   I would do little thumbnail sketches with notes for detailed joints and construction specifications, but for something like the circular sunken pool in Greenwich, Connecticut—I could never draw that ahead of time. That was a pretty hard thing to build without a drawing, but I tried to work things out mathematically. I had lots of little pieces of paper with notes, formulas and dimensions, but at that stage, I couldn't do any drawings. At Nassau County, they wanted to see what I was thinking of doing ahead of time, so I did some real quick drawings. And since then, I've used them. Like Alice, it was a case of teaching myself how to draw. My drawings were quirky because I'd never even looked at a book about how to do an axonometric or isometric. I just draw what I need in order to see and invent, which may be like reinventing the wheel. But if I needed to build an ellipse I would first figure out how to draw one and then I would discover that you could buy all these ellipse forms ready-made! Then I would construct the thing.

**RF**   It's funny because what Alice said about her initial drawings, how they functioned for her, is what I used to do on site. In other words, the most drawing I ever did was with stakes and string out in a space. The ground plane was the piece of paper—that's how I did the Sudan grass pieces. It was all determined by stringing and moving the lines closer or farther apart. The drawings I now do are not illustrations of ideas that I'm working with on another scale. When they are that, for presentation purposes, I don't actually execute them. For example, MIT required literally dozens of contract documents; for that kind of specific drafting, Lane Myer, my assistant, or another draftsman, will draw them. I couldn't do it because I haven't the skill.

**HD**   I know there are lots of blueprints in your studio. Are some of these made after the pieces are built?

Alice Aycock

George Trakas

**RF**  Many are. For the Newport *Sod Maze* the blueprint was drawn after the piece existed, and then it became a record of the permanent site work through its measurements. That's why it always came out to a peculiar dimension, 13¾ inches or whatever, because it was a matter of sensing it physically on the ground, at the site, and then drawing it later.

**MM**  A number of years ago, I started to assemble all those pieces of paper that I had been drawing on and layered them together to create a kind of collage with the drawings and photos of the finished work. I do this to merge all these spare parts into a sense of the layers of ideas—my thinking about the piece—since there are innumerable sources coming into any one piece.

**RO**  Is it like a compendium of ideas that you return to for your own reference?

**MM**  When I start a piece I begin generating a stack of small sketches and notes. Then I sort out which ones I will end up using. It's more like trying to bring back the process I go through for the viewer, not so much a record for me.

**AA**  The drawing is all that one really has—what exists is the thought on paper. Even the photographs of a piece aren't really anything. Maybe this is so because I got so involved in art history and the reconstruction of ideas from fragments. So in some ways I am almost hysterical about the drawings, terrified that they're going to get destroyed because, I think, that's all I really have. Also, because I am always trying to make something that doesn't have a real, definable shape, I see drawing as a schemata for organization, almost the way a painting invents its own organization. It's something I can never do, but I think about it all the time, so I spend a lot of time looking at two-dimensional things. I try to think of new kinds of spatial organization, first two and then three dimensions. That is why the idea of a city is so important to me, because there is more than one dimension to play with.

**RO**  George, what is it in your drawings that is being represented? Certainly your drawings seem more gestural than any of the others.

**GT**  As with Mary, I have a lot of notebooks containing detailed drawings of various structures, because much of my studio work has to do with details—the nature of a joint, the nature of a connection, be it between different sorts of wooden elements or wood and steel. I am also concerned with what might seem unlikely sources—the painting of *St. Francis* at the Frick, for example. All the structures there are measured with an amazing, arcane system, and the painting is also filled with details of rocks, trees, caves, vines, leaves, twigs, etc. Many of my drawings are like that painting in that they bring together all sorts of natural stuff. The other thing that I use the drawings for initially is to investigate a site. I have problems taking slides of a site so I used to explore a site with a sketchbook. I would walk it and pace it off and feel it, and then make a very loose drawing of its topography and natural elements. I could read it as a reference even though no one else could see what was actually going on. To me, somehow, the line in the notebook was an actual hill. When I went to Seattle to work on the piece there, a couple of drawings in my notebook fed me a lot more than dozens of slides, which usually just confuse me.

**RO**  It sounds as if your drawings, then, are an aspect of memory.

**GT**  That's right, but usually it's a perceptual investigation of a physical space, and then I just take it from there.

**MM**  I think the drawings that are most important to me and the things I really love are usually just small things about the size of the palm of your hand, and that's where all my best ideas are, my strongest notions. I have a very unsteady hand; I can't draw very well which is probably why I never relied on that medium. I do a lot of drawings, like Alice, from books and sources or from things I see in my travels. So in some respects they are like the evidence of my ideas—that is so much more important to me than what kind of drawing it is. I can't create things out of a context; I can't dream something up and think I'm going to find it a place, because the idea comes so much from the specific context that it has to tie into a site or it wouldn't have any meaning for me either. It's like trying to straddle these needs to have drawings and models for practical reasons—for my own reference or someone else's.

**AA**  I spend a lot of time before I draw at all, just thinking. I have to see a piece in my head first—it has to emerge, this image—and I don't even do little sketches. It really has to come right from my head, and then I'll sit down and do the whole thing.

**Mary Miss**

Mary Miss

Richard Fleischner

**RO**  So in a sense it's fabricated in the drawing?

**AA**  Yes, but I have to have it down first in my head; I don't spend a lot of time playing with it, arranging, or anything like that. But now I'm starting to think that's why these war strategy things are so important, because I keep thinking there's some kind of thing that will emerge, whether it's in the Rosetta Stone or... The last drawing I did, which didn't work out so well, though I'm going to keep it, was from looking at my palm and starting to read it. I started seeing the Pythagorean theorem and a World War I trench, and some sort of diagram of how the doges get elected in Venice, and some sort of magic sign and the I Ching all in my palm. Different kinds of magic whorls on my fingertips, and then braid that off three-dimensionally, almost architecturalize these different kinds of magic signs. Now drawing has become really important to me, because I want to see the city or see the world in my hand. I also keep thinking there is some sort of crossover between that magic sign and architecture and language, and I want to know what that crossover is now.

## Attitudes and Confluences

**RO**  You are all talking about research, even though we don't use the term; I suppose most people call it references. It seems to me that there is a preparatory level on which you all think about certain kinds of things, whether you're thinking about shoreline rip-rap systems or graphic and warfare modes and game boards. You're also doing drawings based on exotic architecture or looking at certain kinds of ancient spatial attitudes. So there is this pre-construction preparatory level. It's not just going out and pacing off the field.

**MM**  I imagine it's quite different among the four of us but what I do as an artist in the studio is to think and read. I am always looking at images, reading, absorbing things. It's like note taking. I don't go to the studio every day and draw or do something physical but I usually go in and have about three tables of books that I am currently using.

**RO**  Maybe that is what being an artist who works on site is really about—your process no longer includes the romantic notion of going in and doing reams of sketches or being inspired by the isolation of the studio, but instead is primarily a mental activity filtering through all of your visions and found images.

**MM**  Part of the shortcomings I see with architects and engineers is that there is so little experimentation. They simply don't have the luxury as we do to investigate the possibility of new forms.

**RF**  There is a story that I like a lot: when Rodin was accused of imitating Greek statuary, he explained that if he was trying to do anything it was to understand their methods and vision. Instead of relying on given standards, part of what we all do is to clarify those universals—what I often call "critical distances" on a site. One example I always use is the distance between the pitcher's mound and home plate—that distance is very critical to the entire game of baseball. Change it and you throw off the entire system of which it is an integral part. Most of my decisions when I am working on a site involve a very intimate relationship to that site and with a lot of people, like the entire process of the MIT project. Decisions are made in a very plastic way: that is, if it becomes necessary to move something in the midst of the construction, then that decision is made; if something like an extant wall must be cut to maintain "critical distances," then that is decided as part of a constantly evolving process. It has always seemed to me that there is where we all differ from the architectural profession.

**HD**  Is that because the process is so institutionalized? Even if architects want to be flexible it seems to me that there are all kinds of professional obstacles in their way.

**RF**  It is incredible to me that there is no architecture school that I know of where there is a gymnasium-size room with a lot of mock-up materials lying around. The students never get to see what their designs will be like in real space. They never get a chance to deal with the reality of spaces: for example, how big does a room have to get before the height of the ceiling begins to affect how you feel? The profession is just not taught to think in those terms.

**HD**  Alice, though your work seems often to center on imagined spaces, it seems also to be very much tied to the sort of concrete experience that Dicky has been talking about.

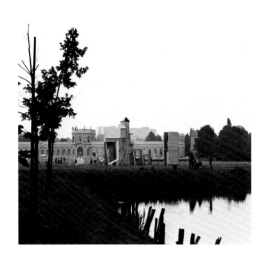

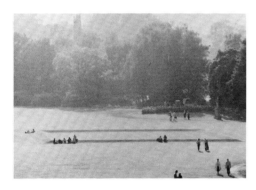

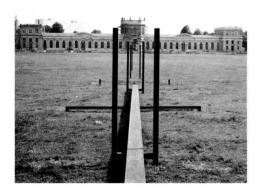

Alice Aycock, *Project Entitled "The Beginnings of a Complex..." For Documenta*, 1977, Kassel, Germany, temporary installation for the exhibition *Documenta 6.*

Richard Fleischner, *Floating Square*, 1977, Kassel, Germany, temporary installation for the exhibition *Documenta 6.*

George Trakas, *Union Pass*, 1977, Kassel, Germany, temporary installation for the exhibition *Documenta 6.*

**AA**   My work is still very much about the physical reality of spaces. In the earlier work, I would literally sit there and lay out the design with a tape measure and then consider what the numbers actually meant. How does a 2- or 3-foot cube feel, how does a space 18 inches high affect us? It was very much about reaching some kind of threshold level—of claustrophobia, acrophobia, and the like. It is less about that now. My work since about 1978 has involved a different layer of consideration. For example, now I will work with the notion of taking a pattern from different dances or diagram it and then make a space out of it. These are still very real spaces but based on systems other than numerical measurement.

**GT**   I think the magic for me in terms of space is the time element. Space is a very complex set of characteristics sensed through time as people walk through it. It is a sort of choreography, the constant connection between the feet and the brain that I try to keep balanced in all my work.

**RO**   Isn't that space-time experience you describe a very cultural/personalized one, since different people have different associations and patterns for experiencing spaces? For example: the different types of spaces in a Japanese home and an American home; the various kinds of sacred spaces and tolerances for smaller or bigger work spaces that exist in different cultures. We have all been using architecture as a point of departure for discussing your works, but aren't there other systems that are more anthropological which you are all addressing?

**MM**   It's not just about the things we make but about the people experiencing them.

**GT**   Walking through these spaces involves a kind of narrative because it is in real time that we walk across a bridge or down a road, and as we make our way along these paths, we carry our memories with us. It is very important that the experience is not just a physically reactive one but one which encourages reflection. That seems to place what we do into this other realm—our realm rather than the arena of life. All the same connections are there, but we encourage their contemplation. Some people have remarked to me that it must be depressing to have all of this work built and then taken down and have much of it physically destroyed. I'm more interested, though, in how the experience of a piece has affected people's mental attitudes. Even though *Rock River Union* at Artpark, for example, is gone, people just don't forget it—it has shifted a certain set of things in relation to what they do in their everyday lives.

**RF**   While you were talking I was thinking about Baltimore, and how I worked that site. I probably went down there at least thirty times, staying anywhere from one hour to a week. The whole joy of working at the Baltimore site was in decoding that situation, finding a line that went between two elements in the landscape or the right axis for a set of elements. When you were doing your bridges, George, I always thought there were points at either end of those structures that created this invisible line. We were, in effect, dealing with some similar observations between points in a landscape.

**HD**   Some of the connections and differences between your ways of working seemed very clear at the 1977 *Documenta 6* exhibition.

**RF**   I loved to look at the three things that George, Alice, and I did at *Documenta* because I realized that in the most basic way they were Alice's vertical plane, my horizontal plane, and George's linear structure. I saw them all as gestures in a landscape. I saw the works in a funny way because there had been these common experiences there and a certain use of space. It was that space in Kassel, including the woods and the paths that went off to each side, to which we were all responding.

**GT**   I think of the space you are referring to as the kind of space we all respond to. It is not just felt with physical relations but with spirit. What we do with our work is almost like creating or re-creating the world, just building and rebuilding it.

**RO**   The kinds of multiple experiences and perceptions of a space that motivate your work are what I sometimes think of as a kind of mapping process, a three-dimensional topology.

**MM**   That kind of diagramming is a beginning, but I want to see how one can integrate all of the things that inflect a site, and make those elements accessible—emotional, physical, sexual, spiritual layering.

**HD**   How important is Rudofsky's book *Architecture without Architects*?

**RF**   I look at it all the time.

**AA** Yes, because it is about something other than the rectilinear structures you usually see.

**RF** It's about common sense and ingenuity.

**MM** It's about architecture emerging out of the needs, desires, geography, and configuration of the culture rather than out of some set of predesigned standards.

**RO** I've described a Fleischner piece as preverbal; that is, he deals with the site before he arrives at the level of expressing it in words. Alice, on the other hand, does a tremendous amount of writing which is always central to my thinking about her work. Is writing also an underlying factor in your working methods?

**GT** For me writing is very similar to the drawings; it's a private world, and I haven't exhibited or published many of the drawings. I have written some text and, in some respects, there is a similarity between how I channel certain feelings in my choice of words and how I do it in a spatial context. I have even worked on a few short stories. Both the drawings and the writing fulfill a need since it sometimes gets so ennervating when you're totally bound up with machinery and materials, timber and metal, and processes like shovelling dirt in all kinds of weather. Sometimes I feel like a complete laborer and other times I just want to savor the luxury of sitting down and writing or drawing. It is a very intense experience for me to get things out in a way that just doesn't happen when I'm on site building the piece in the real world. In some ways, I feel the graphic reading of the text or the drawing is only a fraction of what I work for in the time and space of my physical sites. As Alice has already remarked, the only thing that is going to remain is likely to be the texts and the drawings, so I hope they do contain the spirit of what my sculptural work is all about.

## Museums, Architecture, and Other Contexts

**RO** In a recent article about public art in the *New Yorker*, Calvin Tomkins cites an observation by William Rubin that most contemporary art now has a public aspect to it. What are your responses to that?

**AA** A lot of the art that is being created now is very media oriented; even painting is very public and accessible. I think museums are thinking in terms of large segments of the public.

**HD** The art that is now collected is also portable, storable, and generally manageable.

**RF** And resellable!

**MM** But one of the things that we have all done, in one way or another, is to go outside of that structure of museums, collectors, and galleries and to begin exploring some other territories. I see in Rubin's comment his recognition that we artists have begun to expand into these new territories—it's like a network that is extending out. It used to be only here in New York; but we recently have been working all over the country—in Seattle, Lake Placid, San Diego, and St. Louis. It is only now that museums are beginning to acknowledge the work that has been going on. I think one of our real strengths and contributions is that we took the scene somewhere else—it wasn't going to happen in that other, institutionalized framework.

**AA** I feel very powerless right now; we are out of the critical discourse for the most part.

**MM** But I'm all for getting out of the current art discourse since it's not bringing up issues that I consider interesting.

**GT** One way that we are distinct from other artists is that our works are not commodities: each piece is built separately and, even if it's a studio piece, it's constructed with no sense of repetition. Each has its own complex set of themes and each involves experiencing rather than just looking at it.

**AA** It's also dealing with real time and real space, and I think that ideal has been put aside in today's art world which tends to deal more with the symbolic.

**HD** Given the site specificity of so much of your work, you really can't rely on conventional avenues of support.

**MM** We have to start inventing our own support structure, and I think we have been doing that. We have been finding the ways to support our work, but other

people have to begin working with us. We need people who understand the issues, we need critical help and opportunities like this show. We've all been out in the field working on our own pieces for such a long time that I think we need to acknowledge a joint effort—not in terms of pooling resources, but just acknowledging the overlay.

**AA**  Other camps—expressionistic painting, for example—are very supportive of each other. I am wary of the public situations now because I don't want anybody to tell me what color to make it, how big to make it. Once I get into those committee situations, I just pull back; I don't want to be democratic since many of the ideas have taken a long time to work out and although some things can be flexible, I'm not going to give much away at that stage of the process. For me that sort of public situation is destructive since I see it as a compromising one. I sometimes feel that the only way I can survive is by cultivating a few supportive, eccentric patrons who will allow me to go on producing my work.

**HD**  The rest of you have all built pieces in public, non-art contexts. How has that worked out?

**MM**  One of the really interesting things about this gathering is that we're all somehow related, but we also have really different backgrounds, interests, and everything. But I would also say almost the direct opposite of what Alice does about the relationships to the public situation in my work. I have really thrived, since my earliest work, on going into a situation and having to respond to the specifics of site —the soil content, the grade, the interaction with the sociology, the history.

**RF**  My experience has been different. At MIT the process between me, the people there, and the architects went on for about three years, and I would say, with the piece almost completely built, that there was nothing in that whole situation that has been at all compromising, other than some funding limitations that affect which materials I choose. But in terms of doing what I wanted to do, I feel good about it. I've been there almost every day during the construction process and it's almost as if the drawings I first submitted have been thrown away, and decisions are made out on site with the contractor, the field engineers—it's been an unbelievably fluid dialogue. If I say, 'let's put that element in here,' they string a line and pour a slab from there to wherever I specify it to stop.

**AA**  Another major obstacle to supporting our kind of work is that architects don't want any competition; they really just want to hold onto the processes they've got.

**RO**  Aren't those kinds of on-site decisions and negotiations really a large part of the energy expended on a project like MIT?

**RF**  Of course. All the architects that I've been involved with want to control the situations, and then they're upset when they realize that their process is not my process.

**MM**  My definition of what it is that is most basic to all of us here is that we are the experimental fringe of architecture as much as of art, and that is often what gets people so upset.

**GT**  Part of the problem is that architects consider those public spaces, their spaces. All new art has always worked outside the conventions, but the most important thing for me is that each individual piece takes its course, and its quality affects people.

**MM**  I agree. It's about works affecting people, but that's why I am not interested in having a piece in some museum basement. I want that accessible public contact which is ultimately why I am willing to deal with all those restrictions and compromises. I want it out there where people are—that is the most potent thing to me.

**RO**  What most of you seem to be saying is that there are support systems but they are specific and narrow, which creates a kind of ad hoc situation within which you all work. Studio art is often sold out of the studio, but the market for your work doesn't lend itself to continuous support. Since you provide what amounts to a service for your patrons, you must always be looking for the next commission.

**RF**  Right, there is always that struggle, but there is this body of work, and although each project gets acknowledged, although each is a unique experience, there is overlap among pieces that any of us does as well as between us and other artists. Critically, that has never been considered. There are lots of "peripheral"

things which are by no means superficial to what we are all involved in, whether they be drawings or smaller objects that are never considered when our large-scale work is being discussed.

**MM**  I am interested in going from intimate spaces to public spaces. I'm interested in doing windows in the house, a room divider—from a courtyard to an urban redevelopment. All of this used to be, as George said, the domain of the architect.

**RF**  I haven't really experienced a true collaboration other than the one Paris project I worked on with Romaldo Giurgola. There has been so much bad public art made and supported, I find the whole mechanism of public art patronage questionable. The whole commissioning system has to be reexamined.

**GT**  But the mentality for the proper support is out there. Someone like Paul Wick in Dayton comes to mind, as he created a situation where works like ours could get done. To me it was an ideal situation.

**RF**  I almost think being absorbed into museum exhibitions can be a negative thing; it's like misshaping the work into the context of the museum in such a way that it's really misunderstood.

**MM**  I deal with committee situations because I don't want to build things out in the middle of some special preserve set aside for culture. I want to build things in context. I want to take those awful urban spaces that have been zoned throughout New York City and change them—make them a special type of experience.

**HD**  Haven't there historically been restrictions on work in the public domain—with patrons who dictate the spaces, the program, the imagery?

**AA**  That's all true, but I also think it's necessary to come up with ideas that break out of those restrictions—that's why I like to draw. For example, I like to design cities. I know nobody is ever going to let me build a city, but I'm interested in what a configuration of a city might be that hasn't been laid out in a grid. Drawings allow me to see certain things and to continue thinking about certain things. I'm really interested in the history of ideas and images like the tower of Babel, and if all I get to do is just draw the thing and never get to build it, I won't care because I would rather have it on paper than not at all. I've always thought that the only thing I'm going to have are these drawings in the end, because everything gets destroyed anyway, and at least there will be some thought, some schema that in some way isn't compromised.

**MM**  I think what you are calling power, Alice, I think of as opportunity, availability, or access. On the base level, regardless of our individual and collective appraisals, we are out there in the public realm and we are there to change space.

**GT**  It's usually the case that lots of pressures help get the thing done—that is true throughout the history of large public and architectural commissions. The limits imposed are very often a learning process, a communication process, and without all the limits, without all the conflicts, the piece wouldn't be as rich. It keeps my adrenalin flowing and it also keeps everybody connected to what's going to happen.

**RF**  There's no question about that being true.

**MM**  It's not for its own sake that I want to get out there and make contact with the public but it's for the situation it affords me as an artist. This ends up putting me at the other end of the spectrum from somebody like Duchamp or the traditional avant-garde position which is about negating everyone else's stance. I think it's so boring that somebody sets up this path and then this is what we all have to talk about for the next five years in the art world. It's so boring, the borders and boundaries are so tight.

**GT**  I like the impermanent things tremendously—I think of them in terms of getting things done. I think the federal budget for commissioning these works should increase. Rather than going through all the incredible risks when confronting the developers, architects and others, you can just build the piece within the kind of time frame specified.

**RF**  The thing that I see as unique in what we do is that as we look at situations that need solutions we're dealing with them as artists, we think primarily for ourselves, and that is distinct from the process of architects or planners.

■

Alice Aycock, *The Rosetta Stone City*, 1985, pencil
on mylar, 93 x 95¾ inches, Collection La Jolla
Museum of Contemporary Art, Museum Purchase/
Contemporary Collectors Fund, detail.

As Alice Aycock, Richard Fleischner, Mary Miss, George Trakas, and other artists of their generation move into the third decade of their careers, it is apparent that their sculpture has evolved into separate bodies of work, all with some generalized underpinnings, but each with its own set of priorities and characteristics. Some continue to be concerned with the relationship between site and sculpture, while others have begun to explore different aspects of their work, such as narration, public accessibility, and historical references.

Significantly, these sculptors have produced, throughout the past decade, a richly varied corpus of drawings simultaneous with their larger, constructed projects. We might expect these drawings to be blueprint-like diagrams, addressed more to contractors and engineers than to an art audience. Perhaps surprisingly, such technical sets of drawings, when done at all, constitute only a small fraction of these artists' graphic output. Instead, their drawings run the gamut of media and uses. The artists have worked with graphite, charcoal, ink, colored pencil and gouache, on surfaces ranging from small, bound journal pages to mylar, diazo paper, and more finished artist's stock. Sometimes the drawings are completed before construction is even begun on the projects; some are unrelated to a specific sculpture; others document a completed piece. Occasionally, drawings are intended to complement a sculptural installation and hang near the three-dimensional work (Alice Aycock has, like Vito Acconci and Robert Longo, worked this

# A Dictionary of Assumptions
## Drawings by Aycock, Fleischner, Miss, and Trakas

way). In this case the two-dimensional message may augment and even clarify the intentions behind the accompanying three-dimensional situation. The assumptions on which these sculptors' drawings can be based are perhaps more varied than the distinctions between their built environments.

Alice Aycock's drawings are anything but mechanical blueprints. In the early 1970s, as Aycock began constructing the first of her buildings, tunnels, scaffolds and contraptions, she simultaneously initiated a body of drawings, most of them accomplished in a coherently similar style. While some of the earliest were little more than line plans of the structures she was then building (such as her *Maze* outline of 1973), most of the drawings were conceived in a strange, almost distorted perspective. Her buildings and structures had to be erected in real life within certain structural guidelines and always in the context of a given space, either outdoors or in man-made environments. On the contrary, her drawings are like a totally distinct world where constructions need not have parallel walls, volumes can ignore the rules of perspectival illusions, and complexes of structures can exist in the vacuum-like space of an otherwise blank page.

Most of these characteristics are evident in a pencil-on-vellum work, *A Shanty Town which has a "Lunatic Charm that is Quite Engaging" or rather A Shanty Town Inhabited by Two Lunatics whose Charms are Quite Engaging,* of 1978. Here the drawn world is not cast directly in a one-to-one relationship with any built complex but is instead a kind of scripted chart, depicting, through rendering and text, the newest neighborhood of Aycock's mythical art world. A particularly learned reader might see references here drawn from Aycock's own knowledge of architectural history. The small rows of buildings are perhaps inspired by cities for the dead, cemeteries where accumulations of tombs, vaults, and chapels are built in urban-like density in Mexico and Egypt. But here, as in Aycock's human-scaled environments, such references only divert her audience from the universality of her fantasy world, reflected as clearly in the *way* she draws and in the information she *chooses* to convey as they are through any particular source from the extant world.

An intensive reading of *A Shanty Town . . .* shows her buildings unbounded by a single, coherent space; instead each element is individually distinct—none is overlapped even as she maintains a system of skewed orthogonals along the entire, considerable length of the vellum (it measures approximately 8 by 3½ feet). We are given two exterior sides of each of the shacks and occasional glimpses into their interiors. Each seems firmly cornered on the beginnings of a grid (an urban plan), but since there is no other context except for the other shacks (with one notable exception of a cross at the left center of the sheet discussed here), each seems flattened and floating in a void. (This floating sense is enhanced by the long verticality of her working surface.) Here, again, the drawing enables Aycock to merge text with image, something that she has avoided within the conventions of sculptures, as

we are meant literally to read this complementary level of data. Almost all the shacks are accompanied by written information. In some cases this is little more than a measurement of height or depth, but more often the texts give detailed descriptions of how a particular element should be read or what would be its intended use. For example, the legend on a small shed tells us that "cans of sardines are stacked inside." Other enclosures are earmarked as pens for pigs or graves for dead dogs, and not a few (we are informed) cover the entrances to underground passages. A few of the captions seem to give instructions for a physical exploration of such a shanty town, as we are told that "this fence must be climbed" or "this door is locked (there is a back door)."

Perhaps the key to this drawing and to much of Aycock's art, be it rendered in pencil or built of wood, is the simple penciled "X" at the left of the page. It adds a kind of nonspecific image and a context for the rest of the depicted shacks and fences, but, significantly, Aycock has not drawn in the feature she mentions as "a man-made hill." While such a feature would strongly suggest that the entire shanty town is to be sited outdoors, perhaps a part of a reclamation site, she does not mark the hill itself, but instead uses her cross as an excuse for giving her audience a kind of artistic direction. "Imagine a man-made hill here," is what Aycock tells us to do on the spot where she has provided little more than a reference point. In effect, this direction is a legend for all of Aycock's art; we are seduced by the physicality and specificity of her constructions, whether built or drawn, but they are most likely meant as starting points for our own imagination, a situation made explicit in *A Shanty Town . . .* and similar drawings.

Drawing exists, for many of these sculptors, as a more meditative, less actively engaged form of art making. Surely most of Mary Miss's drawings of the past decade have this more cognitive sense. They can be pencil on paper or ink on mylar, sometimes produced as Miss is working out a sited ensemble of towers, pits and walls, but often based on direct observations, as in a notebook stream-of-consciousness, which are the preludes to her completed environments.

Miss's exhibited drawings often combine different forms of documentation: preparatory sketches, precise graphic delineations of what was built, photographs collaged on the surface recording completed projects and often replete with technical details, dimensional notations, cross-sections, and material notes (for example, "1¼-inch pipe, 1½-inch O.D." written next to a drawn detail). Considered at length, these assembled documents begin to act as surrogate experiences, approximating as closely as possible the visual and physical sensate participation that a viewer would experience on site. Miss's drawings accomplish this while still retaining a specific graphic character as compositions of outline, shades, illusions, and black-and-white photographs across a flat working surface. She has documented her priorities as much as her built sculpture through these works on paper.

Many of George Trakas's drawings display bold, gestural marks, showing little involvement with detail as in an Aycock or Miss rendering. Some drawings may, in fact, be preparatory studies for individual projects, while others reflect more pragmatic concerns encountered on site. As in the extensive campaign of planning and building for the *Log Mass: Mass Curve* project at Amherst in 1980, Trakas often produces a body of drawings ranging from notebook sketches to finished, architectural plans and big, sweeping, spatially suggestive renderings. While the geometric and compositional rationale of this temporary piece is delineated in the starkly drawn plans, the large pencil and charcoal sheet, *Mass Aftermath*, finished two years after its source installation, *Log Mass: Mass Curve*, translates Trakas's sculptural assumptions into a two-dimensional arena. Important for Trakas, as for so many of these artists, is to have some things remain from a temporary installation. Photographs, often taken by others, coolly record the facts of these short-lived works, but Trakas, Miss, and others embrace drawing as a central means of hedging on the durability of much large-scale, impermanent sculpture.

Whether Trakas is working out a set of structural or visual patterns in a lined sketchbook or producing larger sheets (*Mass Aftermath* is 3½ by 7 feet), his concern for gesture, movement, and fluid connections between disparate sculptural elements is always embedded both in what he draws and how it is put on the page. Unlike the fastidious Aycock or Miss drawings, Trakas's are often dominated by the character of his drawn lines. Many of the marks are reworked, erased or smudged, as if he is seeking some perfected state; others are gracefully precise on the first try. Trakas exhibits this range of handling in a medium where he can make instant corrections, flexible adjustments, and even gross deletions with greater ease and facility than in the more unforgiving materials of steel and massive timber.

Something not readily apparent when viewing his sculpture in a gallery is crystallized in its two-dimensional transcription. The interior installation of *Log Mass: Mass Curve* is evoked at the left of *Mass Aftermath* with the contrast between heavy, solid gestural marks and almost evanescent forms, shifting and dissolving across the page. He can intimate and even tease in charcoal, while in steel he asserts. What is clarified here, however, is that this interior construction was conceived by the artist as flowing between the gallery and its immediate exterior environs. In the drawing, the adjacent and critical topography, now the site for a permanent outdoor work by Trakas, is blended with the temporary interior installation by the elimination of walls and shifts in level. While the exterior work was not completed until 1985, in effect, the choreography of the entire arrangement, inside and out, was resolved three years earlier through his graphic investigations.

Like those already discussed, Richard Fleischner has drawn in several distinct genres, from brisk, dynamic sketches to perhaps the fullest body of architectural plans and presentation drawings developed by any contemporary sculptor. In establishing an ongoing dialogue with architects during the past five years, he has enmeshed himself in a tradition that is often distinct from the conventions of sculpture. He has, on occasion, been a member of an architectural design team, working alongside other specialists, in the firms of I.M. Pei, Mitchell/Giurgola, or Edward Larrabee Barnes. Often charged with working out the interstices between or around the architectural structures, Fleischner has produced numerous sheets that show ground plans, elevations, cross-sections, and construction details. Many recent proposals, like that for the MIT Fine Arts Center or the urban plaza adjacent to Temple University in Philadelphia, are for permanent environments and have entailed dozens of drawings from crude, impromptu sketches and doodles to large, finely finished sheets appropriate for presentation to architects and patrons. When the demand became great for such time-consuming preparatory draughtsmanship several years ago, Fleischner began to have the more polished drawings created under his explicit direction by several assistants, each with an intimate knowledge of his aesthetic vocabulary.

Many of Fleischner's earlier sited works are distinctly horizontal (*Sod Maze*, Newport, *The Baltimore Project*, and *Cow Island Project*, Providence), and much of his initial on-site thinking seems to progress across the breadth of a landscape. He physically traverses its topography, pacing its dimensions, marking key axes or boundaries with cords and stakes; in a sense he draws directly on the landscape. While earlier plans on paper could make the position of certain elements quite explicit, they could not begin to reveal the spatial nuances that Fleischner creates in his built environments.

After several years of working directly on the landscape, Fleischner decided, in 1981, to return to his studio as a respite, there to think, read and draw. During a particularly productive period of several months, he created a body of drawings emphatically distinct from his site plans yet intrinsically related to his attitudes about space and the qualities of visual experience. These sheets, often 2 by 2½ feet and usually untitled, are like a primer for what Fleischner brings to his sculpture. Usually, the page holds one boldly drawn charcoal sketch, but occasionally the sheet would be folded or cut into four pieces, each containing an image, that together presented a short paradigm of spatial manipulations. Taken as a group, this series established a process of spatial investigation and reckoning. Inside/outside, light/shadow, open/closed, mass/volume, edge/plane, and dozens of other spatial keys are represented with his often simple, even childlike handling of the thick drawing stick. These drawings, formulated partly as the studio response to the myriad problems of actually erecting a sited work with soil engineers, crane operators, steel erectors, governmental agencies and the like, are informed by the same aesthetic notions that Fleischner would use to manipulate a sod lawn, erect an I-beam colonnade, or cut and position a granite bench. They are a dictionary of his assumptions and, as such, reveal the essence of his art.

*Ronald J. Onorato*

■

# Notes

## Introduction

[1] Lawrence Alloway and John Coplans, "Talking with William Rubin: 'The Museum Concept Is Not Infinitely Expandable'," *Artforum* (October 1974): 52.

[2] Ibid., 52.

[3] Douglas Crimp, "The Art of Exhibition," *October* (Fall 1984): 53.

## Post-Studio Sculpture

[1] David Bourdon, "The Razed Sites of Carl Andre, A Sculptor Laid Low by the Brancusi Syndrome," *Artforum* (October 1966): 15.

[2] David Bourdon, *Carl Andre: Sculpture 1959–1977*, exhibition catalogue (New York: Jaap Rietman, 1978), 27.

[3] Ibid., 50.

[4] Sam Hunter and John Jacobus, *American Art of the 20th Century* (New York: Harry N. Abrams, 1973), 443.

[5] Michael Heizer, "The Art of Michael Heizer," *Artforum* (December 1969): 37.

[6] John Beardsley, *Probing the Earth: Contemporary Land Projects*, exhibition catalogue (Washington, D.C.: Hirshhorn Museum and Sculpture Garden, 1977), 40.

[7] *Michael Heizer*, exhibition catalogue (Essen: Museum Folkwang, Otterlo: Rijksmuseum Kroller-Muller, 1979), 30. Michael Heizer, in a conversation with Hugh Davies in January 1982 at Hiko, Nevada, was adamant that he had nothing in common with site sculptors and viewed the sites of his works as neutral settings with plenty of space.

[8] Nancy Holt, ed., *The Writings of Robert Smithson* (New York: New York University Press, 1979), 202.

[9] Ibid., 47.

[10] Ibid., 111.

[11] Ibid., 124.

[12] *Michael Heizer* (Essen and Otterlo), 14.

[13] Richard Serra, in collaboration with Clara Weyergraf, *Richard Serra: Interviews, Etc. 1970–1980* (Yonkers, New York: The Hudson River Museum, 1980), 70.

[14] Ibid., 72.

[15] Ibid., 25–26.

[16] Robert Morris, "The Art of Existence— Three Extra-Visual Artists: Works in Process," *Artforum* (January 1971): 28.

[17] Robert Morris, conversation with Hugh Davies, Summer 1983, Amherst, Massachusetts.

[18] Robert Morris, statement in *Sonsbeek '71*, exhibition catalogue (Arnhem, The Netherlands: Sonsbeek Foundation, 1971), 57.

[19] Interview with Robert Morris in *Het Observatorium van Robert Morris*, exhibition catalogue (Amsterdam: Stedelijk Museum, 1977), unnumbered pages.

[20] Robert Morris address published in *Earthworks: Land Reclamation as Sculpture*, exhibition catalogue (Seattle: Seattle Art Museum, 1979), 14.

[21] Ibid., 16.

[22] Bourdon, *Carl Andre: Sculpture 1959– 1977*, 38.

## Real Time–Actual Space

[1] Dennis Oppenheim, text for the installation *Theme for a Major Hit*, 1974, cf. *Dennis Oppenheim*, exhibition catalogue (Montreal: Musée d'Art Contemporain, 1978), 77.

[2] Yvonne Rainer, *Yvonne Rainer Work 1961– 1973* (Halifax: Nova Scotia College of Art and Design, 1974), 13.

[3] Ibid., 149.

[4] Hence Robert Morris, who himself choreographed a number of danceworks in the mid-1960s and whose connection to Rainer and her work are documented in the Nova Scotia book, titled a later article, considered seminal by many site artists, "The Present Tense of Space," *Art in America* (January 1978): 70–81.

[5] Vito Acconci, *Catalogue of Headlines and Images* (Amsterdam, The Netherlands, 1978), 2.

[6] This particular event was described graphically by Burton during a conversation in the spring of 1983 and is recapitulated in Robert Pincus-Witten, "Scott Burton: Conceptual Performance as Sculpture," *Arts Magazine* (September 1976): 112–17, in its full theoretical and historical context.

[7] For the Andre-Frampton dialogue see *Twelve Dialogues, Carl Andre/Hollis Frampton*, ed. B.H.D. Buchloh (Halifax: Nova Scotia College of Art and Design, 1980).

## Wonder in Aliceland

[1] Gaston Bachelard, *The Psychoanalysis of Fire*, trans. Alan C.M. Ross (Boston: Beacon Press, 1964), 28.

[2] *Low Building* was constructed in New Kingston, Pennsylvania, 1973, and *Stairs* was installed at 112 Greene Street, New York, 1973–74. More complete information on these and other Aycock works is in the comprehensive catalogue *"after years of ruminating on the events that led up to his misfortune . . .", Alice Aycock Projects and Proposals, 1971–1978*, exhibition catalogue (Allentown, Pennsylvania: The Center for the Arts, Muhlenberg College, 1978).

[3] Much of the information in this essay is the result of the many friendly and informative discussions I have had with the artist over a number of years about her life and work.

Aycock has publicly stated her early and continuing interest in literature in the 1977 videotaped interview conducted by the Video Data Bank, The Art Institute of Chicago.

[4] Alice Aycock, "For Granny (1881– ) Whose Lamps are Going Out: A Short Lecture on the Effects of Afterimages," *Tracks* (Spring 1977): 142–43.

[5] *Wooden Posts . . .* was sponsored by the Nassau County Museum of Fine Arts, Roslyn, New York for the fall 1976 exhibition *Sculpture Sited*.

[6] Bachelard, *Psychoanalysis of Fire*, 7.

[7] Ibid., 17ff.

[8] Gabriel d'Annunzio, *Contemplation de la Mort*, quoted in Bachelard, 17.

[9] See for example such titles as *"I Have Tried to Imagine the Kind of City You and I Could Live in as King and Queen,"* 1978, and the text of the project *The City of the Walls*, 1978, both reproduced in the Muhlenberg catalogue, which has its own revealing title *"after years of ruminating . . ."*. Aycock tells her audience succinctly about the priorities in her own work when she complains in a kind of deadpan comedic voice in that text: "Most of the action is a secret. However, they did squabble about who did what, where, and when . . . But never mind that. Basically all the walls are red herrings."

[10] From text associated with *The City of the Walls*, unnumbered pages.

[11] *An Explanation for the Rainbow* was one of several structures that constituted the *Project Entitled "On the Eve of the Industrial Revolution—A City Engaged in the Production of False Miracles,"* constructed at the Cranbrook Academy of Art, Bloomfield Hills, Michigan, 1978, and reconstructed as a separate indoor installation at Brown University, Providence, Rhode Island early in 1979. *"The Sign on the Door . . ."* was a multipartite outdoor ensemble, largely constructed in the theater scenery shop at the University of Rhode Island and installed on the campus during the spring of 1977. For more on works of this phase, see Edward F. Fry, *Alice Aycock: Projects 1979–1981*, exhibition catalogue (Tampa: University of South Florida, 1981).

[12] This exhibition, organized by Janet Kardon, presented the large, multifaceted inventions of Acconci, Aycock, and Oppenheim in the single atrium space of the gallery. The close, intensely packed installation made it difficult to distinguish where one work ended and another began. It became a kind of curatorial reflection on the trialogue that had developed between these artists in the late seventies and which was a factor in their machine aesthetic, an option for object making which was shared by only a few others at the time, notably the West Coast-based artist, Chris Burden.

[13] For more on memory palaces and earlier systems of memory, see Jonathan D. Spence, *The Memory Palace of Matteo Ricci* (New York: Viking, 1984).

[14] Richard Poirier, *The Performing Self* (New York: Oxford University Press, 1971). See especially Chapter 9, "Escape to the Future," 187–203. In discussions with the author, Aycock has explained how significant a work of criticism she considers the Poirier book to be.

## Richard Fleischner

[1] Much information throughout this essay has been drawn from discussions among Richard Fleischner, Hugh Davies, and Ronald Onorato from 1973 into 1986.

[2] Mazes are one of a number of common forms (houses, plazas, stairways, and bridges among them) that recur in the constructed work of Aycock, Fleischner, Miss, Trakas, and many of their contemporaries. See Ronald J. Onorato, "The Modern Maze," *Art International* (April–May 1976): 21–25; and Hermann Kern, "Labyrinths: Tradition and Contemporary Works," *Artforum* (May 1981): 60–68 for discussion of this form.

[3] This unexpected material may have other more poetic associations for the artist. In *Handball Court Wall* and *Chain Link*, two photographs taken in 1965 by Fleischner, a city space is defined by chain link fencing and the masonry planes of buildings and court wall. These photographs of Fleischner's boyhood neighborhood playground in the Bronx suggest the importance for him of urban space and scale. The photographs are reproduced in Hugh M. Davies, *Richard Fleischner*, exhibition catalogue (Amherst: University Gallery, University of Massachusetts, 1977), 21 and opposite p. 1.

[4] Achille Bonito Oliva, "Art, Tragedy and Comedy," *Flash Art* (November 1980): 31.

[5] John Berger, *Ways of Seeing* (New York: Penguin, 1972), 7. Much of my way of seeing Fleischner's project was inspired by another Berger essay, "Seker Ahmet and the Forest," *About Looking* (New York: Pantheon, 1980), 79–86.

[6] Paul Goldberger, "Toward Different Ends," in *Collaboration: Artists and Architects* (New York: Whitney Library of Design, 1981), 64. Each of the collaborations in the exhibition which the book accompanied seems generated by one or the other dominant priority instead of a true dialogue, emanating clearly from either architect or artist.

[7] Ibid., 57.

[8] There have been more intimate attempts to bring the worlds of art and architecture together, including the informal evening salons organized by Nancy Rosen in Manhattan in the early 1980s, in which artists, architects, and others concerned with these notions could discuss issues and visual material face-to-face. Although received enthusiastically by almost everyone in attendance, such soirees need to be multiplied and expanded if any fuller rapprochement among the disciplines can be achieved.

## Battlefields and Gardens

[1] Jorge Luis Borges, "Of Exactitude in Science," *A Universal History of Infamy* (New York, 1972), 141.

[2] Other materials employed at the time by Miss included canvas awning fabric, heavy metal grating, thin wire cables, and tubing. Many of these formative pieces (of 1966–68) involve hanging or suspended elements. The wire mesh screen is Miss's clearest early statement but by no means her only attempt at spatial articulation.

[3] Lucy Lippard, "Mary Miss: An Extremely Clear Situation," *Art in America* (March–April 1974): 76.

[4] Laurie Anderson, "Mary Miss," *Artforum* (November 1973): 65.

[5] Lippard, "Mary Miss," 76.

[6] For a full treatment of Miss's sculpture intended for interior spaces, like *Box/Set* and *Sapping*, see *Mary Miss, Interior Works 1966–1980*, joint exhibition catalogue (Rhode Island: Bell Gallery, Brown University, Providence and Main Gallery, University of Rhode Island, Kingston, 1981). It includes a thorough interview with Miss by Phyllis Tuchman, extensive illustrations, and a short list of the works exhibited.

[7] Miss used painted planes and edges, usually metallic or black, on several works throughout the decade, in order to tone down the definition of one layer from another or to lighten the effect of the heavy materials used in building the sculptures.

[8] I owe the concept of the refuge space to Nancy Rosen, who cogently suggests it occurs in the work of others, like Aycock and Fleischner, who employ the same architectonic scale.

[9] Mary Miss, correspondence with the author, March 29, 1978.

[10] *Blind* was the basis for a film completed by Miss in the late 1970s, *"Blind" Set*. Although one might find similarities in format or surface between the Miss structure and Robert Morris's *Observatory* in Holland, it would seem that the observatory theme (like other themes of house, bridge, labyrinth, etc.) is one of a number of formats in use by a variety of contemporary artists. I would maintain that the intentions, interests, and priorities that dictate the final manifestations of these apparently similar works are as different as those, for example, that informed the creation of a Last Supper image by Leonardo and one

by Tintoretto or that of a female form painted by Gericault and another by Degas. What we may in fact be talking about here are significant universals transformed by these personal variables, in other words, style.

[11] Robert Morris, "The Present Tense of Space," *Art in America* (January–February 1978): 80. See this amplified discussion of photography and its relationship (or non-relationship) to space, pp. 79–80. Morris has written a body of work on spatial aesthetics applicable to Miss and her contemporaries. See also his "Aligned with Nazca," *Artforum* (October 1975): 26–39. Morris remains one of the few contemporary sculptors who continually attempts to explicate his interests through provocative essays.

[12] Jean Piaget, *The Child's Conception of Space* (New York, 1967), 41–42.

[13] Having been present for one of the presentation sessions between Miss and the officials involved with the Sea-Tac Airport commission, as well as having been involved with other such negotiations over the course of the decade, I have found that for most artists these deliberations become a kind of confrontation, in which they face civic officials, architects, construction professionals, and others who are often suspicious if not outright inimicable to the art, often because of a priori assumptions about the artists' ability to produce some of their seemingly extravagant ensembles. Only in rare cases, as with the projects of Christo, does the artist find something good or at least useful in these often compromising situations. For more on Miss's piece at Sea-Tac and the symposium which sponsored it, as well as projects by Robert Morris, Richard Fleischner, Dennis Oppenheim, Beverly Pepper and others, see *Earthworks: Land Reclamation as Sculpture*, exhibition catalogue (Seattle: Seattle Art Museum, 1979).

[14] One of the reasons for the expansive character of the Long Island piece was that Miss was able to work on site for a long period. The former curator at the Nassau County Museum, Jean E. Feinberg, and the former director, Ward Mintz, were instrumental in cultivating an atmosphere at the museum-estate where artists could let their plans gestate over a relatively long span of time. Miss first visited the site in early 1977, and it would be another eighteen months before the project was completed. This kind of generosity was more the exception than the rule, even at the kind of outdoor galleries and sculpture gardens that developed in the 1970s where many of these artists have worked.

[15] The following excerpts on the Long Island project are all taken from a spiral-bound notebook of the artist, "Notebook 1," May–October 1976.

[16] Michael Klein, "Mary Miss," *Art Express* (May–June 1982): 58.

[17] Miss, "Notebook 1," quoted from Steward Culin, *Games of the North American Indians*, 44.

[18] Miss, correspondence with the author, March 29, 1978.

## George Trakas

[1] George Trakas, interview by Hugh M. Davies and Sally E. Yard, in *George Trakas— Log Mass: Mass Curve*, exhibition catalogue (Amherst: University Gallery, University of Massachusetts, 1980), 49.

[2] Ibid., 61.

[3] Thomas Wolfe, *Look Homeward, Angel* (New York: Charles Scribner's Sons, 1929), 2; George Trakas, interview by Sally Yard, January 1986, La Jolla, California.

[4] Trakas, interview by Yard, January 1986.

[5] Ibid.

[6] C. G. Jung, *Civilization in Transition*, trans. R. F. C. Hull (New York: Pantheon, 1964), 36.

[7] Trakas, interview by Yard, January 1986; Thomas Wolfe, *Of Time and the River* (New York: Sun Dial, 1944), 3.

[8] Trakas, interview by Yard, January 1986.

[9] Ibid.

[10] Vincent Scully, "Architecture, Sculpture, and Painting: Environment, Act, and Illusion," in *Collaboration: Artists and Architects* (New York: Whitney Library of Design, 1981), 19.

[11] Roald Nasgaard, *Structures for Behaviour*, exhibition catalogue (Toronto: Art Gallery of Ontario, 1978), 23.

[12] Catherine Howett, "George Trakas: Working at Emory," *Atlanta Art Workers Coalition Newspaper* (November–December 1979): 6.

[13] George Trakas, interview by Chantal Pontbriand, *Parachute* (Autumn 1978): 30.

[14] George Trakas, statement in Nancy Rosen and Edward F. Fry, *Projects in Nature*, exhibition catalogue (Far Hills, New Jersey: Merriewold West, 1975), unnumbered pages.

[15] Trakas, interview by Yard, January 1986.

[16] George Trakas, conversation with Hugh Davies and Sally Yard, March 1980, Amherst, Massachusetts.

[17] Howett, "Working at Emory," 7.

[18] Trakas, interview by Davies and Yard, *Log Mass: Mass Curve*, 63.

[19] Trakas, interview by Pontbriand, 28. Description revised slightly in interview by Yard, January 1986.

[20] George Trakas, interview by Hugh Davies and Sally Yard, January 1986, La Jolla, California.

[21] George Trakas, conversation with Hugh Davies and Sally Yard, December 1982, Amherst, Massachusetts.

[22] George Trakas, conversation with Hugh Davies, May 1985, Pistoia, Italy.

[23] Ibid.

[24] Erich Neumann, *The Great Mother* (Princeton, New Jersey: Princeton University Press, 1972), 260, quoted in Lucy R. Lippard, *Overlay—Contemporary Art and the Art of Prehistory* (New York: Pantheon, 1983), 65.

[25] Trakas, interview by Davies and Yard, January 1986; "He Wishes for the Cloths of Heaven," *The Collected Poems of William Butler Yeats* (London: Macmillan, 1965), 81.

[26] Trakas, interview by Yard, January 1986.

[27] George Trakas, Notebook, 1981.

[28] Heinrich Zimmer, *The King and the Corpse*, ed. Joseph Campbell (New York: Meridian, 1960), 171; Trakas, interview by Yard, January 1986.

[29] Trakas, conversation with Davies, May 1985.

# Drawings

Plate 1
Alice Aycock, *The Villa Gamberaia*, 1983, pencil on
mylar, 54 x 84 inches, Collection Henry S. McNeil, Jr.

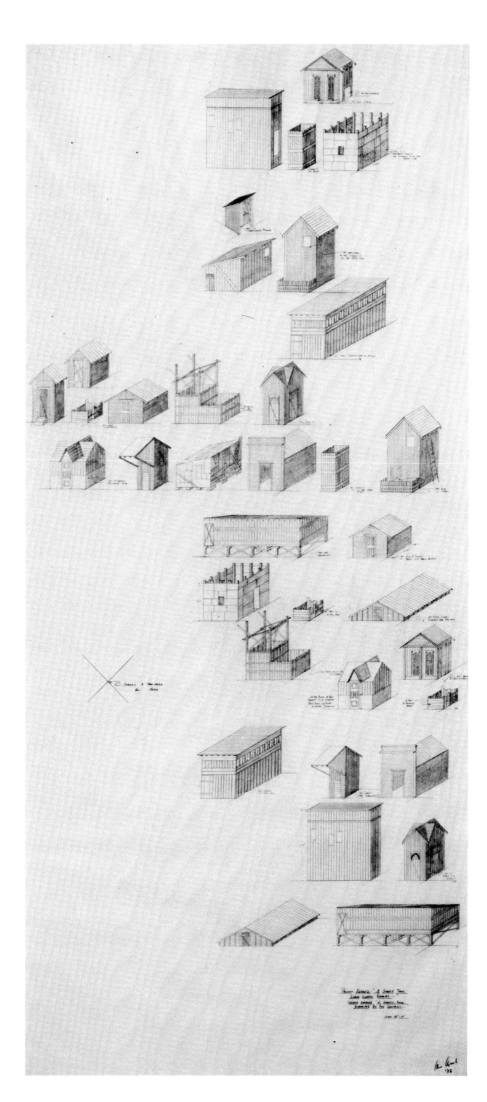

Plate 2
Alice Aycock, *A Shanty Town which has a "Lunatic Charm that is Quite Engaging" or rather A Shanty Town Inhabited by Two Lunatics whose Charms are Quite Engaging*, 1978, pencil on mylar, 96 x 48 inches, Collection University Gallery, University of Massachusetts, Amherst.

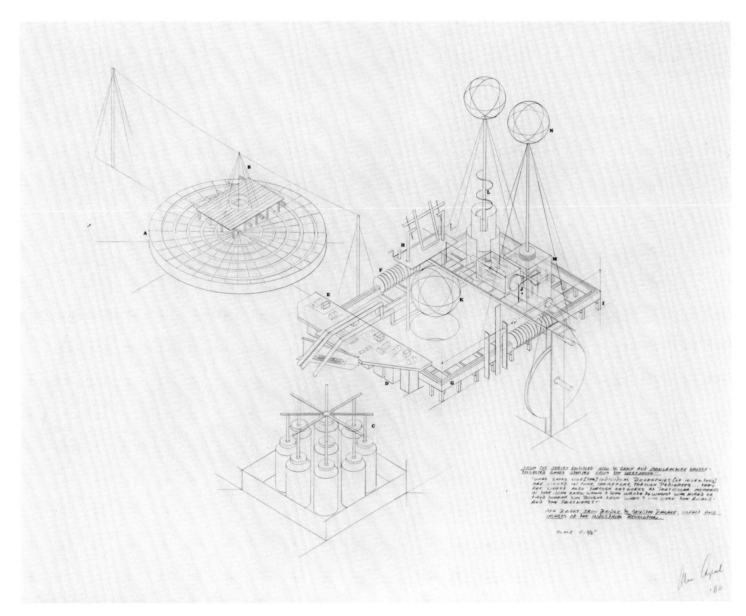

Plate 3
Alice Aycock, *Collected Ghost Stories from the
Workhouse*, 1980, pencil on mylar, 36 x 42 inches,
Collection Gilbert and Lila Silverman, Detroit,
Michigan.

Plate 4
Alice Aycock, *Tower of Babel*, 1985, watercolor,
color pastel, and pencil on paper, 44 x 30 inches,
Collection Mrs. Sue Rowan Pittman.

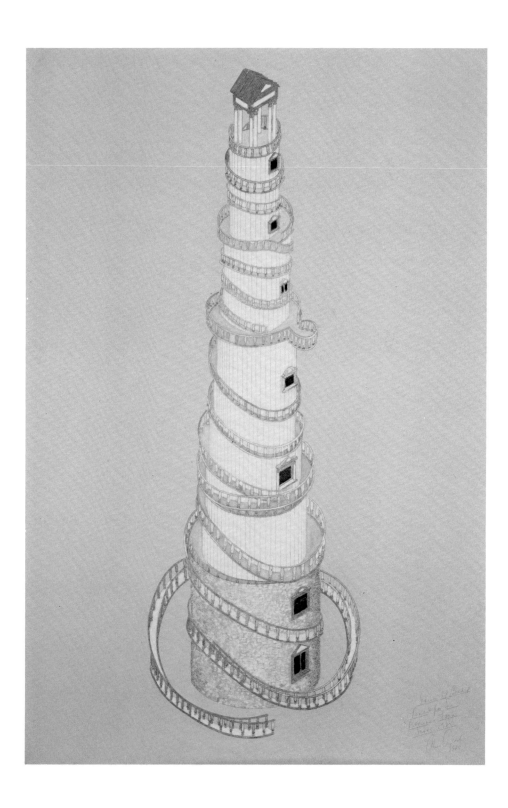

Plate 5
Richard Fleischner, Untitled, 1981, graphite on
paper, 22⅝ x 28¼ inches, Collection of the artist.

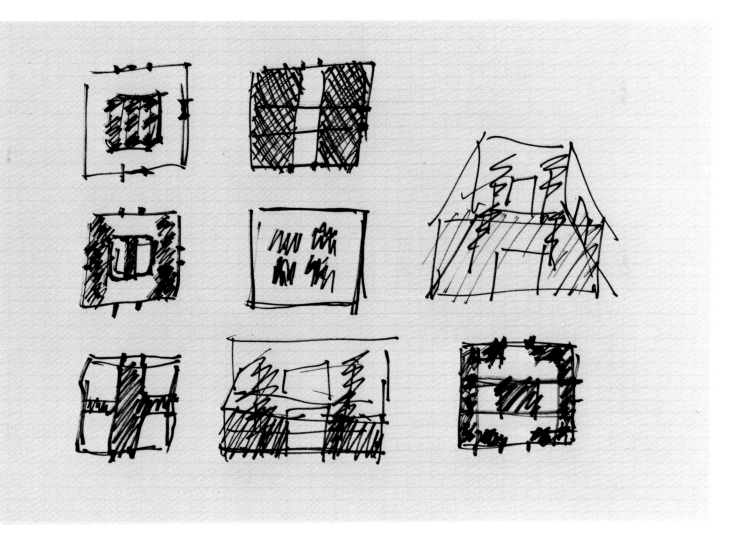

Plate 6
Richard Fleischner, *Drawing for the Dallas Museum Courtyard*, 1982, ink on paper, 8½ x 12¼ inches, Collection of the artist.

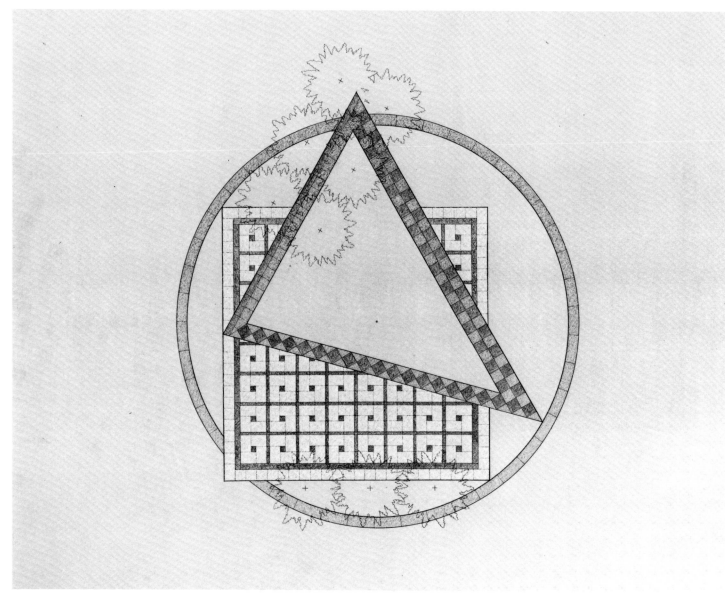

Plate 7
Richard Fleischner, *Proposal for Chandler Square
(Plan, Chandler, Arizona)*, 1985, colored pencil
on diazo print, 35 x 50¼ inches, Collection of the
artist.

Plate 8
Richard Fleischner, *La Jolla Grove Proposal Draw-
ing*, 1982, conte, pencil, and chalk on diazo print,
30 x 42½ inches, Collection of the artist.

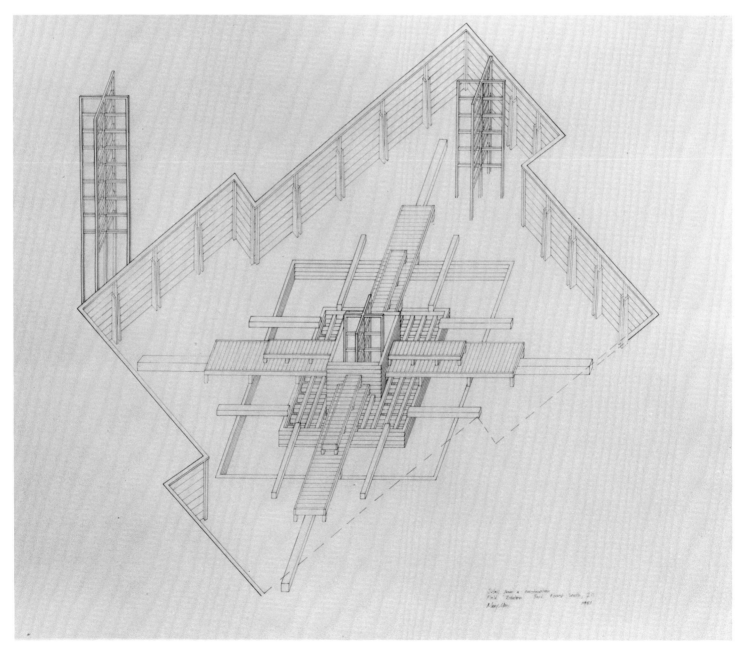

Plate 9
Mary Miss, *Detail from a Construction—Field
Rotation, Park Forest South, Illinois*, 1981, ink on
mylar, 43 x 53 inches, Collection of the artist.

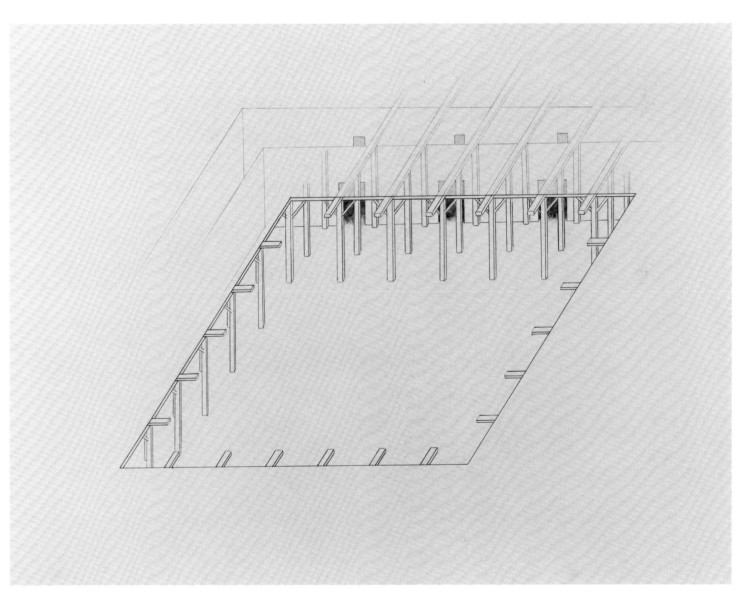

Plate 10
Mary Miss, *Study for Underground Structure—*
*Perimeters/Pavilions/Decoys*, 1977, pencil and ink
on paper, 22¼ x 29¾ inches, Collection of the artist.

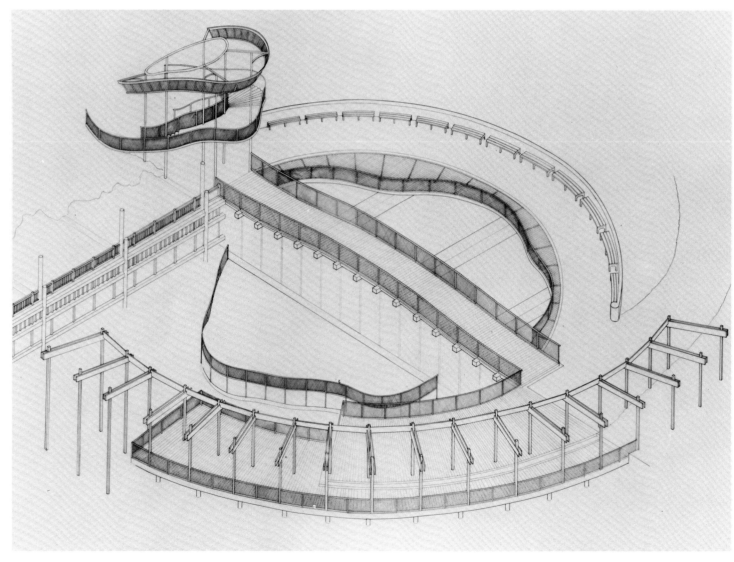

Plate 11
Mary Miss, *Study for Battery Park City Project,*
1985, ink on mylar, 40 x 59 inches, Collection of
the artist.

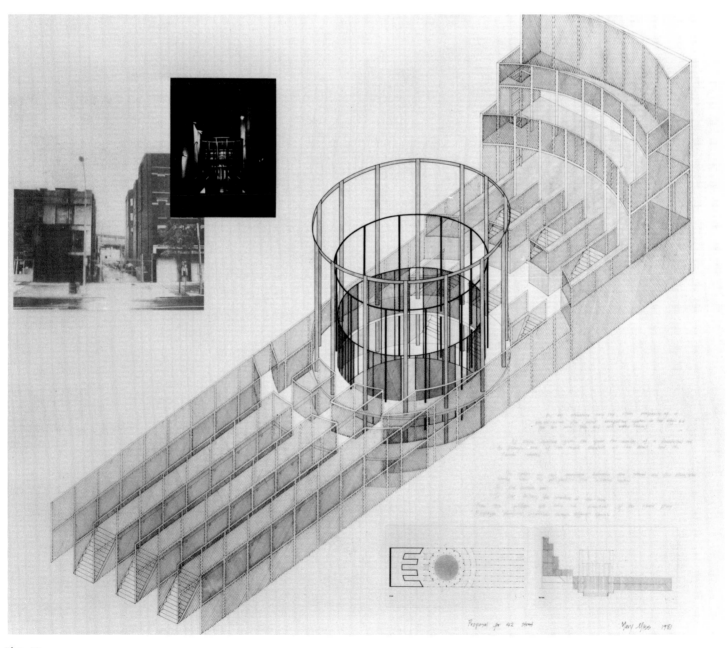

Plate 12
Mary Miss, *Study for 42nd St. Project*, 1981,
collage, pencil, and ink on mylar and photographs,
42¼ x 54 inches, Collection of the artist.

Plate 13
George Trakas, *Study for Baie d'Eternité: View
from the South*, 1979, pencil and charcoal on paper,
31⅕ x 39⅕ inches, Collection National Gallery of
Canada, Ottawa.

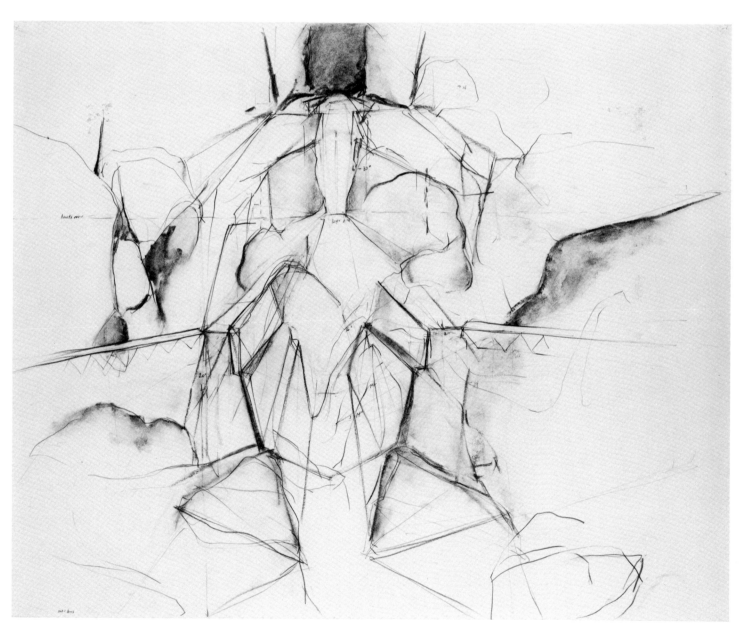

Plate 14
George Trakas, *Study for Baie d'Eternité: Tide
Elevations; dock detail*, 1979, pencil and charcoal
on paper, 31⅕ x 39⅕ inches, Collection National
Gallery of Canada, Ottawa.

133

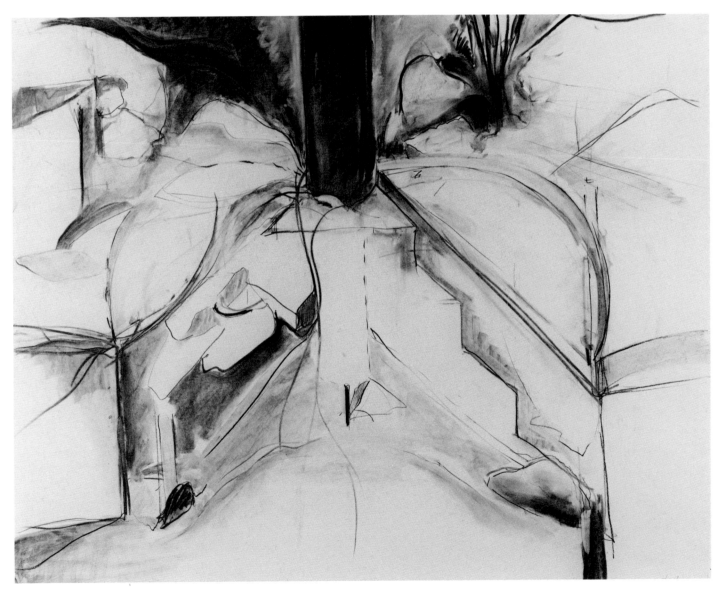

Plate 15
George Trakas, *Berth Haven*, 1983, pencil and
charcoal on paper, 23 x 29 inches, Collection of the
artist.

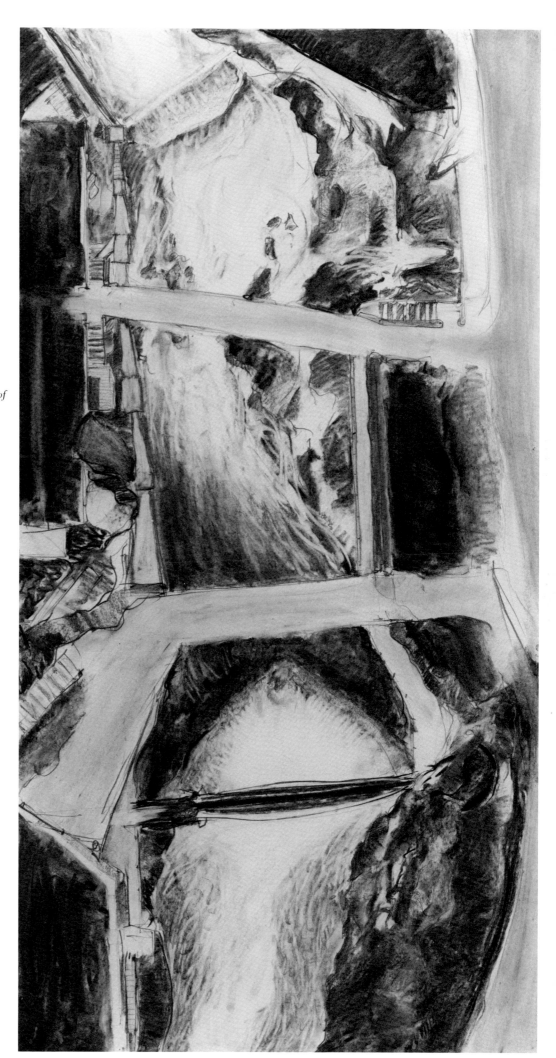

Plate 16
George Trakas, *Study for the Pit of Hell, plan of the piece (Le Creux d'Enfer, Thiers)*, 1985–86, pencil and charcoal on paper, 52 x 28 inches, Private collection.

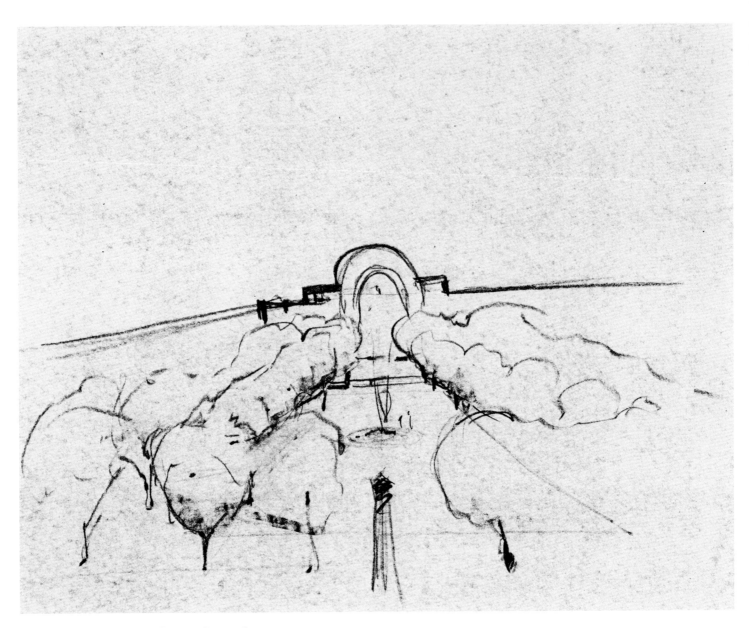

Richard Fleischner, *Battery Park Proposal I (Aerial View Toward Winter Garden)*, 1983, graphite on paper, 18½ x 24 inches, Collection of the artist.

# Catalogue
## Of the Exhibition

*Height precedes width.*

## Alice Aycock

*Project for Five Wells Descending a Hillside (Isometric View)*, 1975
Pencil on vellum
19 x 35¾ inches
Collection Lauren Ewing

*Project for Wooden Posts Surrounded by Fire Pits (Isometric View)*, 1976
Pencil on vellum
36 x 50 inches
Collection John Weber

*A Shanty Town which has a "Lunatic Charm that is Quite Engaging" or rather A Shanty Town Inhabited by Two Lunatics whose Charms are Quite Engaging*, 1978
Pencil on mylar
96 x 48 inches
Collection University Gallery, University of Massachusetts, Amherst

*Collected Ghost Stories from the Workhouse*, 1980
Pencil on mylar
36 x 42 inches
Collection Gilbert and Lila Silverman, Detroit, Michigan

*The Miraculating Machine in the Garden*, 1980 (proposed for Douglass College)
Pencil on mylar
39⅝ x 42½ inches
Collection Henry S. McNeil, Jr.

*Simple Network of Underground Tunnels*, project 1975, redrawn 1985
Pencil and colored pencil on paper
30¼ x 44¼ inches
Collection of the artist, Courtesy John Weber Gallery, New York

*The Villa Gamberaia*, 1983
Pencil on mylar
54 x 84 inches
Collection Henry S. McNeil, Jr.

*The Indian World View: The World Above, The World Below*, 1985
Watercolor, pencil, pastel, and ink on paper
48 x 48 inches
Collection of the artist, Courtesy John Weber Gallery, New York

*The Rosetta Stone City*, 1985
Pencil on mylar
93 x 95¾ inches
Collection La Jolla Museum of Contemporary Art, Museum Purchase/ Contemporary Collectors Fund

*The Vale Above the Tempe (Isometric and Isometric Section)*, 1985
Pencil and pastel on paper
Diptych, each panel 44½ x 30 inches
Collection of the artist, Courtesy John Weber Gallery, New York

*Tower of Babel*, 1985
Watercolor, pastel, and pencil on paper
44 x 30 inches
Collection Mrs. Sue Rowan Pittman

## Richard Fleischner

*Proposed Interior—Meeting Space— Wood Construction*, 1979–80
Graphite on paper
32 x 55⅜ inches
Collection of the artist

*Untitled*, 1981
Graphite on paper
22⅝ x 28¼ inches
Collection of the artist

*Drawing for the Dallas Museum Courtyard*, 1982
Ink on paper
8½ x 12¼ inches
Collection of the artist

*La Jolla Grove Proposal Drawing*, 1982
Conte, pencil, and chalk on diazo print
30 x 42½ inches
Collection of the artist

*La Jolla Grove Proposal Drawing*, 1982
Conte, pencil, and chalk on diazo print
30 x 42½ inches
Collection of the artist

*Battery Park Proposal I (Aerial View Toward Winter Garden)*, 1983
Graphite on paper
18½ x 24 inches
Collection of the artist

*Battery Park Proposal I (Axonometric Plan)*, 1983
Graphite on paper
35¾ x 48 inches
Collection of the artist

*Battery Park Proposal I (Preliminary Sketch)*, 1983
Graphite on paper
14 x 34¼ inches
Collection of the artist

*Black Square Outside Red Square*, 1983
Gouache on paper
14⅛ x 11⅛ inches
Collection of the artist

Untitled, 1984
Graphite on paper and painted wood
23 x 24¾ x 1 inches
Collection of the artist

Untitled, 1984
Graphite on paper and painted wood
23 x 24¾ x 1 inches
Collection of the artist

General Mills Proposal, 1985
Colored pencil on diazo print
36 x 51⅜ inches
Collection of the artist

Proposal for Chandler Square
    (Plan, Chandler, Arizona), 1985
Colored pencil on diazo print
35 x 50¼ inches
Collection of the artist

Richard Fleischner was assisted on some
of his drafting by Shaun B. Curran,
Lane Myer, and Bob O'Neal.

## Mary Miss

Study for Towers—Perimeters/
    Pavilions/Decoys, 1977
Ink on paper
22¼ x 29¾ inches
Collection of the artist

Study for Underground Structure—
    Perimeters/Pavilions/Decoys, 1977
Pencil and ink on paper
22¼ x 29¾ inches
Collection of the artist

Study for Staged Gates—Dayton, Ohio,
    1979
Collage, pencil, ink, and photographs
    on paper
26 x 38½ inches
Collection of the artist

Study for Mirror Way, 1980
Collage, pencil, ink, and photographs
    on paper
40¼ x 45¾ inches
Collection of the artist

Detail from a Construction—Field
    Rotation, Park Forest South, Illinois,
    1981
Ink on mylar
43 x 53 inches
Collection of the artist

Early Plans—Field Rotation, 1981
Collage, pencil, ink, and photographs
    on paper
22¾ x 28¼ inches
Collection of the artist

Study for 42nd St. Project, 1981
Collage, pencil, and ink on mylar and
    photographs
42¼ x 54 inches
Collection of the artist

Study for a Courtyard: Approach to a
    Stepped Pool, 1983
Pencil and ink on mylar
39 x 96 inches
Collection of the artist

Study for Laumeier Project, St. Louis,
    1983
Collage and ink on paper, mylar, and
    photographs
40¼ x 49 inches
Collection of the artist

Study for Port Townsend, Washington
    Project, 1984
Collage, pencil, ink, and photographs
on mylar
33¼ x 27¼ inches
Collection of the artist

Study for San Diego State University
    Project, 1984
Collage and ink on mylar
47¾ x 40¾ inches
Collection of the artist

Site Plan—Battery Park City Project,
    1985
Pencil and ink on paper
36¼ x 49 inches
Collection of the artist

Study for Battery Park City Project,
    1985
Ink on mylar
40 x 59 inches
Collection of the artist

## George Trakas

Study for Cap Trinité, Baie d'Eternité,
    Québec, 1978
Pencil on paper
9 x 12 inches
Private collection

Study for Baie d'Eternité: Tide
    Elevations; dock detail, 1979
Pencil and charcoal on paper
31⅕ x 39⅕ inches
Collection National Gallery of Canada,
    Ottawa

*Study for Baie d'Eternité: View from the South*, 1979
Pencil and charcoal on paper
31⅘ x 39⅘ inches
Collection National Gallery of Canada, Ottawa

*Atlanta Drawing: Route Source (Emory Ravine Axis)*, 1982
Graphite and charcoal on paper
22¹⁄₁₆ x 30¹⁄₁₆ inches
Collection Emory University Museum of Art and Archaeology

*Atlanta Drawing: Route Source (Emory Ravine, Lower Area)*, 1982
Graphite and charcoal on paper
22¹⁄₁₆ x 30¹⁄₁₆ inches
Collection Emory University Museum of Art and Archaeology

*Mass Aftermath*, 1982
Pencil and charcoal on paper
42¼ x 84⅝ inches
Collection University Gallery, University of Massachusetts, Amherst

*Berth Haven*, 1983
Pencil and charcoal on paper
23 x 29 inches
Collection of the artist

*La Vita di Cuore (Life of the Heart)— Via de l'Amore*, 1982–85
Pencil and charcoal on paper
48 x 36 inches
Collection of the artist

*Study for the Hofgarden in Dusseldorf*, 1982–86
Pencil and charcoal on paper
42 x 84 inches
Collection Michael Krichman and Leslie Simon

*Via de l'Amore, Villa Celle*, 1982–86
Pencil and charcoal on paper
32 x 42 inches
Collection Derrel Marsella and Donald Marsella

*East River Pier Study*, 1985–86
Pencil and graphite on paper
18 x 24 inches
Collection of the artist

*Les Chutes du Creux (The Falls in the Pit), Thiers*, 1985–86
Pencil, charcoal, and water on paper
40 x 30 inches
Collection of the artist

*Study for the Pit of Hell, plan of the piece (Le Creux d'Enfer, Thiers)*, 1985–86
Pencil and charcoal on paper
52 x 28 inches
Private collection

*Pacific Union*, 1986
Pencil and charcoal on paper
42 x 94 inches
Collection of the artist

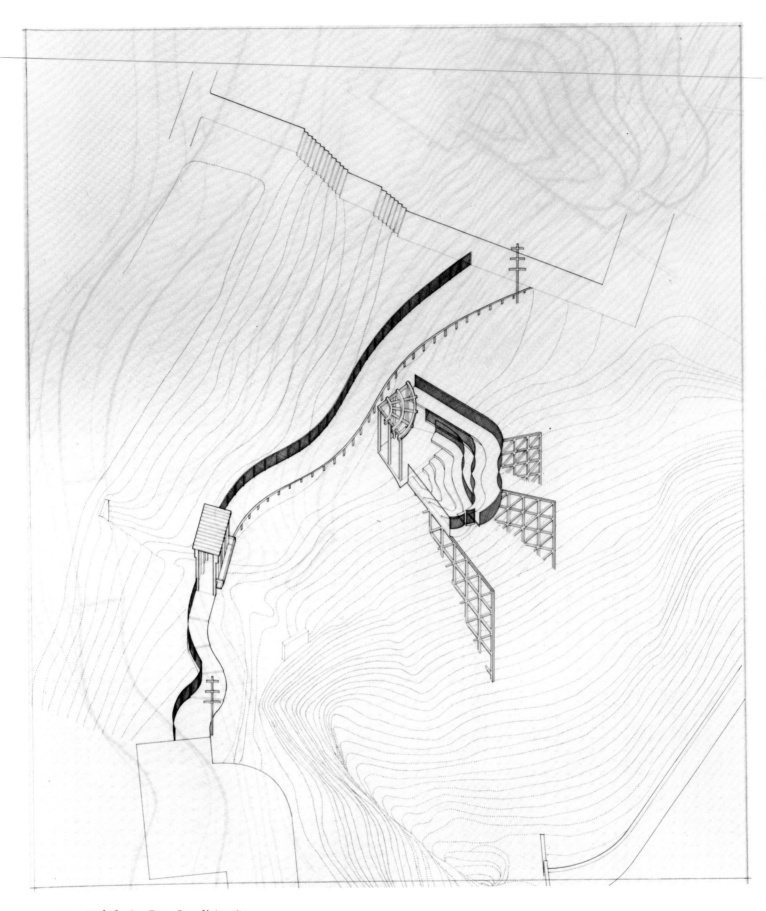

Mary Miss, *Study for San Diego State University
Project*, 1984, collage and ink on mylar, 47¾ x 40¾
inches, Collection of the artist.

# Biographies
## Selected Bibliographies

## Alice Aycock

Born in Harrisburg, Pennsylvania, 1946
Lives in New York City

### Education

Douglass College, New Brunswick, New
    Jersey, B.A., 1968
Hunter College, New York, M.A., 1971

### Teaching

Hunter College, New York, 1972–73
Williams College, Williamstown,
    Massachusetts, 1974
Rhode Island School of Design, Providence,
    1977
School of Visual Arts, New York, 1977–85
Princeton University, Princeton, New
    Jersey, 1979
San Francisco Art Institute, 1979

### Grants

National Endowment for the Arts Artists
    Fellowship, 1975, 1980
New York State Creative Artists Public
    Service Grant, 1976

### Selected Sited Works

*indicates permanent installation*

*Names of exhibitions (in quotation marks)
follow titles of works where appropriate.*

1972    *Maze*, Gibney Farm, New Kingston,
Pennsylvania

1973    *Low Building with Dirt Roof (for
Mary)*, Gibney Farm, New Kingston,
Pennsylvania

1973–74    *Stairs (These Stairs can be
Climbed)*, 112 Greene Street, New York

1974    *Walled Trench/Earth Platform/
Center Pit*, Gibney Farm, New Kingston,
Pennsylvania

1975    *Simple Network of Underground
Wells and Tunnels*, "Projects In Nature,"
Merriewold West, Far Hills, New Jersey

1976    *Circular Building with Narrow Ledges
for Walking*, Fry Farm, Silver Springs,
Pennsylvania

*Wooden Posts Surrounded by Fire Pits*,
"Sculpture Sited," Nassau County Museum
of Fine Arts, Roslyn, New York

1977    *Project Entitled "Studies for a Town,"*
"Projects," Museum of Modern Art, New York

*Project Entitled "The Beginnings of a Com-
plex . . ." Excerpt Shaft #4/Five Walls*, Art-
park, Lewiston, New York

*Project Entitled "The Beginnings of a Com-
plex . . ." For Documenta*, "Documenta 6,"
Kassel, Germany

*The True and the False Project Entitled "The
World is So Full of a Number of Things,"* 112
Greene Street, New York

1978    *Project Entitled "On the Eve of the
Industrial Revolution, A City Engaged in the
Production of False Miracles,"* Cranbrook
Academy of Art, Bloomfield Hills, Michigan

*Project Entitled "The Angels Continue Turn-
ing the Wheels of the Universe Despite Their
Ugly Souls . . . ,"* Salvatore Ala, Milan, Italy

*Project Entitled "The Sign on the Door Read
the Sign on the Door . . . ,"* University of
Rhode Island, Kingston

*The Angels Continue Turning the Wheels of
the Universe: Part II*, "Made by Sculptors,"
Stedelijk Museum, Amsterdam, The
Netherlands

*The Happy Birthday Day Coronation Piece*,
"Projects and Proposals," Muhlenberg
College Center for the Arts, Allentown,
Pennsylvania

1979    *Explanation, An, of Spring and the
Weight of Air*, Contemporary Arts Center,
Cincinnati, Ohio

*Flights of Fancy*, San Francisco Art Institute

*How to Catch and Manufacture Ghosts*, and
*The Machine that Makes the World*, John
Weber Gallery, New York

*Studies in Mesmerism*, University Gallery,
University of Massachusetts, Amherst

1980    *Collected Ghost Stories from the
Workhouse*, University of South Florida,
Tampa

*The Game of Flyers*, Washington Project for
the Arts, Washington, D.C.

*The Large Scale Dis/Integration of Micro-
electronic Memories (A Newly Revised
Shanty Town)*, Battery Park City landfill,
New York

1981    *Hoodo (Laura) Vertical and Horizon-
tal Cross Sections of the Ether Wind*,
"Metaphor: New Projects by Contemporary
Sculptors," Hirshhorn Museum and Sculp-
ture Garden, Washington, D.C.

*Mock Suns and Halos 'Round The Moon,'*
"Machineworks," Institute of Contemporary
Art, University of Pennsylvania, Philadelphia

*The Miraculating Machine: The Charmed
Circle*, "Myth and Ritual," Kunsthaus, Zurich,
Switzerland

*The Savage Sparkler*, State University of
New York, Plattsburgh

1982    *Nets of Solomon*, Fattoria di Celli,
Pistoia, Italy

*The Miraculating Machine in the Garden
(Tower of the Winds)*, Douglass College, New
Brunswick, New Jersey

1983    *The Nets of Solomon, Phase II*, Mu-
seum of Contemporary Art, Chicago

*The St. Gall Pantomime*, "Het Idee Van De
Stad," Kunst Actualiteiten, Arnhem, The
Netherlands

**1984** *The House of the Stoics*, "Environment and Sculpture," International Contemporary Sculpture Symposium, Lake Biwa, Japan

*The Hundred Small Rooms*, "Bayou Show, The Houston Festival," Houston

**1985** *\*Tower of Babel*, Collection Mrs. Sue Rowan Pittman

**Under construction** *\*The Great God Pan*, Salisbury State College, Salisbury, Maryland

*The Milan Project*, "Triennale," Milan, Italy

## Selected Bibliography

**1973** Lippard, Lucy R., ed. *Six Years: The Dematerialization of the Art Object from 1966 to 1972*. New York: Praeger.

**1975** Morris, Robert. "Aligned with Nazca." *Artforum* (October): 26–39.

Onorato, Ronald J. *Labyrinth—Symbol and Meaning in Contemporary Art*. Exhibition catalogue. Norton, Massachusetts: Watson Gallery, Wheaton College.

Rosen, Nancy, and Fry, Edward F. *Projects in Nature*. Exhibition catalogue. Far Hills, New Jersey: Merriewold West.

**1976** Aycock, Alice. "Project for Five Wells Descending a Hillside." *Tracks* (Spring): 23–26.

Kardon, Janet. "Janet Kardon Interviews Some Modern Maze-makers." *Art International* (April–May): 64–68.

Onorato, Ronald J. "The Modern Maze." *Art International* (April–May): 21–25.

**1977** Aycock, Alice. "For Granny (1881–   ) Whose Lamps are Going Out: A Short Lecture on the Effects of Afterimages." *Tracks* (Spring): 142–43.

_____. *Project Entitled "The Beginning of a Complex . . ." (1976–1977): Notes, Drawings, Photographs*. New York: Lapp Princess Press, in association with Printed Matter.

_____. "Projects for My Body." *17 Lotus International* (Italy) (December): 104–9.

_____. "Work 1972–1974." In *Individuals: Post-Movement Art in America*, edited by Alan Sondheim, 104–21. New York: E. P. Dutton.

Rosen, Nancy. "A Sense of Place: Five American Artists." *Studio International* (March–April): 115–21.

Schneckenburger, Manfred. *Documenta 6*. Exhibition catalogue. Kassel, Germany.

Sheffield, Margaret. "Mystery Under Construction." *Artforum* (September): 63–65.

Torre, Susana, ed. *Women in American Architecture: A Historic and Contemporary Perspective*. New York: Whitney Library of Design.

**1978** Denton, Monroe, ed. *"after years of ruminating on the events that led up to his misfortune . . .", Alice Aycock Projects and Proposals 1971–1978*. Exhibition catalogue, with essays by Stuart Morgan and Edward F. Fry. Allentown, Pennsylvania: The Center for the Arts, Muhlenberg College.

Kardon, Janet. *Projects for PCA: Alice Aycock: History of a Beautiful May Rose Garden in the Month of January*. Exhibition catalogue. Philadelphia: Philadelphia College of Art.

Kingsley, April. "Six Women at Work in the Landscape." *Arts Magazine* (April): 108–12.

Lippard, Lucy R. *Dwellings*. Exhibition catalogue. Philadelphia: Institute of Contemporary Art, University of Pennsylvania.

Morgan, Stuart. "Alice Aycock: 'A Certain Image of Something I Like Very Much'." *Arts Magazine* (March): 118–19.

Morris, Robert. "The Present Tense of Space." *Art in America* (January–February): 70–81.

**1979** Lippard, Lucy R. "Complexes: Sculpture in Nature." *Art in America* (January–February): 86–97.

McShine, Kynaston. *Contemporary Sculpture, Selections from the Collection*. Exhibition catalogue. New York: Museum of Modern Art.

Munro, Eleanor. *Originals: American Women Artists*. New York: Simon and Schuster.

*1979 Biennial*. Exhibition catalogue. New York: Whitney Museum of American Art.

**1980** Barber, Bruce. "Architectural References: Post-Modernism, Primitivism and Parody in the Architectural Image." *Parachute* (Winter): 5–12.

Kuspit, Donald. "Aycock's Dream Houses." *Art in America* (September): 84–87.

Wortz, Melinda. "University of California, Irvine." In *Architectural Sculpture: Projects*. Exhibition catalogue. Los Angeles: Los Angeles Institute of Contemporary Art.

**1981** Diamonstein, Barbaralee, ed. *Collaboration: Artists and Architects*. New York: Whitney Library of Design.

Fry, Edward F. *Alice Aycock: Projects 1979–1981*. Exhibition catalogue. Tampa: University of South Florida.

_____. "The Poetic Machines of Alice Aycock." *Portfolio* (November–December): 60–65.

Larson, Kay. "Alice in Duchamp-Land." *New York Magazine*, May 25, 66.

*Machineworks: Vito Acconci, Alice Aycock, Dennis Oppenheim*. Exhibition catalogue. Philadelphia: Institute of Contemporary Art, University of Pennsylvania.

*Mythos und Ritual in der Kunst der 70er Jahre*. Exhibition catalogue. Zurich, Switzerland: Kunsthaus.

*1981 Biennial*. Exhibition catalogue. New York: Whitney Museum of American Art.

Vowinckel, Andreas, ed. *Natur-Skulptur*. Exhibition catalogue. Stuttgart, Germany: Wurttembergischer Kunstverein Stuttgart.

**1982** Barzel, Amnon. *Spazi d'Arte '82*. Pistoia, Italy: Celli.

Fox, Howard N. *Metaphor: New Projects by Contemporary Sculptors*. Exhibition catalogue. Washington, D.C.: Hirshhorn Museum and Sculpture Garden.

Tsai, Eugenie. "A Tale of (at least) Two Cities: Alice Aycock's 'Large Scale Dis/Integration of Microelectric Memories (A Newly Revised Shantytown)'." *Arts Magazine* (June): 134–41.

**1983** *Alice Aycock, Retrospective of Projects and Ideas, 1972–1983*. Stuttgart, Germany: Wurttembergischer Kunstverein.

*ARS 83*. Exhibition catalogue. Helsinki, Finland: Art Museum of the Ateneum.

*Biennale 17*. Exhibition catalogue. Antwerp, Belgium: Middelheim.

Foster, Hal, ed. *The Anti-Aesthetic, Essays on Post-Modern Culture*. Port Townsend, Washington: Bay.

Lippard, Lucy R. *Overlay—Contemporary Art and the Art of Prehistory*. New York: Pantheon.

Onorato, Ronald J. "A Dictionary of Assumptions: Drawings by Contemporary Sculptors." *Drawing* (November–December): 79–83.

Price, Aimee Brown. "A Conversation with Alice Aycock." *Architectural Digest* (April): 54–60.

Shinoda, Takatoshi, ed. "Women Artists." *Monthly Art Magazine Bijutsu Techo* (Japan) (September): 24–40.

Sonfist, Alan, ed. *Art in the Land, A Critical Anthology of Environmental Art*. New York: E. P. Dutton.

Viladas, Pilar. "Speaking in Metaphors." *Progressive Architecture* (September): 108–15.

**1984** Elwood, Sean, ed. *The 1984 Show*. Exhibition catalogue. New York: Ronald Feldman Fine Arts.

*Environment and Sculpture*. Exhibition catalogue. Lake Biwa, Japan: International Contemporary Sculpture Symposium.

Robins, Corinne. *The Pluralist Era in American Art 1968–1981*. New York: Harper and Row.

Van Damme, Leo. "Alice A. in Wonderland, The Investigations of Alice Aycock." *Arte Factum* (Belgium) (March): 16–21.

**1986** Davies, Hugh M., and Onorato, Ronald J. *Sitings*. Exhibition catalogue. La Jolla, California: La Jolla Museum of Contemporary Art.

# Richard Fleischner

Born in New York City, 1944
Lives in Providence, Rhode Island

## Education

Rhode Island School of Design, Providence,
B.F.A., 1966; M.F.A., 1968

## Teaching

Brown University, Providence, Rhode
Island, 1970–74
Rhode Island School of Design, Providence,
1977

## Grants

Grant-in-Aid, Rhode Island State Council on
the Arts, 1974
The American Academy of Arts and Letters
and the National Institute of Arts and Let-
ters Grant, 1974
National Endowment for the Arts Artists
Fellowship, 1975, 1980

## Selected Sited Works

*indicates permanent installation

Names of exhibitions (in quotation marks)
follow titles of works where appropriate.

**1966–68** *Diner*, Barrington, Rhode Island

**1971** *Hay Corridor, Hay Interior, Hay Line,
Hay Maze*, and *Incomplete Hay Square*,
Rehoboth, Massachusetts

**1972** *Bluff* and *Zig Zag*, Rehoboth,
Massachusetts

**1973** *Tufa Maze*, Pocantico Hills, New York

**1974** *Sod Maze*, "Monumenta," Newport,
Rhode Island

**1975** *Sod Drawing*, "Projects in Nature,"
Far Hills, New Jersey

**1976** *Sited Works*, "Sculpture Sited," Nas-
sau County Museum of Fine Arts, Roslyn,
New York

*Sod Construction*, Hammarskjold Plaza,
New York

*Sod Drawing*, "Sculpture 76," Greenwich,
Connecticut

*Wood Interior*, Artpark, Lewiston, New York

**1976–77** *Cow Island Project*, Roger
Williams Park, Providence, Rhode Island

**1977** *Floating Square*, "Documenta 6,"
Kassel, Germany

**1978–79** *Chain Link Maze*, University of
Massachusetts, Amherst

*Sites Resited*, Dayton, Ohio

**1978–80** *The Baltimore Project*, Wood-
lawn, Maryland

**1980** *Fence-Covered Fence*, Winter Olym-
pics, Lake Placid, New York

*Wood Interior*, Museum of Art, Rhode Island
School of Design, Providence

**1981–83** *Courtyard Project for the Dallas
Museum of Art*, Dallas

**1982–84** *La Jolla Project*, Stuart Collec-
tion, University of California, San Diego

**1980–85** *MIT Project*, Massachusetts
Institute of Technology, Cambridge

**1981–85** *Alewife Station Project*, Cam-
bridge, Massachusetts

**Under construction** *Becton Dickinson
Project*, Franklin Lakes, New Jersey

*Chandler Square Project*, Chandler,
Arizona

*General Mills Project*, Minneapolis,
Minnesota

*Rochester Project*, Rochester, New York

## Selected Bibliography

**1970** Bongartz, Roy. "It's Called Earth Art
—and Boulderdash." *New York Times Maga-
zine*, February 1, 16–17, 22–30.

**1974** Hughes, Robert. "Sea with Monu-
ments." *Time*, September 2, 60.

Hunter, Sam, ed. *Monumenta*. Newport,
Rhode Island.

Russell, John. "Art: Sculpture's the Thing as
Newport Get[s] a Look at 'Monumental'."
*New York Times*, August 17, 24.

**1975** Onorato, Ronald J. *Labyrinth—Sym-
bol and Meaning in Contemporary Art*.
Norton, Massachusetts: Watson Gallery,
Wheaton College.

Rosen, Nancy, and Fry, Edward F. *Projects
in Nature*. Far Hills, New Jersey: Merriewold
West.

Russell, John. "Art." *New York Times*, Oc-
tober 11, 23.

Sheffield, Margaret. "Projects in Nature."
*Studio International* (November): 234.

**1976** Edelman, Sharon, ed. *Artpark: The
Program in Visual Arts*. Exhibition cata-
logue. Lewiston, New York: Artpark.

Kardon, Janet. "Janet Kardon Interviews
Some Modern Maze-Makers." *Art Interna-
tional* (April–May): 64–68.

Onorato, Ronald J. "The Modern Maze." *Art
International* (April–May): 21–25.

_____. "Sighted Sites." *Soho Weekly News*,
October 14, 21.

Rubin, Ida E., ed. *Sculpture 76*. Exhibition
catalogue. Greenwich, Connecticut.

Russell, John. "Art People." *New York Times*,
August 27, section 3, p. 12.

_____. "Art: A Fine Omen for New Season."
*New York Times*, September 24, section
3, p. 16.

**1977** Beardsley, John. *Probing the Earth: Contemporary Land Projects*. Exhibition catalogue. Washington, D.C.: Hirshhorn Museum and Sculpture Garden.

Davies, Hugh M. *Richard Fleischner*. Exhibition catalogue. Preface by William H. Jordy. Amherst, Massachusetts: University Gallery, University of Massachusetts, Amherst.

_____. "Richard Fleischner's Sculpture of the Past Decade." *Arts Magazine* (April): 118–23.

di Rita, Cirio. "E Qui Vedete un Prato d'autore." *L'Espresso* (Italy) July 3, 102–11.

Howett, Catherine. "New Directions in Environmental Art." *Landscape Architecture* (January): 38–46.

Perlberg, Deborah. "'Sculpture Sited,' Nassau County Museum of Art." *Artforum* (January): 67–68.

Rosen, Nancy D. "A Sense of Place: Five American Artists." *Studio International* (March–April): 115–21.

Schneckenburger, Manfred. *Documenta 6*. Exhibition catalogue. Kassel, Germany.

Shapiro, David. "A View of Kassel." *Artforum* (September): 56–62.

**1979** *Earthworks: Land Reclamation as Sculpture*. Exhibition catalogue. Seattle, Washington: Seattle Art Museum.

Foote, Nancy. "Monument—Sculpture—Earthwork." *Artforum* (October): 32–37.

Lippard, Lucy R. "Complexes: Architectural Sculpture in Nature." *Art in America* (January–February): 86–97.

Onorato, Ronald J. "Review: Chain Link Maze." *Artforum* (March): 68–69.

*Quintessence 2*. Exhibition catalogue. Dayton, Ohio: City Beautiful Council.

Schneckenburger, Manfred. "Plastik als Handungsform." *Kunst Forum International* (Germany) (April): 20–115.

*Site, Sculptures and Landscape Architects Exploring Interdisciplinary Alternatives*. Minneapolis, Minnesota: Minneapolis College of Art and Design.

Stevens, Mark. "The Dizzy Decade." *Newsweek*, March 26, 88–94.

Yard, Sally, and Sandler, Irving. *Images of the Self*. Exhibition catalogue. Amherst, Massachusetts: Hampshire College Gallery.

**1980** *Art at the Olympics, A Survey of the Fine Arts Program*. Lake Placid, New York: 1980 Winter Olympics.

Davies, Hugh M. *Arts on the Line*. Cambridge, Massachusetts: Hayden Gallery, Massachusetts Institute of Technology.

*Drawings: The Pluralist Decade*. Exhibition catalogue, 39th Venice Biennale. Philadelphia: Institute of Contemporary Art, University of Pennsylvania.

Foote, Nancy. "Situation Esthetics, Impermanent Art and the Seventies Audience." *Artforum* (January): 22–29.

Larson, Kay. "The Expulsion from the Garden: Environmental Sculpture at the Winter Olympics." *Artforum* (April): 36–45.

Leja, Michael. "Subterranean Proposals—Art for the Boston Subway." *Art in America* (May): 13–16.

McFadden, Sarah. "Report from Lake Placid, The Big Secret: Art at the Olympics." *Art in America* (April): 53–63.

Tarbell, Roberta K. *The Figurative Tradition*. Exhibition catalogue. New York: Whitney Museum of American Art.

Yard, Sally. *A Sense of Place—The American Landscape in Recent Art*. Exhibition catalogue. Amherst, Massachusetts: Hampshire College Gallery.

**1981** Harney, Andy Leon, ed. *Art in Public Places*. Washington, D.C.: Partners for Livable Places.

Kern, Hermann. "Labyrinths: Tradition and Contemporary Works." *Artforum* (May): 60–68.

Linker, Kate. "The Pursuit of the Pleasurable and Profitable Paradise." *Artforum* (March): 64–73.

_____. "Public Sculpture II: Provisions for the Paradise." *Artforum* (Summer): 37–42.

Onorato, Ronald J. "Richard Fleischner's Baltimore Project." *Arts Magazine* (October): 64–67.

Rickey, Carrie. "Curatorial Conceptions, the Whitney's Latest Sampler." *Artforum* (April): 52–57.

*Variants: Drawings by Contemporary Sculptors*. Exhibition catalogue. Houston: Sewall Art Gallery, Rice University.

**1982** Donohoe, Victoria. "An Exhibit of Nine Proposals for Gems Called Public Art." *Philadelphia Inquirer*, February 21, 8.

*Form and Function: Proposals for Public Art for Philadelphia*. Philadelphia: Pennsylvania Academy of Fine Arts.

Onorato, Ronald J. "Art Outdoors." *Art Express* (May–June): 57.

*Ten Years of Public Art 1972–1982*. New York: Public Art Fund.

**1983** Garrels, Gary. *Beyond the Monument*. Exhibition catalogue. Cambridge, Massachusetts: Hayden Gallery, Massachusetts Institute of Technology.

Lippard, Lucy R. *Overlay—Contemporary Art and the Art of Prehistory*. New York: Pantheon.

Onorato, Ronald J. "A Dictionary of Assumptions: Drawings by Contemporary Sculptors." *Drawing* (November–December): 79–83.

Pittas, Michael. "Site, The Meaning of Place in Art and Architecture." *Design Quarterly*, 28–29.

Sozanski, Edward J. "Pieces of Stone that Cry for Peace." *Philadelphia Inquirer*, April 19, section E, p. 1.

Tarlow, Lois. "Alternative Space: Richard Fleischner." *Art New England* (April): 14–15.

Tomkins, Calvin. "Like Water in a Glass," *New Yorker*, March 21, 92–97.

Viladas, Pilar. "Speaking in Metaphors." *Progressive Architecture* (September): 108–16.

**1984** Beardsley, John. *Earthworks and Beyond*. New York: Abbeville.

Dixon, John M. "Art Oasis." *Progressive Architecture* (April): 127–36.

"Fleischner Courtyard Created for Gateway Gallery." *Dallas Museum of Art Bulletin* (Winter): 36–37, 41.

Goldberger, Paul, and Russell, John. "Dallas Celebrates Art Museum by Edward Larrabee Barnes." *New York Times*, January 23, section C, p. 17.

Harris, Stacy Paleologos, ed. *Insights/On Sites—Perspectives on Art in Public Places*. Washington, D.C.: Partners for Livable Places.

Kline, Katy. "Space into Place: Richard Fleischner." *Places*, vol. 1, no. 2, 59–65.

Kutner, Janet. "The DMA Courtyard as Art." *Dallas Morning News*, January 18, section F.

Lewinson, David. "Sculpture Goal at UCSD a Step Closer." *San Diego Union*, May 13, section E, pp. 1–2.

Rubin, William, ed. *Primitivism in 20th Century Art*. New York: Museum of Modern Art.

Russell, John. "Dallas Christens Its Exemplary Home-Grown Museum." *New York Times*, January 29, section H, p. 25.

Tomkins, Calvin. "Agora." *New Yorker*, October 15, 126–32.

_____. "Perception at All Levels." *New Yorker*, December 3, 176–81.

**1985** *Artists and Architects Collaborate: Designing the Wiesner Building*. Cambridge, Massachusetts: Committee on the Visual Arts, Massachusetts Institute of Technology.

**1986** Davies, Hugh M., and Onorato, Ronald J. *Sitings*. Exhibition catalogue. La Jolla, California: La Jolla Museum of Contemporary Art.

Masheck, Joseph. "Architecture, Living Modern." *Art in America* (February): 27–31.

# Mary Miss

Born in New York City, 1944
Lives in New York City

## Education

University of California, Santa Barbara,
    B.A., 1966
Rhinehart School of Sculpture, Maryland Art
    Institute, Baltimore, M.F.A., 1968

## Teaching

School of Visual Arts, New York, 1972,
    1983–present
University of Rhode Island, Kingston, 1972
Hunter College, New York, 1972–75
Pratt Institute, Brooklyn, New York,
    1973–74
Sarah Lawrence College, Bronxville, New
    York, 1976–83
Cooper Union for the Advancement of
    Science and Art, New York, 1983–84

## Grants and Awards

New York State Creative Artists Public
    Service Grant, 1973, 1976
National Endowment for the Arts Artists
    Fellowship, 1974, 1975, 1984
Brandeis University Creative Arts Award,
    1982

## Selected Sited Works

*indicates permanent installation*
*Names of exhibitions (in quotation marks)*
*follow titles of works where appropriate.*

**1968**  *Stakes and Ropes*, Colorado Springs,
Colorado

*Stakes on Hill*, Baltimore, Maryland

*Window in the Hill*, Colorado Springs,
Colorado

**1969**  *Ropes/Shore*, Wards Island, New York

*Vs in the Field*, Liberty Corner, New Jersey

**1973**  * Untitled, Allen Memorial Art
Museum, Oberlin College, Oberlin, Ohio,
permanently installed in 1975

Untitled, Battery Park City landfill, New
York

**1974**  *Sunken Pool*, Greenwich,
Connecticut

**1976**  *Blind*, Artpark, Lewiston, New York

Untitled, "Projects," Museum of Modern
Art, New York

**1978**  *Perimeters/Pavilions/Decoys*, Nassau
County Museum of Fine Arts, Roslyn, New
York

**1979**  *Screened Court*, Minneapolis College
of Art, Minnesota

*Staged Gates*, Dayton, Ohio

*Veiled Landscape*, Winter Olympics, Lake
Placid, New York

**1980**  *Mirror Way*, Fogg Art Museum,
Harvard University, Cambridge,
Massachusetts

**1981**  * *Field Rotation*, Governors State
University, Park Forest South, Illinois

**1983**  *Study for a Courtyard: Approach to a
Stepped Pool*, "Art and Architecture," Insti-
tute of Contemporary Arts, London, England

**1985**  * *Laumeier Project*, Laumeier
Sculpture Park, St. Louis, Missouri

**Under construction**  * Project for Battery
Park City Esplanade III—South Cove, New
York

* Project for Gemeentemuseum, The
Hague, The Netherlands

* Project for Hayden Square, Tempe,
Arizona

* Project for the Thomas P. O'Neill Building,
Boston

* *San Diego State University Project*, San
Diego, California

## Selected Bibliography

**1970**  *1970 Annual Exhibition: Contemporary
American Sculpture*. Exhibition catalogue.
New York: Whitney Museum of American Art.

**1971**  Wellish, Marjorie. "Material Extension
in New Sculptures." *Arts Magazine* (Sum-
mer): 24–26.

**1972**  Alloway, Lawrence. "Art." *The Nation*,
March 27, 413–14.

———. *New York Women Artists*. Exhibition
catalogue. Albany, New York: University Art
Gallery, State University of New York, Albany.

Celant, Germano. "Informazione Negata."
*Domus* (June): 53–56.

*GEDOK American Women Artists*. Ex-
hibition catalogue. Hamburg, Germany:
Kunsthaus.

**1973**  Anderson, Laurie. "Mary Miss." *Art-
forum* (November): 64–65.

Bear, Liza. "Rumbles." *Avalanche* (Winter–
Spring): 8.

Celant, Germano. "Undernewyork." *Domus*
(July): 46.

Golub, Leon. "2D/3D." *Artforum* (March): 65.

Kingsley, April. "Reviews." *Artforum* (Janu-
ary): 90.

*1973 Biennial*. Exhibition catalogue. New
York: Whitney Museum of American Art.

Spear, Athena. "Some Thoughts on Contem-
porary Art." *Allen Memorial Art Museum
Bulletin* (Spring): 90–98, 105–9.

*Waves*. Exhibition catalogue. Bloomfield
Hills, Michigan: Cranbrook Academy of Art
Museum.

**1974**  Dreiss, Joseph. "Reviews." *Arts Mag-
azine* (December): 14.

Lippard, Lucy R. "Mary Miss: An Extremely Clear Situation." *Art in America* (March–April): 76–77.

**1975** Bear, Liza. "Films." *Avalanche* (Summer): 6.

Heineman, Susan. "Reviews." *Artforum* (March): 60–61.

Morris, Robert. "Aligned with Nazca." *Artforum* (October): 26–39.

Ratcliff, Carter. "New York Letter." *Art International* (December): 42–44.

**1976** Alloway, Lawrence. "Women's Art in the 1970s." *Art in America* (May–June): 64–65.

Baracks, Barbara. "Artpark: The New Esthetic Playground." *Artforum* (November): 32–33.

Edelman, Sharon, ed. *Artpark: The Program in Visual Arts*. Exhibition catalogue. Lewiston, New York: Artpark.

Foote, Nancy. "Reviews." *Artforum* (January): 63–64.

Frank, Peter. "Reviews." *Art News* (January): 122.

Klein, Michael. *Four Artists*. Exhibition catalogue. Williamstown, Massachusetts: Williams College Museum of Art.

Lippard, Lucy R. *From the Center*. New York: E. P. Dutton.

*New York–Downtown Manhattan: Soho*. Exhibition catalogue. Berlin: Akademie der Kunst.

Oliva, Achille Bonito. *Drawing/Transparency*. Exhibition catalogue. Rome: Cannaviello Studio d' Arte.

*Rooms, P.S.1*. Exhibition catalogue. New York: Institute for Art and Urban Resources.

**1977** Baracks, Barbara. "Reviews," *Artforum* (January): 57–58.

Lippard, Lucy R. "Art Outdoors: In and Out of the Public Domain." *Studio International* (March–April): 85–89.

———. *Contact: Women and Nature*. Exhibition catalogue. Greenwich, Connecticut: Greenwich Library.

Rosen, Nancy. "A Sense of Place: Five American Artists." *Studio International* (March–April): 115–21.

Shapiro, David. *Drawings for Outdoor Sculpture, 1946–1977*. Exhibition catalogue. New York: John Weber Gallery.

Shearer, Linda. *Nine Artists: Theodoron Awards*. Exhibition catalogue. New York: Solomon R. Guggenheim Museum.

Torre, Susana, ed. *Women in American Architecture: A Historic and Contemporary Perspective*. New York: Whitney Library of Design.

**1978** Alloway, Lawrence. "Art." *The Nation*. October 14, 389–90.

Kingsley, April. "Six Women at Work in the Landscape." *Arts Magazine* (April): 108–12.

Morris, Robert. "The Present Tense of Space." *Art in America* (January–February): 70–81.

Onorato, Ronald J. "Illusive Spaces: The Art of Mary Miss." *Artforum* (December): 28–33.

———. *Mary Miss—Perimeters/Pavilions/Decoys*. Exhibition catalogue. Roslyn, New York: Nassau County Museum of Fine Arts.

Perrault, John. "Art." *Soho Weekly News*, October 12, 35.

**1979** *Earthworks: Land Reclamation as Sculpture*. Exhibition catalogue. Seattle, Washington: Seattle Art Museum.

Krauss, Rosalind. "Sculpture in the Expanded Field." *October* (Spring): 31–44.

Sargent-Wooster, Ann. "Architects Paint Pictures, so Artists Build Buildings." *Modo* (May): 68–70.

Stevens, Mark. "Three for the Eighties." *Newsweek*, March 26, 92.

**1980** *Drawings: The Pluralist Decade*. Exhibition catalogue, 39th Venice Biennale. Philadelphia: Institute of Contemporary Art, University of Pennsylvania.

Foster, Hal. "Reviews." *Artforum* (Summer): 84.

Hubert, Christian. "Falsework: Passage as Presence." *Skyline* (May): 12.

Larson, Kay. "The Expulsion from the Garden: Environmental Sculpture at the Winter Olympics." *Artforum* (April): 36–45.

Linker, Kate. "An Architectural Analogue." *Flash Art* (January–February): 19–25.

McFadden, Sarah. "Report from Lake Placid, The Big Secret: Art at the Olympics." *Art in America* (April): 53–63.

Noah, Barbara. "Cost-Effective Earth Art." *Art in America* (January): 12–15.

Radici, Barbara. "La Chiamano 'Architectural Sculpture'." *Casa Vogue* (June): 150–51.

Saalfield, Agnes. *Mary Miss*. Exhibition catalogue. Cambridge, Massachusetts: Fogg Art Museum, Harvard University.

Yard, Sally. *A Sense of Place—The American Landscape in Recent Art*. Exhibition catalogue. Amherst, Massachusetts: Hampshire College Gallery.

**1981** Linker, Kate. "The Pursuit of the Pleasurable and Profitable Paradise." *Artforum* (March): 64–73.

———. "Public Sculpture II: Provisions for the Paradise." *Artforum* (Summer): 37–42.

Tuchman, Phyllis. *Mary Miss, Interior Works 1966–1980*. Joint exhibition catalogue. Rhode Island: Bell Gallery, Brown University, Providence and Main Gallery, University of Rhode Island, Kingston.

Vowinckel, Andreas, ed. *Natur-Skulptur*. Stuttgart, Germany: Wurttembergischer Kunstverein Stuttgart.

**1982** Kingsley, April. "Public Acres of Art: Artpark and the Leisure Landscape." *Art Express* (May–June): 26–29.

Klein, Michael. "Mary Miss." *Art Express* (May–June): 58.

Schauer, Lucy, ed. *Stadt und Utopie: Modelle Idealer Gemeinschaften*. Exhibition catalogue. Berlin, East Germany: Neuer Berliner Kunstverein, Staatlichen Kunsthalle.

**1983** Foster, Hal, ed. *The Anti-Aesthetic, Essays on Post-Modern Culture*. Port Townsend, Washington: Bay.

Friedman, Martin. "Site II: The Meaning of Place in Art and Architecture." *Design Quarterly*, 31.

Garrels, Gary. *Beyond the Monument*. Exhibition catalogue. Cambridge, Massachusetts: Hayden Gallery, Massachusetts Institute of Technology.

Hill, Peter. "Reviews." *Artscribe* (June): 44–45.

Kardon, Janet. *Connections: Bridges/Ladders/Staircases/Tunnels*. Exhibition catalogue. Philadelphia: Institute of Contemporary Art, University of Pennsylvania.

Linker, Kate. *Mary Miss*. Exhibition catalogue. London, England: Institute of Contemporary Arts.

Onorato, Ronald J. "A Dictionary of Assumptions: Drawings by Contemporary Sculptors." *Drawing* (November–December): 79–83.

Sonfist, Alan, ed. *Art in the Land, Critical Anthology of Environmental Art*. New York: E. P. Dutton.

Viladas, Pilar. "Speaking in Metaphors." *Progressive Architecture* (September): 108–16.

**1984** Harris, Stacy Paleologos, ed. *Insights/On Sites—Perspectives on Art in Public Places*. Includes essay, "From Atrocity to Integration: Redefining the Objectives of Public Art," by Mary Miss. Washington, D.C.: Partners for Livable Places.

Miss, Mary. "On a Redefinition of Public Sculpture." *Perspecta 21: Yale Architectural Journal*, 52–70.

Phillips, Patricia. "Reviews." *Artforum* (Summer): 95–96.

**1986** Davies, Hugh M., and Onorato, Ronald J. *Sitings*. Exhibition catalogue. La Jolla, California: La Jolla Museum of Contemporary Art.

# George Trakas

Born in Quebec, 1944
Lives in New York City

## Education

Sir George Williams University, Montreal, 1962–63
New School for Social Research, New York, 1963–64
Brooklyn Museum Art School, Brooklyn, New York, 1964–67
Hunter College, New York, 1964–67
Art Students League, New York, 1967
New York University, New York, B.S., 1967–69

## Teaching

School of Visual Arts, New York, 1972–76
Yale University, New Haven, Connecticut, 1984

## Grants

National Endowment for the Arts Artists Fellowship, 1979
John Simon Guggenheim Memorial Foundation Fellowship, 1982

## Selected Sited Works

* indicates permanent installation
Names of exhibitions (in quotation marks) follow titles of works where appropriate.

**1970**   *Crotch Dock*, Mountainville, Maine

⇆ *(The piece that went through the window)* and ⇕ *(The piece that went through the floor)*, 112 Greene Street, New York

**1971**   *Brooklyn Bridge*, "Brooklyn Bridge Festival," Sculpture Pier, Brooklyn, New York

*Locomotive and Shack*, "Ten Young Artists: The Theodoron Awards," Solomon R. Guggenheim Museum, New York; reinstalled at the Hopkins Center, Dartmouth College, Hanover, New Hampshire; Contemporary Arts Center, Cincinnati, Ohio; Art Gallery, University of Alabama, Tuscaloosa; La Jolla Museum of Contemporary Art, La Jolla, California; Vancouver Art Gallery, Vancouver, Canada

**1972**   *Passage*, "12 Statements: Beyond the 60s," Detroit Institute of Arts, Michigan

**1974**   *Tank*, "Discussions: Works/Words," The Clocktower, New York

**1975**   *Union Station*, "Projects in Nature," Merriewold West, Far Hills, New Jersey

**1976**   *Milled Transit*, Vassar College Art Gallery, Poughkeepsie, New York

*Rock River Union*, Artpark, Lewiston, New York

*Transit Junction*, "Sculpture Sited," Nassau County Museum of Fine Arts, Roslyn, New York

**1977**   *Columnar Pass*, Philadelphia College of Art

* *Rock Pine Pass*, "Quintessence," The Alternative Spaces Residency Program, Dayton, Ohio

*Route Point*, "Scale and Environment: 10 Sculptors," Walker Art Center, Minneapolis, Minnesota

*Union Pass*, "Documenta 6," Kassel, Germany

**1978**   *Extruded Routes* and *Transfer Station*, "Structures for Behaviour," Art Gallery of Ontario, Toronto, Canada

* *Leon's Route*, installed at Omaha Opportunities Industrialization Center for "New Dimensions," Joslyn Art Museum, Omaha, Nebraska

**1979**   *EL*, "1979 Biennial," Whitney Museum of American Art, New York

*Log, Beam,* and *Root Transport*, Montreal Museum of Fine Arts

*Milled Route* and *Mined Station*, Hammarskjold Plaza, New York

*The Quad Piece* and *The Gulch Piece*, Emory University, Atlanta, Georgia

* *Route Source* (permanent version of *The Gulch Piece*)

**1980**   *Log Mass: Mass Curve*, University Gallery, University of Massachusetts, Amherst

*Lorrain Station*, Swarthmore College, Swarthmore, Pennsylvania

*Sullivan Passage*, Omaha Opportunities Industrialization Center, Omaha, Nebraska

**1982**   * *Via de l'Amore*, Fattoria di Celli, Pistoia, Italy

**1983**   * *Berth Haven*, National Oceanic and Atmospheric Administration (NOAA), Seattle, Washington

**1981–85**   * *Isle of View*, University Gallery, University of Massachusetts, Amherst

**1985**   *Rock Pine Station*, Sarah Lawrence College, Bronxville, New York

**1985–86**   * *Le Pont d'Epée (Le Creux d'Enfer)*, Thiers, France

**1986**   * *Pacific Union*, La Jolla Museum of Contemporary Art, La Jolla, California

## Selected Bibliography

**1970**   Schjeldahl, Peter. "Sculpture Found in a Rag Factory." *New York Times*, November 1, section 2, p. 28.

**1971**   Kramer, Hilton. "Guggenheim Shows 10 Young Artists." *New York Times*, September 25, 27.

Schjeldahl, Peter. "And Now a 'Teddy' for the Artist?" *New York Times*, October 17, section 2, p. 25.

Sharp, Willoughby. "112 Greene Street." *Avalanche* (Winter): 12–15.

Shearer, Linda, and Waldman, Diane. *Ten Young Artists: The Theodoron Awards*. Exhibition catalogue. New York: Solomon R. Guggenheim Museum.

Shirey, David L. "Downtown Scene: Destructive Threat." *New York Times*, January 23, 25.

Trakas, George. "Outcrops." *Avalanche* (Fall): 52–61.

**1972** Kolbert, Frank. *12 Statements: Beyond the 60s*. Exhibition catalogue. Detroit, Michigan: Detroit Institute of Arts.

**1973** *1973 Biennial*. Exhibition catalogue. New York: Whitney Museum of American Art.

**1975** Crary, Jonathan. "Projects in Nature." *Arts Magazine* (December): 52–53.

Pincus-Witten, Robert. "Reviews." *Artforum* (Summer): 67.

Rosen, Nancy, and Fry, Edward F. *Projects in Nature*. Exhibition catalogue. Far Hills, New Jersey: Merriewold West.

Russell, John. "Sculpture in Fields of a Jersey Estate." *New York Times*, October 25, 25.

Sheffield, Margaret. "Review: New York." *Studio International* (November–December): 233–35.

Smith, Roberta. "Reviews." *Artforum* (December): 68–69.

Stimson, Paul. "Review of Exhibitions." *Art in America* (September–October): 94.

**1976** Baracks, Barbara. "Artpark: The New Esthetic Playground." *Artforum* (November): 28–33.

Edelman, Sharon, ed. *Artpark: The Program in Visual Arts*. Exhibition catalogue. Lewiston, New York: Artpark.

Kardon, Janet. *Private Notations: Artists' Sketchbooks*. Exhibition catalogue. Philadelphia: Philadelphia College of Art.

Linker, Kate. "George Trakas and the Syntax of Space." *Arts Magazine* (January): 92–94.

Onorato, Ronald J. "Sighted Sites." *Soho Weekly News*, October 14, 31.

Russell, John. "Art People." *New York Times*, August 27, section C, p. 12.

Shirey, David L. "Drawing the Viewer into the Art." *New York Times*, October 17, section 21, p. 29.

**1977** Baker, Elizabeth. "Report from Kassel: Documenta VI." *Art in America* (September–October): 44–45.

Balkind, Alvin. "Three Vistas and a Detour (In Expectation of Rising Anxieties)." *Vanguard* (Vancouver Art Gallery) (October): 9.

Busch, Mary. "George Trakas, Environmental Sculptor." *Vassar Quarterly* (Winter): 38–41.

Feaver, William. "The Password is 'Media' at This Year's Documenta." *New York Times*, July 3, section 2, p. 17.

Friedman, Martin, and Shopmaker, Laurence. *Scale and Environment: 10 Sculptors*. Exhibition catalogue. Minneapolis, Minnesota: Walker Art Center.

Heinrich, Theodore Allen. "Sculpture for Hercules: Documenta 6," *Artscanada* (October–November): 1–15.

Hirshorn, Ann Sue. "Review." *Philadelphia Arts Exchange*, vol. 1, no. 3, 34–35.

Howett, Catherine. "New Directions in Environmental Art." *Landscape Architecture* (January): 38–46.

Kardon, Janet. *George Trakas: Columnar Pass*. Exhibition catalogue. Philadelphia: Philadelphia College of Art.

Kuspit, Donald B. "Reviews: Philadelphia." *Art in America* (September–October): 121–23.

Lippard, Lucy R. "Reviews: Roslyn, L.I." *Art in America* (March–April): 120.

Perlberg, Deborah. "Reviews: Nassau County Museum." *Artforum* (January): 67–68.

Pontbriand, Chantal. "Documenta 6." *Parachute* (Autumn): 15.

Rosen, Nancy. "A Sense of Place: Five American Artists." *Studio International* (March–April): 115–21.

Russell, John. "The Arts in the 70's: New Tastemakers on Stage." *New York Times*, January 23, section 2, pp. 1, 20.

Schneckenburger, Manfred. *Documenta 6*. Exhibition catalogue. Kassel, Germany.

Shapiro, David. "A View of Kassel." *Artforum* (September): 55–62.

Stevens, Mark. "Holy Foolishness." *Newsweek*, August 8, 82–83.

**1978** Hegeman, William R. "Reviews: Minneapolis—Sculpture to walk through." *Art News* (January): 115–17.

Morris, Robert. "The Present Tense of Space." *Art in America* (January–February): 70–81.

Nasgaard, Roald. *Structures for Behaviour*. Exhibition catalogue. Toronto, Canada: Art Gallery of Ontario.

Phillips, Lisa. *Architectural Analogues*. Exhibition catalogue. New York: Downtown Branch, Whitney Museum of American Art.

Pontbriand, Chantal. "Interview." *Parachute* (Autumn): 28–37.

Tuchman, Phyllis. "Sculptors Mass in Toronto." *Art in America* (September–October): 15–16, 21, 23.

Wick, Paul, Levine, Edward, and Zurcher, Susan, eds. *Quintessence*. Exhibition catalogue. Dayton, Ohio: City Beautiful Council.

**1979** *George Trakas—Montreal*. Exhibition catalogue. Montreal: Montreal Museum of Fine Arts.

Howett, Catherine. "George Trakas: Working at Emory." *Atlanta Art Workers Coalition Newspaper* (November–December): 1, 6–7.

*1979 Biennial*. Exhibition catalogue. New York: Whitney Museum of American Art.

Tousley, Nancy. "Natural Hierarchy of Materials: An Interview with George Trakas." *Artscanada* (August–September): 24–26.

**1980** Davies, Hugh M., and Yard, Sally E. *George Trakas—Log Mass: Mass Curve*. Exhibition catalogue. Amherst, Massachusetts: University Gallery, University of Massachusetts, Amherst.

**1981** Harney, Andy Leon, ed. *Art in Public Places*. Washington, D.C.: Partners for Livable Places.

**1982** Barzel, Amnon. *Art '82*. Paris: V.N.U. Books International.

———. *Spazi d'Arte '82*. Pistoia, Italy: Celli.

Davies, Hugh M. "*Island Project* by George Trakas." *Art Express* (May–June): 58–59.

**1983** Onorato, Ronald J. "A Dictionary of Assumptions: Drawings by Contemporary Sculptors." *Drawing* (November–December): 79–83.

**1984** Beardsley, John. *Earthworks and Beyond—Contemporary Art in the Landscape*. New York: Abbeville.

Harris, Stacy Paleologos, ed. *Insights/On Sites—Perspectives on Art in Public Places*. Washington, D.C.: Partners for Livable Places.

Robins, Corinne. *The Pluralist Era in American Art 1968–1981*. New York: Harper and Row.

**1985** Fuller, Patricia. *Five Artists at NOAA—A Case Book on Art in Public Places*. Seattle, Washington: The Real Comet Press.

Schwartz, Joyce Pomeroy. *Artists and Architects—Challenges in Collaboration*. Exhibition catalogue. Cleveland, Ohio: Cleveland Center for Contemporary Art.

**1986** Davies, Hugh M., and Onorato, Ronald J. *Sitings*. Exhibition catalogue. Includes essay, "George Trakas: Passion in Public Places," by Hugh M. Davies and Sally Yard. La Jolla, California: La Jolla Museum of Contemporary Art.

Glueck, Grace. "A New Face and Fresh Ideas in the Public-Art Debate." *New York Times*, January 12, section 2, pp. 35–36.

George Trakas, *Atlanta Drawing: Route Source
(Emory Ravine Axis)*, 1982, graphite and charcoal
on paper, 22¹⁄₁₆ x 30¹⁄₁₆ inches, Collection Emory
University Museum of Art and Archaeology.

La Jolla Museum of Contemporary Art

Typography: RS Typographics, North Hollywood
Lithography: Rush Press, San Diego, in an edition of 3000
Editors: Sally Yard and Julie Dunn

Photography:

Michael Arthur: *cover, 93 bottom right, 112, 134, 135*
Clinton Born: *56*
Joel Breger: *60, 61, 62, 63*
Rudolph Burckhardt: *12, 13*
Colleen Chartier: *98, 99 below*
Hugh Davies: *101*
Gene Dwiggins: *54, 55, 58, 67*
Roy M. Elkind: *128, 130, 131, 140*
John A. Ferrari: *46, 121*
Ellen Fleischner: *108 center*
Fleischner Studio: *53 above, 64, 66*
Ira Garber: *33*
Gianfranco Gorgoni: *16, 17, 19*
Red Holsclaw: *149*
Susan Horwitz: *24*
Jean Paul Judon: *100 above, 106 below*
Balthazar Korab: *23*
Richard Landry: *84 below, 86 above*
Stephen Long: *94 above*
Robert K. McElroy: *29*
Fred Moore: *94 below, 95*
Lane Myer: *9, 52, 65 above, 104*
Bob O'Neal: *107 below*
Evelyn Schwark: *90, 91*
Robert Thornton: *53 below*
Susan Zurcher: *70, 102*